The Advanced Digital Photographer's Workbook

Professionals Creating and Outputting World-Class Images

The Advanced Digital Photographer's Workbook

Professionals Creating and Outputting World-Class Images

Yvonne J. Butler, Editor

30519007464871

AMSTERDAM • BOSTON • HEIDELBERG • LONDON
NEW YORK • OXFORD • PARIS • SAN DIEGO
SAN FRANCISCO • SINGAPORE • SYDNEY • TOKYO
Focal Press is an imprint of Elsevier

ELSEVIER

Focal Press

Focal Press is an imprint of Elsevier
200 Wheeler Road, Burlington, MA 01803, USA
Linacre House, Jordan Hill, Oxford OX2 8DP, UK

Library of Congress Cataloging-in-Publication Data
The advanced digital photographer's workbook : professionals creating and outputting
world-class images / Yvonne Butler, Editor.
 p. cm.
 Includes index.
 ISBN 0-240-80646-8 (alk. paper)
 1. Photography—Digital techniques—Handbooks, manuals, etc. 2. Image process-
ing—Digital techniques—Handbooks, manuals, etc. I. Butler, Yvonne.
 TR267.A28 2005
 775—dc22 2004030222

British Library Cataloguing-in-Publication Data
A catalogue record for this book is available from the British Library.

ISBN: 0-240-80646-8

For information on all Focal Press publications
visit our website at www.books.elsevier.com

05 06 07 08 09 10 10 9 8 7 6 5 4 3 2 1
Printed in China

Contents

PART 1 – Advanced Digital Requisites 1

PART 2 – Digital Capture 91

PART 3 – Advanced Digital Darkroom 203

Contents

Acknowledgments

I thank Diane Wurzel for sharing the vision of and commissioning this book, Becky Golden-Harrell for editing assistance, and all the editors and staff of Focal Press for seeing this project through to completion.

I also acknowledge and thank the contributors to the book—Steve Anchell, Stephen Burns, Eric Cheng, Joe Farace, Lou Jones, Rick Sammon, George Schaub, Jeremy Sutton, Tony Sweet, Taz Tally, and Eddie Tapp—for their numerous hours of research, testing, writing, and photography for their chapters. Without their individual and collective energy, knowledge, and pursuit of excellence, this book would not have come to fruition.

I also thank so, so many members of the photo industry community, far too many to name here, but particularly staffs of Canon, Leica, Sony, nik Multimedia, Epson, Olympus, Wacom, Photoflex, Chimera, Lowepro, Fujifilm, Tiffen, Kodak, Extensis, Legasse Marketing, iView, Lowepro, Mamiya, Leaf, Minolta, Vivitar, Nikon, Adobe, Lasersoft, SmartDisk, Capture One, Pantone, and all the others who provided technical assistance, support, and documentation for the book.

On a very personal note, thank you from the bottom of my heart to my parents, godparents, partner, close friends, and photography mentors for encouraging me to always keep on keeping on. I am eternally grateful to you and you are my inspiration.

Yvonne J. Butler

Introduction:
Taking It to the Next Level

There are numerous reasons why you might have this book in hand. You have finally decided it's time to learn how to calibrate your monitor, you are a film diehard and you just want easy post-capture solutions, or you've got a digital workflow that's not exactly the easiest to get through. Perhaps you see some exciting topics from some of the best in the business and you want to check them out or your in-laws have given you a copy of this book for your birthday and you thought you'd better open it up and have a look. Whatever the reason, we would like to rock you out of your existing digital comfort zone and take you into a new zone full of somewhat complex yet practical solutions for advanced photographers. As the old saying goes, knowledge is power. We want you to increase your digital imaging power by "taking it to the next level."

This digital imaging how-to book comprises topics and information we deem critical to the future growth of the advanced photographer. We believe most of us learn by doing and doing and doing. We also believe we all have to pay our dues and spend time reading available information and staying abreast of the latest developments in the photo industry. We firmly believe it is up to all of us to test drive the technical background information and sample exercises found in this book and adapt them to our own styles and preferences.

The first part of the book might be the toughest or at least the "driest" one for you to get through, unless of course you are a techno-geek who thrives on techno-chatter. We know some of you might leaf through the first chapter or even all of Part 1 and say, no way, I'm moving straight to Part 2 on Digital Capture. We suggest you bite the bullet and go through Part 1 with purpose to see why we believe calibration, color correction, proper scanning, file format selection (JPEG or raw), and workflow are all "required reading." Expecting to get predictable, reliable results from a non-calibrated system or working without an established formal or informal color-managed workflow is tantamount to depending on the lottery to make a living. Your ability to grasp what we have to say in the rest of the book really depends on your having a solid understanding of the topics presented in Part 1.

After you work through Part 1, move on to Part 2 where we take you through some fascinating enjoyable discussions on how we approach lighting challenges in a digital context, the ins and outs of portraiture, the new developments in digital macro- and infrared capture, and the omnipresent allure of travel photography, that all-encompassing niche for eclectics. Sure, we could have covered other specialties, such as fashion, architecture, and outdoor/nature/landscape, but we elected to select a few to serve as a basis for your other work. Light is light and color casts are color casts; issues of highlights and shadows are always there no matter what your specialty or forte might be.

Part 3 takes us into the digital darkroom where we give you another stab at color correction—a part of our plan to have redundancy in a few places throughout the book in case you skip chapters, skip around, or need a refresher within that particular chapter's context. We also cover the best image sharpening options, advanced power tools for Photoshop, and black and white for the digital photographer. Part 4 is devoted to the fine art studio, with an insider's view of how two fine art specialists produce their masterpieces.

Finally in Part 5, after you have worked your way through all the steps for creating breathtaking color-managed images, we want you to tie down the components that will help ensure your output matches what you originally saw and/or created. What is the point of grabbing or creating the best shot of your lifetime only to find your print does not even come close to your vision? The chapter on inkjet printing and color synchronization will take you back to the importance of system-wide calibration and reinforce color techniques for output. The last two chapters provide a little more on black and white and fine art printing, respectively.

There is something here for just about everyone. Have fun with whatever you elect to work on and through. We'll look forward to seeing your world-class images in magazines, galleries, online, and elsewhere. We're counting on it!

<div align="right">Yvonne J. Butler, Editor and Co-Author</div>

Part 1

ADVANCED DIGITAL REQUISITES

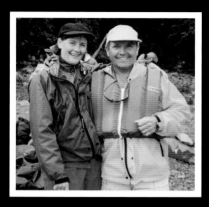

Chapter 1

Calibration and Color Correction

Taz Tally

Grayscale, Color, and Why Calibration Is Important

Calibration is the process by which an image-capture or output device is adjusted so it will accurately, predictably, and consistently reproduce image data. In the case of digital-capture devices, such as scanners and digital cameras, you focus on the accurate, predictable, and consistent capture of black and white or grayscale data. There is no such thing as a color scanner or color digital camera; they do not exist! Scanners and digital cameras, being digital devices, only capture 1s and 0s or black and white as various shades of gray known as grayscale data. All color is created by output devices, not captures by input devices. You don't believe me? Open up any RGB image in Photoshop. Look at its three building blocks: red, green, and blue channels. All you will see is grayscale data (Figure 1.1 a-d). The color you see on screen is being created by the RGB output device you call a monitor. Look at your printing devices; they supply the cyan, magenta, and yellow inks or toners used to print your images in color. See, it's true! The color that you see is all created by color output devices such as monitors and printers.

Figure 1.1 Color images, such as this typical three-channel RGB color image, are constructed out of multiple grayscale channels. Image © Taz Tally.

The first step to controlling output, either grayscale or color, is to control the input grayscale values of the pixels in a digital image, which in turn control the output of grayscale, RGB, and CMYK values of our images. If our scanners or digital cameras do not capture grayscale values accurately and/or consistently, then our images will not be accurate or consistent when they are output. Using calibrated devices definitely improves image quality, as shown in Figure 1.2, and capture consistency.

What Is Calibration?

Calibration usually involves the capture or output of a grayscale target with multiple swatches (grayscale areas) whose grayscale values are known. The captured or output grayscale values are then measured and compared with the known values. Any disparity between the known value and the captured output value must then be adjusted. We address two basic types of calibration in this chapter: linearization and neutralization.

Linearization is the adjustment (or calibration) of an image-capture or output device so that it will capture or output grayscale image areas with their proper grayscale values. The concept of linearization (which means a straight line) refers to the equality (or straight-line relationship) between input and output data. For instance, a linear scanner or digital camera will create a 35% pixel (output) when it "sees" a 35% grayscale area in an image (input). Similarly, a calibrated (linear) monitor or printer will also faithfully render this area as 35% grayscale pixel data and as 35% on output. Nonlinear scanners or digital cameras will capture an original 35% grayscale value as a value other than 35% when it "sees" a 35% grayscale image area. Typically, non-calibrated (nonlinear) scanners or digital cameras create pixels that are darker than the original grayscale values of an image. For instance, an original 50% grayscale area may be captured as 60% gray by a nonlinear scanner or digital camera. This will result in images that look and print too dark. In addition,

non-calibrated devices often clip one or both ends of a captured image's gray tones, resulting in loss of either or both shadow and highlight detail (Figure 1.2). In addition to creating image quality problems on individual images, using non-calibrated devices makes creating consistent images—so crucial in multiple-shot captures such as food, clothing, and other product that may occur over multiple day shots—very difficult to achieve. So, calibration helps to improve both individual image quality as well as consistency between images.

Neutralization: Calibration and Image Channels

The concept behind neutralization of a device with a grayscale target is that if a device is adjusted (calibrated/neutralized) so that it will capture or output a grayscale target that is properly neutral, it will do so with other images as well. For grayscale images, which have only one grayscale channel, linearization of a single set of grayscale pixels (the one channel) is all that is required for calibrating a capture or output device. When you work with color images with three or more channels (three channels for a typical RGB image, one for each color that will be output; Figure 1.1), each channel must be calibrated (linearized). This multichannel linearization is known as neutralization. Neutralization is the adjustment, or calibration, of a device so that neutral portions of a color image, such as a white highlight or a mid-tone gray, will be captured as neutral rather than having a color cast. Neutral gray areas, such as the swatches on a grayscale target, should have equal RGB values. A non-neutral area will have unequal RGB values. For instance, a neutral 5% white highlight area should have RGB values all equal to 5%. A neutral gray mid-tone should have RGB values all equal to 50%. Neutral areas that are captured with unequal RGB values will appear and print with an unwanted color cast.

To control the RGB color values in our images, all we really need to do is control the grayscale values in the

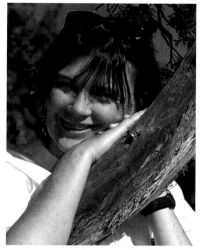

Figure 1.2 Non-calibrated versus calibrated image capture. Note how the image captured with a non-calibrated device is darker and lower contrast and has lost its details in the highlights and shadows (check out the hair). Image © Taz Tally.

5

channels of our color images. This is precisely why we can calibrate color devices with grayscale targets.

Common Calibration Challenges

Calibration is necessary because each scanner or other image-capture device is unique and slightly different from every other capture device. And, over time, capture devices change as they age. Scanners and other image-capture devices must be continually calibrated to guarantee consistent results.

One of the most common calibration-related problems you may encounter is that scanners and digital cameras tend to capture images too dark. This results from the fact that most scanners and digital cameras are nonlinear and typically on the dark side. For instance, a typical nonlinear scanner or digital camera might capture a 50% grayscale area in an image as 60%. And the 60% area of the original image might be captured as 70%, and so on. This results in images that are much darker than they should be, particularly from the mid-tone to the shadow position of images (Figure 1.2).

In addition to the linearization challenges you have with both grayscale and color images, you must also use calibration to prevent color cast. Color cast results when scanners, or other digital devices, do not have consistent capture values on all three (RGB) channels. Remember that a digital RGB color image is really a sandwich of three grayscale images. The grayscale values of these channels control the RGB values on output. If grayscale capture values vary among the three channels, then you will not have predictable and consistent color images as a result. Color cast problems are most evident when neutral gray areas, such as white highlight areas, are captured. Any neutral area you capture should have equal RGB values. For instance, a 5% white highlight area should have RGB all equal to 5% (R = 5%, G = 5%, B = 5%). If the RGB values are not equal, then you will have a color cast in that area. A white highlight area that is captured with unequal RGB values, such as R = 5%, B = 8%, G = 5%, will appear

and print with an unwanted blue cast. You can neutralize (calibrate) a scanner or digital camera by capturing a target that contains a series of neutral/grayscale swatches with known values. You will measure and compare the RGB (grayscale) values of the captured grayscale swatches with the original equal RGB target values. Then you will correct any disparity between the original known values and the captured values. This is calibration!

Measuring Grayscale

As discussed above, both the grayscale values of grayscale images and the color values of color images are controlled by measuring grayscale values. Several measurement systems are available to measure grayscale values, including percent or "K" grayscale (K = 0–100%), luminosity or "L" values (L = 100–0), brightness or "V" values (V = 100–0), density or "D" values (D = 0–4), and RGB values (RGB = 0–255). The two most common value units you will find are the percent grayscale (%K) and RGB (0–255) systems. In the percent grayscale or % black, the K values vary from 0% for pure white to 100% for pure black. The % gray or K scale is often used by image editing applications like Photoshop when working with grayscale images. With the RGB measurement system R, B, and G values will vary from 0 for pure black to 255 for pure white. A mid-tone value of 50% gray is 127, midway between 0 and 255.

The 0–255 scale is commonly used when working with RGB images. Sophisticated image editing applications like Photoshop allow you to change between measurement systems and even view more than one measurement system's values at a time (Figure 1.3). You will note that the K and RGB scales work on the opposite or inverse order, so that 0% K is pure white and 0 RGB value is pure black. Because of this you will always want to make sure which measurement system you are using at any given time. You will make much use of these grayscale values both in calibration and color correction.

Figure 1.3 Measuring grayscale. There are several unit scales for measuring grayscale. Two of the most common, percent (0–100%) grayscale and grayscale value units, measured as 0–255 RGB values, are shown here in these three Photoshop Info Palettes. Image © Taz Tally.

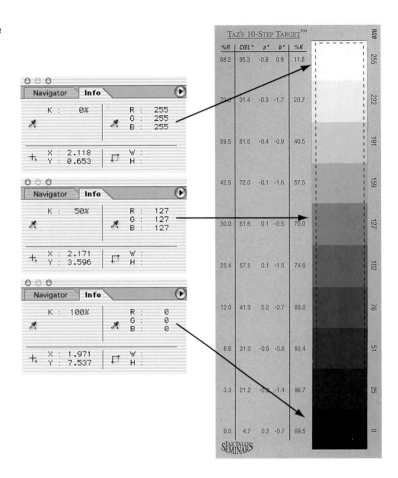

Calibration Requirements

Calibration of any device requires that you are able to

1. Capture the grayscale target;
2. Measure the grayscale values of the swatches;
3. Compare the captured values with the known target values;
4. Adjust, through software, the values the scanner or digital camera will capture;
5. Recapture the image using the adjusted device.

The following calibration tools are required:

- Capture device (scanner or digital camera)
- Calibration target: Taz's 10-Step Calibration Target or similar target (Figure 1.4)
- Info tool for measuring grayscale values of swatches

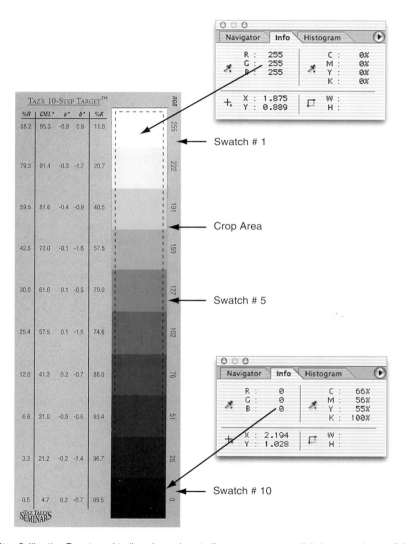

Figure 1.4 10-Step Calibration Target used to linearize and neutralize your scanner or digital camera. Image © Taz Tally.

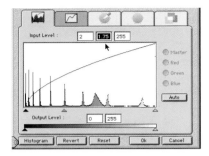

Figure 1.5 Editable histogram tool. Adjust the highlight slider until the white swatch measures "255" and the shadow slider until the black swatch measures "0."

- Editable histogram tool (like the Levels tool in Photoshop) (Figure 1.5)
- Gamma curve adjustment tool
- A curve tool (like Photoshop's Curve tool)
- A way to save and recall settings (often a preference in the scanner or digital camera software)

Scanners versus Digital Cameras

Your multistep calibration target can be used for calibration and/or color correction. The way you use your target will depend on your device and its software correction capabilities and your image-capture conditions. Most scanners have consistent lighting and necessary software tools (listed above) that will allow you to create a preview and correct the capture characteristics of the scanner. Many digital cameras, particularly low- to medium-priced digital cameras, do not have this capability. But with photography, even if you have all the software adjustment tools, unless you are in a controlled lighting environment, such as a studio, changing light conditions often makes continuous calibration impractical. In my case I shoot mostly outdoors while I am hiking or kayaking so calibration is often not practical (nor do the cameras I use contain the proper software to allow me to calibrate). So, for my digital photography workflow, I typically use my target as a color correction tool (after I shoot my images) rather than as a pre-shot calibration tool (see Digital Camera Calibration and Image Color Correction, on page 13).

Grayscale Calibration at Image-Capture Stage

In this grayscale calibration exercise, you will be performing the calibration as if you were controlling the calibration at the capture stage through software control of your digital camera or scanner.

Linearization for Grayscale Image Capture

A simple linearization calibration step by step for grayscale images is as follows:

Step 1: If shooting with a camera, clean your lens and any filters. If scanning, clean your scanner bed and your image. Then place your 10-step calibration target in your field of view or squarely on the scanner bed.

Step 2: Perform an initial shot or preview scan of the target in grayscale mode (8- to 16-bit mode).

Step 3: Select the 10-step grayscale portion of the target, including the pure white and pure black end swatches. (Be careful to select just the grayscale portion of the target.) (See Figure 1.4.)

Step 4: Select the editable histogram tool (like Levels in Photoshop) (Figure 1.5).

Step 5: Adjustment. Move the highlight and shadow pointers to the beginning and the end of the histogram visible data (the beginning and the end of the peaks in the histogram). Move the highlight and shadow sliders until the pure white swatch measures "255" with your info tool (Figure 1.4) and the pure black swatch measures "0."

Step 6: Zoom in a bit on the middle portion of the grayscale target so that you have a good view of the middle swatches. Use swatch no. 5 (127) to start (counting down from the white swatch) (Figure 1.4).

Step 7: Now with the Info tool, measure the grayscale value of the no. 5 target swatch. Swatch no. 5 will probably register a grayscale value lower (darker) than its actual value of 127 (a value of ~110 is common).

Step 8: Quick overall (gamma-based) calibration adjustment. Locate the gamma adjustment in your software referred to in Figure 1.6. To make a quick overall correction of your scanner's response to grayscale values, adjust the mid-point of the gamma curve by changing the value in the middle box of the Histogram tool until the Info tool (Figure 1.7) measures the no. 5 target swatch at ~127. The default gamma value in most capture software will be between 1.0 and 1.5. Adjust the gamma curve mid-tone value up until the no. 5 grayscale swatch measures 127. Perform this change incrementally, 0.1 per change, and watch how the Info readings

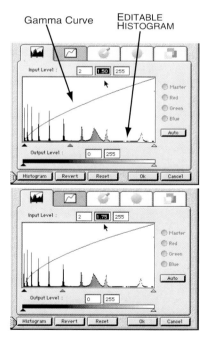

Figure 1.6 Gamma curve linearization effects an overall calibration of your scanner or digital camera and lightening of your images.

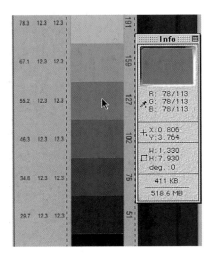

Figure 1.7 The Info tool is used to measure grayscale values on targets and images. Note the starting (113) and ending (127) values before and after gamma curve adjustment.

gradually increase. You may have to jiggle the Info tools slightly (move the cursor) after each adjustment to make sure the software registers the change in grayscale value. A typical adjusted mid-point in the gamma curves may be 1.7–2.0. Note how, in this case, the curve arches up, which will lighten the entire image when you make this adjustment. Note: Some software does not show a gamma curve but rather just a numeric adjustment. Don't worry if the Info tool doesn't read exactly 127 or if the value varies slightly (by one or two points) as you move the Info tool around the swatch.

The results of capturing an image with a calibrated versus a non-calibrated device can be seen in Figure 1.8, where the calibrated capture shows more apparent shadow detail as well as improved overall image brightness.

Alternative Step 8: Multiswatch detailed calibration adjustment. If you want to make a more detailed precise calibration adjustment than the single gamma curve calibration above, you can measure and correct up to all 10 swatches on the calibration target. Here's how:

- Locate an active, editable curve tool (Figure 1.9).
- Using the Iinfo tool to measure the various swatch values, adjust the curve in up to 10 places (Figure 1.9), so that all the swatches register their correct grayscale values when measured with your Info tool.
- Save this curve as your calibration curve (tip: label the curve with the date so you will know when this curve was made).
- Load this curve before all your image-capture sessions.

Note: If your scanner or digital camera does not allow you to load curves, a calibration curve can be created, saved, and loaded in Photoshop and applied to your images (using a Photoshop Action for ease and speed; see Chapter 12) after the image is captured. If you apply calibration corrections in this manner, your image quality will be best served by capturing images in 10-bit or higher mode. Also, typically you will achieve higher image quality and faster workflow if calibration can be applied at the image-capture stage.

Step 9: Save the corrected scanner/digital camera settings as default settings, so they will automatically be applied to each captured image. Typically, corrections can be saved as default values using a "Settings" or "Preferences" menu and/or dialog. Neither the gamma nor multipoint adjustment curve should be touched again while adjusting individual images to avoid destroying the calibration adjustment we just performed.

Note: For best results, this linearization calibration should be performed at the beginning of each image-capture session.

Tip: Protect your targets. When not in use, keep your targets in moisture-proof light-tight containers. Constant exposure to light and humidity will progressively degrade the target, which will then no longer be consistent with its published data sheet values.

Calibration Reminder

This simple linearization adjustment provides you with an easy way to make noticeable improvements in the overall quality and consistency of your scanned images without drowning you in technical details, long procedures, or costly purchases. Remember that once you have set the gamma curve mid-point, do not adjust it when you are scanning individual images or you will destroy the calibration setup. Any tool used for calibration should not be used for any other purpose!

Digital Camera Calibration and Image Color Correction at Post Image-Capture Stage

Unlike the previous grayscale calibration exercise in which we controlled the calibration through software control of the scanner or digital camera, here we make a calibration/color correction in the post–image-capture stage, as we are often required to perform when working with digital photography.

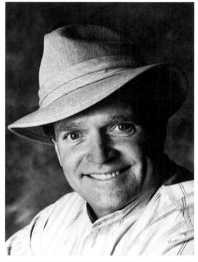

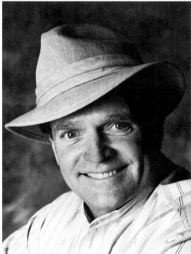

Figure 1.8 Pre- and post-calibration. The top image was captured with an uncalibrated device (default gamma = 1.5). The lower image was captured after calibration (corrected gamma = 1.8). Note how the shadow areas (hat) in the bottom image are more apparent and how the overall image brightness is improved over the top image. Image © Taz Tally.

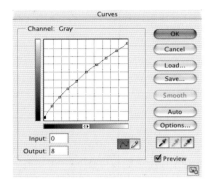

Figure 1.9 Multipoint calibration correction curve. This multipoint calibration curve can be created and applied in either the image-capture software or in Photoshop after the image has been captured.

Color Linearization and Neutralization the Quick and Easy Way

Much photography is performed in unknown and variable lighting conditions. This results in unknown and variable color. And if you take multiple pictures of the same scene, even if the shots are separated by only a few minutes, you may well encounter different lighting conditions and therefore different color values. Making these images look color correct and consistent can be quite a chore, unless you know a little trick. A quick and easy way to perform a color correction (neutralization) of a digital camera image or multiple images follows.

The tools you will need are 1) a digital camera, 2) a multistep neutral (equal RGB values) grayscale card with known RGB values (I will use my Taz's 10-Step Calibration Target designed for this purpose), and 3) an image editing program (Photoshop in this case) that allows you to measure (with an Info tool) and correct (with an editable histogram) color values.

The process is very simple in concept and even simpler in practice. Place the 10-step target somewhere in the scene to be shot with the digital camera. Place the target in an area that can later be cropped out of the final image. You will use the known values of the grayscale target to provide you with the neutral values you need to color correct your images. You can take advantage of the fact that all color in digital images is actually controlled by grayscale values that your camera captures—remember that your camera does not actually capture color, it captures grayscale values. The color you see is created by the output devices on which you view or print your images.

The concept is this: 1) you capture an image that includes the neutral multiswatch grayscale target and 2) you neutralize the grayscale target, which in turn neutralizes and color corrects the image. Our ace in the hole is we know what the grayscale values of the target are supposed to be (remember we specified known values, and in this case the values are printed directly on the target). So, if you adjust the RGB values across the

entire image so that the target swatch values are all neutral, then the color values in the rest of the image will be corrected as well. If we perform this correction on multiple images, creating the same grayscale values on the target swatches of each image, then each image will be color correct and consistent. So there's the concept; now let's apply it, and I'll bet the concept will become a bit clearer.

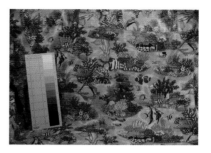

Figure 1.10 Captured image with multistep grayscale target. Image © Taz Tally.

Step 1: Place the grayscale target (Figure 1.10) within the area of the scene that will be captured by the digital camera. Select a location that you will be able to crop out later. Placing the target off to one side as I have done in Figure 1.10 is a good choice.

Step 2: Take the picture using whatever normal settings you would use in terms of image dimension, quality (usually a compression setting that I minimize/remove for the highest quality images), exposure, color balance, and file format (I suggest TIFF or raw to be sure that no image-damaging compression will be applied to your image).

Step 3: Transfer your image to your computer and open it in Photoshop.

Step 4: Make a copy of the image. (I like to use Image > Duplicate so that the original image remains open on screen as well as my new copy, so I can do a compare and contrast with the initial and correct images.)

Step 5: Zoom in so you can clearly see and read the grayscale values of the top couple of swatches on the target.

Step 6: Activate the Info tool (I) and place directly underneath the top white swatch.

Step 7: Open the Levels tool Image menu > Adjustments > Levels (or Command/Control + "L"). The Levels tool with an editable histogram showing the distribution of grayscale values will appear (Figure 1.11). Place the Levels window just to the right of the top white swatch and the Info tool. The target, the Info tool, and the Levels tool should all be visible (Figure 1.3).

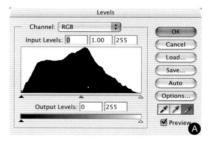

Figure 1.11 Editable histogram (Levels) showing the distribution of grayscale values.

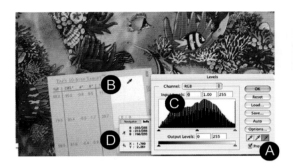

Figure 1.12 Neutralize the highlight by clicking on the top swatch with the highlight dropper. Image © Taz Tally.

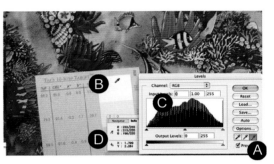

Figure 1.13 Neutralizing the mid-tone by clicking on\ the 127 swatch with the mid-tone dropper. Image © Taz Tally.

Step 8: Click on the Highlight eye dropper tool in the lower right-hand corner of the level window (Figure 1.12, location A).

Step 9: Now click on the top white swatch (Figure 1.12, location B) (labeled with an RGB value of 255) of the target with the Highlight eyedropper tool. You will notice several things happen (Figure 1.12): the colors in the image will shift, the histogram (location C) will change, and the Info tool values (location D) will change from the original RGB values of 233/213/190 to 255/255/255 (identical to the printed swatch value of 255!).

Step 10: Now move the zoomed view so that you can see the mid-tone swatch, labeled with an RGB value of 127 (Figure 1.13).

Step 11: Click on the mid-tone eyedropper tool in the lower right-hand corner of the level window (Figure 1.13, location A).

Step 12: Now click on the mid-tone swatch (location B) (labeled with an RGB value of 127) of the target with the mid-tone eye dropper tool. Once again, you will notice several things happen (Figure 1.13): the colors in the image will shift again, the histogram (location C) will

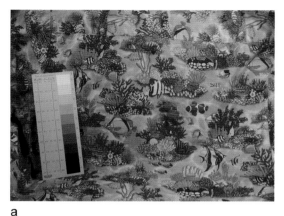

a b

Figure 1.14 Before (a) and after (b) target-based color correction. Image © Taz Tally.

change, and the Info tool values (location D) will change
from the original RGB values of 127/104/85 to
133/133/133. (Note that this is not identical to the 127
printed value, but it's close, and a darn sight better than
the original uneven values.)

Step 13: Now zoom out and compare your corrected
(neutralized) image with the original color-casted image
(Figure 1.14).

Discussion
You will notice that the whites are whiter, the colors are
more saturated, and the overall brightness and contrast are
all improved. And this adjustment just takes a minute to
perform. This quick and easy process both linearizes and
neutralizes the image, which results in a neutral-based
color correction. You, of course, could achieve even more
accurate results by performing a multipoint curve
adjustment using all the swatches in the 10-step
Calibration Target (just as we did at the end of the
grayscale calibration exercise). You will find, however, that
for many purposes this simple method will provide
acceptable results, allowing you to improve your
productivity (and get out kayaking sooner).

Some Calibration Tips

Tip 1: Linearize and neutralize your scanner, as described above, at the beginning of each scan session.

Tip 2: Use only targets that have known grayscale and/or RGB values associated with them, such as Taz's 10-Step Target used in this manual.

Tip 3: When linearizing and neutralizing a scanner, measure and correct at least three swatches of the grayscale spectrum, preferably near the highlight, mid-tone, and shadow regions of the spectrum.

Tip 4: Use a separate tool for calibration (linearization–gamma curve and neutralization–color cast adjustment tool) that you do not adjust after you linearize and/or neutralize the scanner.

Tip 5: To save time on color scans, a combined linearization/neutralization calibration can be performed at the beginning of each scan session. Note: As mentioned above, you should use separate tools for calibration of the scanner and then use other tools to adjust individual images.

Tip 6: It is usually better to linearize and neutralize a scanner than to wait to make these corrections in the post-scan in Photoshop® to preserve image data and quality.

Tip 7: Calibration settings can be saved either as default settings, which will automatically be applied to each image scanned, or as separate data files, which can be loaded and used whenever you choose.

Monitor Calibration

Depending on your work methods and workflow, monitor calibration may the most or the least important part of your calibration process. If you depend on your on-screen view of your image for making color decisions and maybe

even selling your images to clients, then your monitor calibration is critical. Also, if you want what you see on your monitor to closely resemble what is printed on your printer, then calibration is a must. Note: Adjusting your monitor to closely resemble a specific print output device requires more than calibration. Achieving as close a "match" as possible between monitor and print output devices requires the creation and mapping of custom color profiles for both your monitor *and* each of your print devices. Calibration is an absolute fundamental requirement for successful participation in any color management process. Without calibration, profile-based color management is not possible. Even if you do not choose to jump into profile-based color management, calibrating your monitor in addition to any print devices you are using will move you much closer to achieving similar monitor and print results.

Complete monitor calibration typically involves setting three parameters: 1) defining a target gamma and viewing conditions, which adjusts a monitor's overall brightness and contrast; 2) the tristimulus values, which balance the monitor's red, green, and blue output values; and 3) a white point setting based on the lighting characteristics of your final output viewing conditions. Monitor calibration methods fall into two general categories: built-in monitor calibration and external monitor calibration. Built-in monitor calibration uses either software that is part of the operating system or a separate monitor calibration software that arrives with the monitor. Built-in monitor software will allow you to set the monitor gamma and the white point parameters but not the tristimulus values (which require an external measuring device). External monitor calibration methods, which typically involve the use of either a tristimulus colorimeter or a spectrophotometer, allow you to adjust all three calibration values. At the very least you will want to use a built-in method of calibration (which for many uses may be sufficient). If you are attempting to set up a complete closed loop color management system with as much

control of your monitor as possible, then you will want to use an external calibration method.

Below are examples of external calibration tools and methods with step by step discussions for each process.

External Custom Monitor Calibration

If you do not achieve the consistency and matching results you want, the solution is to take the next step up in quality (and price) by purchasing an external monitor calibration and color profiling system. These systems typically include a measuring device, such as a tristimulus colorimeter and accompanying profiling software. The colorimeter is used to measure the actual color values produced by your monitor. With these kits, you can accurately adjust all three key monitor profiling characteristics: gamma, white point, and RGB values.

There are a wide range of these monitor profiling devices and kits available starting at around $150 and going up from there. Shown here (Figure 1.15) is the Spyder Monitor profiling kit from Pantone (www.pantone.com). Like many calibration systems, the Spyder kits are available in two flavors, a basic Spyder and a Pro version with more bells and whistles. The basic kit allows you to calibrate your monitor to set standards for consistent monitor performance. The SpyderPro kit provides the additional ability to create and use custom profiles for specific output uses.

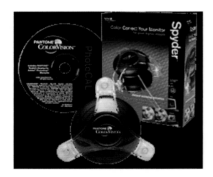

Figure 1.15 Monitor calibration kit with a tristimulus colorimeter (Pantone Spyder).

Creating a Custom Monitor Profile

Here we use a Pantone SpyderPro system to create a custom monitor profile. The profiling process involves the following components: 1) defining a set of target viewing conditions; 2) measuring the actual output of your monitor using a tristimulus colorimeter (*tri* meaning "three" for measuring the red, green, and blue output values of your monitor), here the SpyderPro; 3) evaluating the tristimulus colorimeter reading by profiling software (here Pantone OptiCAL) that compares what the colorimeter "sees" with what it should see to provide you with a linear and neutral monitor; and 4) creating a set of instructions,

called a profile, which is used to adjust the output of your monitor so that it will display images correctly for your target viewing conditions.

Various profiles can be created, saved, and loaded for different viewing environments, such as prepress or the Web. And because monitors tend to drift over time, profiles can, and should, be updated to keep your monitor's output consistent.

Step 1: Read your installation instructions! Follow the instructions carefully for your operating system. Make sure that your version of the operating system is supported by the profiling software. Mac and Windows installation procedures are typically somewhat different. There are often key elements or a specific order for performing a proper installation. For instance, with the Pantone kit, you will want to install your profiling software *before* attaching your Spyder hardware.

Hardware Note: If you are using a USB-based device, it is usually best to attach your hardware to a port on the computer rather than through an external connection such as a keyboard or USB hub.

Software Note: It is a good idea to deactivate any virus protection software as well as any other monitor calibration software before installing the calibration/profiling software. Initially, set your monitor controls to the factory defaults using the built-in monitor control panel that comes with your operating system.

Environmental Note: Remove any external direct lighting, such as a lamps, overhead lights, or direct window light, from your monitor. Also, make sure that the viewing conditions under which you profile your monitor match those in which you will be viewing your monitor when you work.

Step 2: Install your calibration/profiling software, in this case the Pantone OptiCAL software. I like to deactivate/quit all my other software when I calibrate or profile. Follow the instructions provided with your kit.

Step 3: Using the lighting conditions under which you typically work, adjust the brightness and contrast of your monitor using the instructions that come with the software. This usually involves adjusting a two-part image until the two parts have the same contrast. This is a critical step, because this step will adjust your monitor's contrast for your specific viewing conditions. This is why it is critical to maintain consistent viewing conditions.

Note: Some monitors, such as laptop LCDs, do not have contrast adjustments, so this step is not possible.

Step 4: Prepare to attach your tristimulus colorimeter to your monitor. Depending on your monitor type you may use suction cups to attach the colorimeter to your monitor screen (most CRTs) or you may hang your colorimeter over your monitor using a counter balance (most LCDs use this arrangement because suction cups don't work well on and in fact may damage LCD screens). If you are using a counter-balanced arrangement, be sure there is room for the counter-balanced weight to hang free from the back side of your monitor (Figure 1.16).

Step 5: Launch the OptiCAL software.

Note: Before attaching your Spyder, you will want to configure your OptiCAL software to match your viewing preferences and hardware.

Step 6: Activate the OptiCAL Preferences from the Application menu in Mac OS X or the Edit menu in Windows. Make sure the Calibration Method is set to "Standard." Then click OK (Figure 1.17). This will return you to the OptiCAL settings window.

Note: This type of window is used to define the target viewing conditions for which you will create an adjustment profile for your monitor.

Step 7: In the Monitor area of the OptiCAL window, click either the CRT or LCD button depending on which type of monitor you have (Figure 1.18).

Step 8: In the Target area of the OptiCAL window, select a gamma curve setting. For CRT monitors, use Gamma

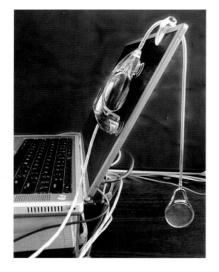

Figure 1.16 Counter-balanced Spyder.

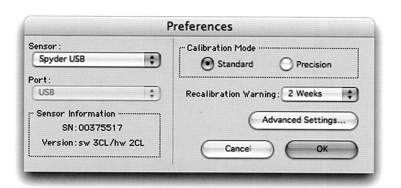

Figure 1.17 Spyder preferences.

1.8 for Mac monitors and Gamma 2.2 for Windows monitors.

Note: You can select specific gammas for various types of viewing environments such as NTSC for TV viewing or PAL for video viewing (Figure 1.18).

Step 9: From the White point menu select a white point temperature. For CRT monitors, select 5000 K for prepress work, 6500 K for inkjet and WEB work. For LCD monitors, Pantone recommends that you use "Native." Check to make sure that the "calibration enabled" check box is active (Figure 1.18).

Note: You can create multiple profiles for various types of work, such as prepress, Web, TV, video, and so on.

Step 10: Click the Calibrate button to begin the colorimeter measurement and profile creation process.

Step 11: Position your Spyder over the specified target area and click the "Continue" button (Figure 1.19).

Step 12: Wait for the OptiCAL software to progress through a series of measurements, including white point and individual red, green, and blue output readings.

Step 13: When the calibration (profile creation) process is completed, you will be presented with a window that will allow you to name and save the profile you and OptiCAL have just created. You might include a name of the viewing use and the date you created the profile, such as "Prepress_04.21.04" (Figure 1.20). With this

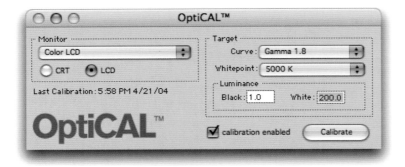

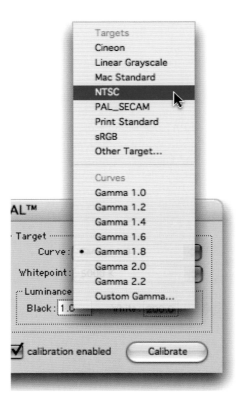

Figure 1.18 OptiCAL settings.

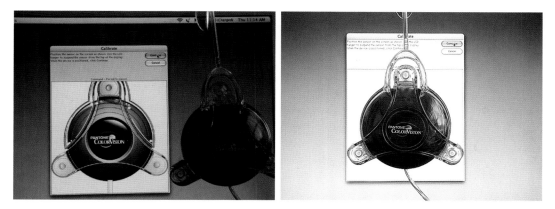

Figure 1.19 Spyder placement.

naming system you can easily identify the target use of
and when you created the profile. (If you are like me, I
forget when I created my last profile, so this name is an
easy way to remember.)

Note: Your custom profile will be stored in a Profile
folder in your operating system, so that you can access
this profile for other color management uses.

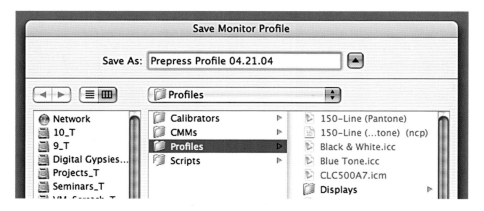

Figure 1.20 Save and name profile.

Note: Your monitor will drift over time, requiring recalibration through the updating/recreation of your monitor profile. You can set OptiCAL to remind you when to recalibrate. To maintain consistent monitor viewing performance, I recommend recalibrating at least once each week. (Some folks recalibrate every day!)

Step 14: To set OptiCAL to remind you to recalibrate, activate the OptiCAL preferences. Set the time interval (here "1 week") from the "Recalibrate Warning" menu (Figure 1.21).

If you would like to see how OptiCAL has adjusted your monitor to meet the specified target values, select OptiCAL's Tools menu > Curves window. By clicking on the Target, Uncorrected, and Correction check boxes, you will be able to isolate and view your monitor's adjustment states (Figure 1.22).

Controlling Your Perception

To get the most accurate and consistent view of your images on your screen, it is a good idea to set your monitor background to a neutral gray. Colors surrounding your images will affect the way you perceive the images you view on your monitor. If you are viewing your images in Photoshop, simply type the "F" character key to cycle through normal background, neutral mid-tone gray

Figure 1.21 Recalibrate warning.

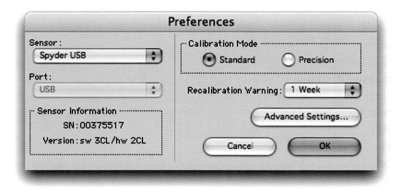

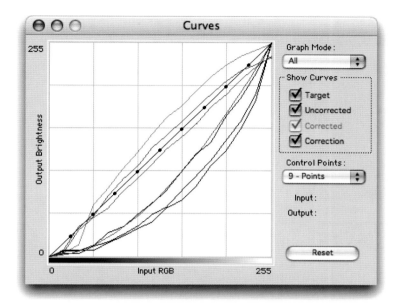

Figure 1.22 Curves window for viewing initial, target, and adjustment curve values.

background, and a neutral black background. Use the neutral mid-tone gray background. Besides being more conducive to accurate viewing of color, using the consistent neutral gray background is far less visually confusing (Figure 1.23).

Printer Calibration
Built-In Calibration

Most decent printing devices sold today offer at least a simple built-in calibration system, similar to the built-in monitor calibration I discussed earlier. Some print devices have sample print targets that can be printed and measured. Many users don't know if their printers have such a capability. Find out, and if your print device has one, learn how to run the built-in calibration procedure. Run this calibration procedure at least once a week. Having some sort of built-in calibration mechanism should be part of your print buying decision (see Chapter 16).

Figure 1.23 Normal versus neutral gray background view. Original image © Taz Tally.

Custom Calibration and Profiling

Companies such as Pantone, Monaco, and Gretag-Macbeth produce calibration and profiling kits for your print devices as companions to their monitor calibration kits. Again, they come in basic calibration and more advanced profiling systems. But just as with the monitor calibration we performed, the goal of these calibration and profiling systems is to adjust your print devices so they are linear and neutral and will reproduce color faithfully and consistently.

Most effective printer calibration/profiling systems involve the following key steps:

Step 1: Printing a target (grayscale and/or CMYK) with a range of known grayscale and/or color values (Figure 1.24) to your printing device.

Note: For the most effective results, you will want to print the calibration/profiling target on the paper you intend to use for final output. Changing paper stock has a large impact on the results.

Step 2: These printed test targets are then "read" by a measuring device, usually either a densitometer or a spectrophotometer.

Figure 1.24 Output target (Pantone PrintFix) used for measuring and creating print profiles. © Pantone ColorVision.

Step 3: The recorded values are then analyzed by calibration/profiling software.

Step 4: A print profile for a specific print stock is created through the use of the profiling software that analyzed the printed target data.

Step 5: This profile is then selected for use when printing to that stock.

Note: I recommend that you create a separate calibration/profile for each paper stock you use.

Calibration and profiling systems vary widely in their price and capabilities, from about $150 for Pantone's PrintFix system (which supports a limited number of desktop inkjet printers) to $5000+ for top of the line profiling systems from Gretag and Monaco that work with a wide range of printing and measuring devices. The more expensive systems have greater precision, more flexibility and editability, and they work faster. You might want to start with a simple system and work up from there as your skills and needs increase.

Chapter 2

Getting Set Up for Your Film Capture

Tony Sweet

Okay. You're probably wondering about a film chapter in an advanced digital photography book. Well, many photographers shoot both film and digital. The inherent archival nature of film is attractive to many, and it is used among professionals as a solid backup. Actually, aside from capturing images on film, everything else in the film shooter's workflow is handled digitally. After the initial scan to create your digital file, image editing software such as Photoshop is used to color correct, clean up, and sharpen the images.

Film (positive-transparency, negative-black and white, color, infrared) is loaded into a film scanner to create digital files. In the following examples, the Nikon Super Coolscan 4000ED is used. Rather than using the Nikon scanning software that comes packaged with the scanner, the illustrations in this chapter will use Lasersoft's Silverfast scanning software. Silverfast is believed by many professionals to be the best scanning software on the market. There will be more on Silverfast at the conclusion of this chapter. The Nikon scanning software is also excellent, as are many software packages that come

packaged with various scanners. The bottom line is if your scanning software is understandable to you and gets you the results you want, stick with it.

Calibration between scanners, printers, and your monitor is a defining issue and will likely remain so. Many of these issues were addressed in Chapter 1 and are also touched on in subsequent chapters. So, let's get set up to scan your film capture!

The pre-scan (Figure 2.1) is where you get your first look at your digital image. After loading your film in the scanner, click on your <Preview> or <Prescan> button (these commands may vary depending on which scanner and scanning software that you use). The image may come up in the wrong orientation or too light or too dark, again depending on how your preferences are set on your particular scanner, but not to worry.

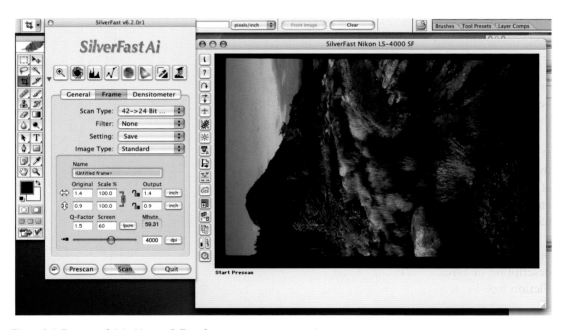

Figure 2.1 Pre-scan. Original image © Tony Sweet.

Although it is common practice to perform a great majority of corrections in Photoshop, there are a couple of things that may be set while using the scanning software. First, reset the output dimensions, if needed. In this case, reset the horizontal size to 0.9 inches, the vertical size to 1.4 inches (which are both the size of the 35mm slide being scanned), and set the dpi to the maximum allowable by your scanner (e.g., on the Nikon Super Coolscan 4000ED, set the dpi to 4000). Then adjust the black and white points (read your particular scanner software manual to determine how to make this adjustment) and do the rough crop in the preview window. The cropping will be precise when you get to Photoshop, where the image can be sized to 100% to clearly see where to crop, leaving no rough edges. Then reorient the image to the vertical format of this image. This may not need to be done for horizontal images, depending on how your particular software is configured. It is common for scanning software to scan at the orientation of the last scanned image. So, if the last scan was a horizontal image, the next vertical image will preview in the same horizontal format, needing reorientation, as in this image.

As you can see in Figure 2.2, the image has been oriented correctly and the black and white points have been set, creating a properly exposed image, lighter than the preview, and the output information has been set.

Make sure you scan the image in at the size of the slide at your scanner's maximum resolution. For example, using the Nikon Super Coolscan 4000ED, images are scanned in at the size of the 35mm slide at 4000 dpi, which gives you an approximate file size of 60 megabytes at 8 bit or 65 megabytes if you scan outside of the slide mount.

We are now ready to scan the image into Photoshop, but first a word about DIGITAL ICE. Here is a description of DIGITAL ICE from the Applied Science Fiction website, www.asf.com:

The award-winning DIGITAL ICE technology automatically removes surface defects, such as dust and scratches, from a scanned image. DIGITAL ICE Technology differentiates itself

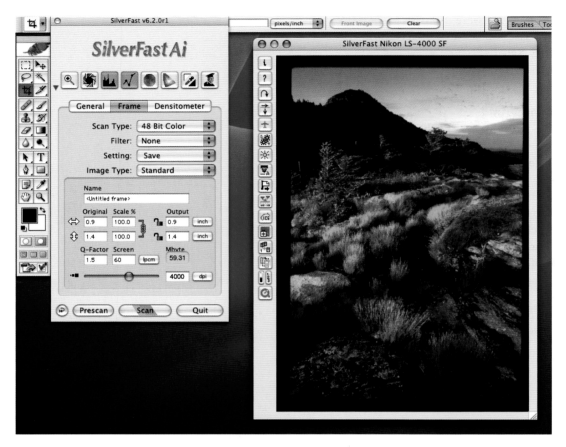

Figure 2.2 Correct orientation. Original image © Tony Sweet.

from software-only solutions because it does not soften, blur or otherwise alter any under-lying details or composition of the original image. Instead, the patented DIGITAL ICE Technology works from within the scanner, during the scanning process, to provide users with a clear, authentic base image that improves the original image.

After spending many many hours cloning out various marks from scans, this software is a miracle. If your scanner software does *not* use DIGITAL ICE technology, you could waste many hours cloning out digital artifacts, scratches, and dust marks. I highly recommend you update your software to its latest version, which may use DIGITAL ICE, or buy

scanning software that does use DIGITAL ICE. The time you save will be well worth the money spent for DIGITAL ICE. Silverfast scanning software incorporates DIGITAL ICE in all its various scanner software products.

Sharpening

For most applications, the <Auto Sharpen> command in Silverfast is excellent, especially when using fine art watercolor papers. There are many ways to manually sharpen an image and probably several formulas, one of which is disclosed later in the chapter. But when using watercolor paper for fine art printing, the paper absorbs so much of the ink that tack sharpness is not an overriding concern (e.g., the use of the Auto Sharpen command). Professional printers will use the <Unsharp mask> command in Photoshop and pretty much "eyeball" the sharpness, not relying on any formulas (see Chapter 11).

That said, we'll hit the scan button to bring the image up as a digital file in Photoshop. Figure 2.3 shows our

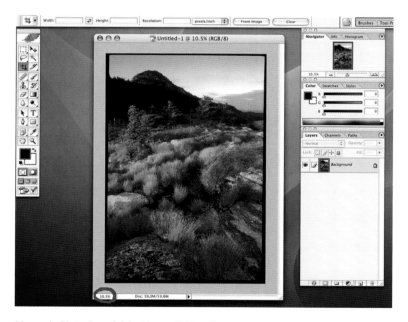

Figure 2.3 Scanned image in Photoshop. Original image © Tony Sweet.

image in Photoshop. Notice the black border around the image. We need to crop that out cleanly and precisely. For us to do that, we'll have to see the image at a much greater magnification, and we'll do that now by changing the percentage in the bottom left (circled) window to 100% (Figure 2.4).

Now we can clearly see where to begin the process. Placing your mouse on the scroll bar, scroll from the top left (shown here) to the top right and adjust the crop marks along the top border, then down to the bottom right adjusting the crop marks, to the bottom left adjusting the crop marks, then back to the top left adjusting crop marks. After accurately placing your crop marks to create a clean edge of the image, stay at 100% viewing to double check that the cropping is clean all the way around the image edges by using the scroll bars. Double click inside the crop

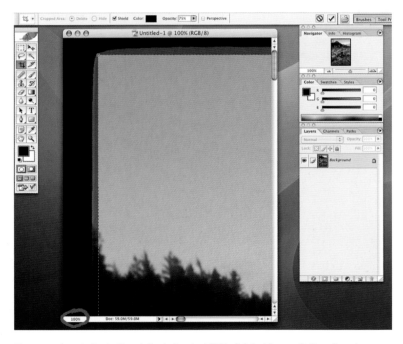

Figure 2.4 Change the percentage in the bottom left window to 100%. Original image © Tony Sweet.

marks or select Image > Crop to complete the cropping command. Then press Command > 0 (zero) or go to View > Fit on Screen to resize the full image to the screen.

If everything is calibrated correctly (Figure 2.5), either by using software or by luck, you should be ready to resize to the appropriate usage for e-mail or for print.

Now, what happens if your monitor and scanner are not calibrated? Have no fear; the following explanations

Figure 2.5 A correctly calibrated image. Original image © Tony Sweet.

and illustrations will show how to correct scans that come in too dark, too light, washed out, with too much contrast, or too soft.

Now we've scanned in an image that is dark (Figure 2.6), needs to be cropped, and is soft. As in Figure 2.3, we need to crop and we'll draw our crop border slightly outside of the image to get started (Figure 2.7).

Figure 2.6 Scanned image that is dark, uncropped and soft. Original image © Tony Sweet.

Figure 2.7 Draw a crop border. Original image © Tony Sweet.

Next, double click inside the crop rectangle or select Image > Crop to complete the crop (Figure 2.8).

Scroll from the top left, shown here, to the top right and adjust the crop marks, then down to the bottom right to adjust the crop marks, then to the bottom left. After placing your crop marks, stay at 100% viewing to double

Figure 2.8 Double click of use Image>Crop. Original image © Tony Sweet.

check that the cropping is clean all the way around the image edges by using the scroll bars. Double click inside the crop marks or select Image > Crop to complete the cropping command. Then press Command > 0 (zero) or go to View > Fit on Screen to resize the full image to the screen (Figure 2.9).

Now our image is properly cropped but still needs to be color corrected and sharpened.

Figure 2.9 Properly cropped image. Original image © Tony Sweet.

Next, we'll go to the Levels command (Figure 2.10), Image > Adjustments > Levels (Command > L). Notice the two red circles. This is your histogram, and you want to slide both carats at the extreme ends in to the inner and outer edges of the graphic to adjust the highlights and

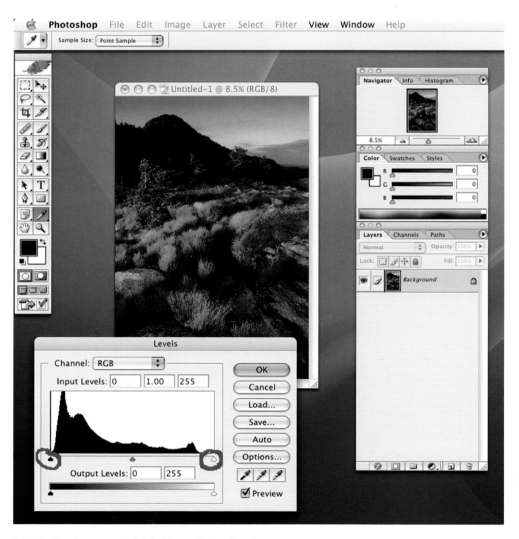

Figure 2.10 Use Levels command. Original image © Tony Sweet.

shadows. The one at the far left (shadows) is at the edge and is fine, in this case. If it were farther left of the left edge of the graphic, you would need to move it in to the edge. The carat at the far right (within the red circle) has to be moved in to the edge of the graphic to properly adjust the highlights. The carat at the center is for adjusting contrast, and the way this is used depends on the image and on the subjectivity of the artist. It is customary to adjust this a bit to lower contrast to 1.25. This is not set in stone and depends on your image, scan, and, most importantly, what you want to achieve. The results are illustrated in Figure 2.11.

As you can see, the image comes to life after moving in the right-most carat to the edge of the graphic and moving the center carat (contrast) to 1.25. These two moves adjust the image to the same exposure as the original transparency.

Unless you are auto-sharpening your image in your scanner software, the image will be soft or unsharp. This is where you will use the <Unsharp Mask> command in Photoshop to sharpen the image (Figure 2.12).

The first step in this particular sharpening procedure is to determine the pixel dimension on the long side. As seen in the circled "Height" box, that number is 5380 pixels. Write that down, because you'll need it later.

Figure 2.13 simply shows you the path to the <Unsharp Mask> command

Figure 2.14 shows the Unsharp Mask box where you enter the appropriate numbers for sharpening. This formula is as follows:

1. Set the Amount to 100%.
2. Set the Radius to 0.001% of the long side in pixels. In other words, refer to the number that you wrote down (5380), the long side of the image in pixels, and move the decimal point three places to the left ($5380 \times 0.001 = 5.380$ rounded to 5.4). Enter 5.4 in the Radius box.
3. Set the Threshold to 4.

Figure 2.15 shows the finished digital image, fully corrected and sharpened.

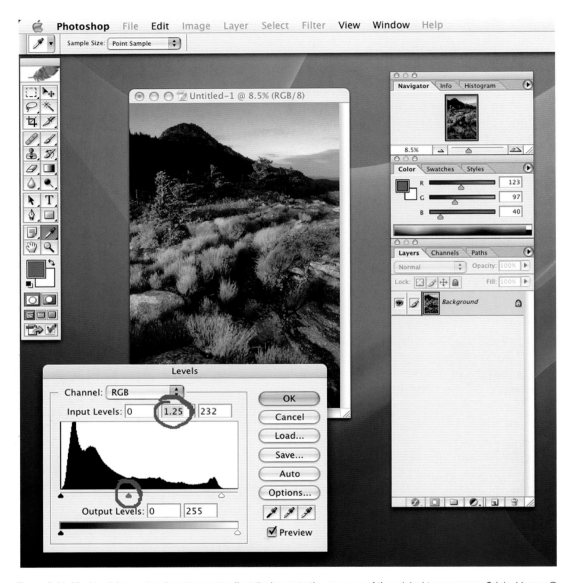

Figure 2.11 Moving right-most and center carats adjust the image to the exposure of the original transparency. Original image © Tony Sweet.

Figure 2.12 Use the Unsharp Mask command in Photoshop to sharpen the image. Original image © Tony Sweet.

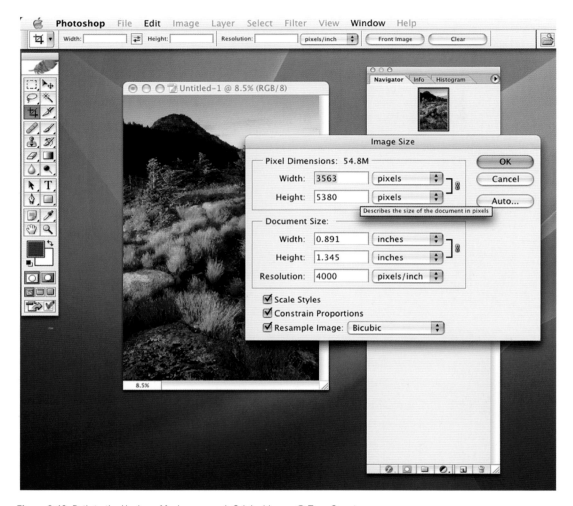

Figure 2.13 Path to the Unsharp Mask command. Original image © Tony Sweet.

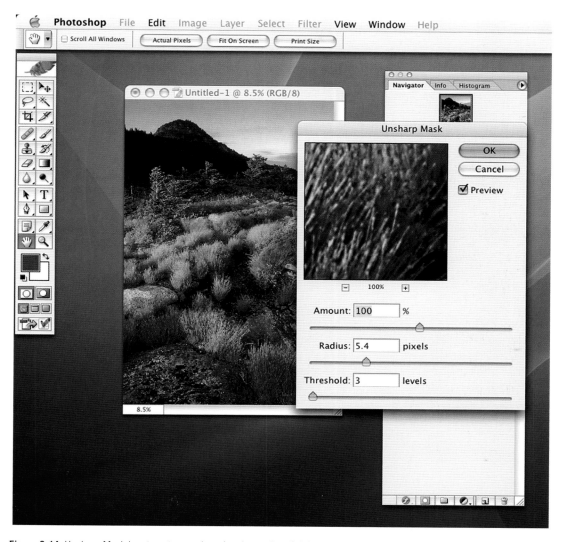

Figure 2.14 Unsharp Mask box to enter numbers for sharpening. Original image © Tony Sweet.

Figure 2.15 The finished digital image. Original image © Tony Sweet.

The following conclusions can be made:

- When scanning color transparencies, black and white film, or color film, the adjustments described herein are the same.
- As stated earlier, many photographers choose to make their color and sharpening adjustments in Photoshop. This works best when images are scanned in at 48 bit. When scanned in at 24 bit, color corrections and sharpening are best handled in Silverfast.
- Silverfast (http://silverfast.com) is the award-winning software developed by Lasersoft Imaging and supports over 200 flatbed, film, and drum scanners. It is a Photoshop plug-in that is as viable for novices to use as it is for professionals. It is an intuitive master tool for scanning and color reproduction.

Chapter 3

File Formats: Choosing JPEG or Raw Capture

Yvonne J. Butler

One of the most rigorous, often contentious, discussions in digital photography is whether you should use raw or JPEG file format. Some purists insist every photographer should "get it right the first time" and not use raw like a crutch for incorrect settings. Others say, "It's all about having control," and raw provides ultimate control over image optimization. Still others say shooting in raw mode is too slow, creates additional work on the back end, and/or their clients don't need it anyway; shooting in JPEG at the highest possible resolution is a practical choice for personal and business needs. Well, the final decision is yours. Let's take a look at both file formats and what each has to offer.

Not too long ago I read a story about how staff and assignment photographers handle event photography for *Sports Illustrated* and how photo editors select and process digital images submitted right after a major event such as a Super Bowl (football match) or Wimbledon (tennis match). The story has relevance to this discussion of when and why we choose to use JPEG or raw capture in our digital workflow. See the sidebar on the following page.

Apparently, after filling their "gig" cards or microdrives chock full of high-resolution JPEG images, probably often in burst mode, staff and assignment photographers immediately submit to photo editors standing at the ready in nearby trailers the very memory cards on which their work was stored in real time. The event photographers do not have a chance to review, delete, or process images. All images, whether good, bad, or indifferent, are immediately evaluated by the editors and chucked out or tossed into "keeper" folders. The chief photo editor literally sits in front of monitors clicking through images faster than the blink of an eye, until an image catches his or her fancy. The photo editor saves the latest "winner" in a folder (probably after checking a histogram and inspecting it up close with zoom) and considers it the best possible candidate for a cover or feature until something else in the stacks of memory cards bumps the leading contender. And the winner is

What struck me about the *Sports Illustrated* story and why I am sharing it with you is selecting raw over JPEG capture is not always the better choice for event photography. For instance, the sports photographers at *Sports Illustrated* take their best shots, rock-and-roll those JPEG files out to the trailer on memory cards or microdrives, and don't look back. How's that for streamlining their part of the workflow?

Yet, with a few modifications to the event photography workflow, raw capture is feasible. Allowing for file capacity on memory cards, photographers would shoot in raw + JPEG mode or even raw mode, download and view JPEG thumbnails for image selection and batch processing, and save selected images to the DNG archival raw file format (see the section Raw Digital Negative). In the *Sports Illustrated* scenario, photographers would shoot in raw + JPEG mode and submit memory cards to editors who would view JPEG thumbnails for image selection. Editors would send selected images for further processing in imaging software and digital asset management software.

Here's another scenario. One of my commercial clients recently asked me to do a fairly large product photography project for the company's on-line sales Website. The project entailed photographing over 500 laptop and related computer parts, such as microprocessors, hard drives, batteries, and connectors, all at Web-ready specifications of low resolution, small image dimension, and medium compression of 7-8 (for relatively quick loading on screen). I captured the images in-studio under controlled lighting conditions. I opted to shoot all of them in JPEG, based on the form of deliverable: small JPEG files uploaded to a website and never ever to be printed in large sizes. If I had thought the client would ever need the images for large output, I would have shot in raw + JPEG mode, archived optimized raw images for each product in DNG format, and submitted Web-ready JPEGs for the company's immediate needs. (In this instance the client insisted on receiving only Web-ready images).

Yet another scenario is as follows. In Chapter 8, I talk about a recent photo safari (and commercial shoot) in South Africa. On that assignment I shot a mix of high-resolution JPEG and raw. Because of the company's financial restraints, to make the Web images of a luxury resort, I worked in high-resolution JPEG; when I worked in the field from a Land Rover with the engine often running, using a DSLR and 800mm lens over monopod for burst mode quick action shots of a Big Five game I worked in JPEG. And when I had time to breathe, shoot swimming pools and local flora and fauna at my own pace, and not worry about running out of card space or read/write speed in the field, I chose raw for its full control, large file size, and quality. Knowing what I now know about raw, I would definitely shoot raw on safaris and commercial shoots anywhere in the world.

There are plenty of times when the features and benefits of raw capture make it the file format of choice. If we select an improper white balance at the time of capture or we have exposure or color saturation issues, for example, we can merely click on a drop-down menu tab in our raw processing software and make adjustments. If creating the largest possible file size is paramount, raw is an excellent choice. If low light conditions prevail, we can use raw to make small adjustment requirements later in the darkroom.

Whether you shoot in JPEG or raw, you should always meter accurately, calibrate correctly, and think through your settings for exposure, white balance, ISO, aperture, shutter speed, depth of field, and all the other topics we discuss throughout this text. Make the best possible shot you can make the *first time* (or first few times.) You can take your shot, check the histogram, make an adjustment, and take another and another until you get it right. If you shoot in raw, you might consider raw capture a safety net, but while you are shooting try to work as if its post-capture options are not even there. All this is not to suggest you should go one way or the other or that you should exclusively use one file format over another. Perhaps there is a time and place for either file format, and you should be the final judge of what works for you and when.

Let's take a deeper look into what the two (really three) file formats are all about and the advantages and disadvantages of using each of them. First, let's refresh our minds about how digital cameras work.

How Digital Cameras "See" and "Think"

Digital cameras are not able to see color. Quite simply, their image sensors capture gray values and are filtered by color filters. Raw files are grayscale (see Chapter 1). Each pixel works like a light meter and records how much light reaches it during the actual exposure. When using JPEG (or even TIFF but not raw) mode to capture an image, your camera translates that information into image data in your camera and takes the image through heavy-duty processing (color, sharpening, exposure, noise reduction, and more). The camera has a processor inside to handle these tasks. Some of the challenges of this in-camera processing are the resulting presence of artifacts, such as moiré patterns and color aliasing (discoloration, for example).

With raw capture, the digital camera stores only the raw data and EXIF (metadata: camera type, lens and focal length used, aperture, shutter, and more) data. When you shoot in raw, this in-camera processing is nonexistent. Any camera presets and parameter settings you make, such as contrast, saturation, sharpness, and color tone (found in the Parameters menu on the Canon EOS 10D, for example), do not affect the data recorded for the image. They become defaulted "marked" values or metadata tags during raw conversion, until you elect to change all or some of them. Even the white balance setting you choose is saved as a tag. Only ISO speed, shutter speed, and aperture setting affect (are processed for) the captured pixels. You get pure unadulterated raw information that, if you choose, may be adjusted in the digital darkroom.

What Are JPEG and Raw?

JPEG Digital "Slides"

Shooting with the standard JPEG file format (see ERI-JPEGs from Kodak, below) is like working with slides.

What you generate is what you get, more or less. JPEG is a "lossy" file format that offers speed and convenience. When working in JPEG format, properly setting in-camera exposure and white balance is critical. JPEG is considered an established universal standard that may be opened by most image processing software, and it's a standard option in most digital cameras in today's marketplace.

JPEG is great for taking images that will not require much post-processing. Obviously, if you read the scenarios above, it's also a good choice when post-processing is not practical or feasible. JPEG files conserve memory card space in contrast to raw files, and they are easily saved in web-ready condition without having to extract a JPEG version in raw file conversion converter software.

One problem with JPEG is its high compression attribute that causes a loss of information and the presence of artifacts after compression. Opening and closing JPEG files over and over will result in a tremendous loss of information and maybe even in posterization if you make major adjustments to them along the way. Another disadvantage is standard JPEGs are 8-bit grayscale files with a bit depth of only 256 tones of information per pixel (see Chapters 1, 10, and 16). Eight bits is perfect for screen and Web views, but the advantages of 12 bits in raw files becomes apparent when enlarging and printing files. When acceptable exposure and white balancing are a quick and easy solution for a fast paced in and out workflow or where there is little concern for maintaining data for future access, JPEG makes sense for now. I predict raw capture, processing, and archiving will become a natural prevailing part of just about everyone's workflow in the near future. See Figure 3.1 for more details on the advantages and disadvantages of JPEG and raw.

ERI-JPEGs from Kodak

Just when you believe you know everything there is to know about JPEG, along comes an innovative version of standard JPEG. ERI-JPEG is the acronym for Kodak's proprietary image format called the Extended Range

Imaging Technology. The ERI-JPEG files are compatible with Kodak's ProShots studio software, and the format is available in the Kodak Pro DCS-14n pro-level Digital SLR and other Kodak Professional DCS cameras. According to Kodak sources, this proprietary image file format offers "the convenience of JPEG and the power and flexibility of raw files." An ERI-JPEG file is similar to a standard JPEG file except this type of JPEG:

1. Provides two stops of exposure latitude and extended color space;
2. Delivers high dynamic range 36-bit image quality;
3. Saves a minimum of four times more images in-camera than raw;
4. Simplifies workflow while maintaining control (Source: www.kodak.com).

In my ongoing readings, I have found several claims that ERI-JPEG also provides more highlight information than standard JPEG. Gosh, that's good news. File Save options in the Kodak professional cameras are raw, ERI-JPEG, or JPEG and in combinations of the three at various resolutions.

This apparent solution to the disadvantages of using standard JPEG seems to be a viable alternative on the face of it. I am particularly interested in ERI-JPEG's raw-like features of editing, color balance, and color compensation and the economically low in-camera storage requirements. Time will tell if artifacts and loss of information through compression are not issues. An ERI-JPEG workflow just might be the nice compromise solution, if you will, for photographers who need to work in JPEG for output, convenience, and/or client requirements.

Raw Digital "Negative"
Simply stated, a raw file is raw data generated by a camera. Digital images produced in raw format preserve all of the color and tonal range originally captured by the image sensor in the camera without processing it and saves its metadata (data about data). The camera records up to 12 bits of information per pixel. The 12 bits per color

provide 4096 shades or tonal values per pixel. After post-capture adjustments, raw files may be converted into standard JPEG and TIFF formats, at 8- and/or 16-bit levels, for Web, printing, and archival storage.

Adobe Systems Incorporated introduced a new standard file format for raw capture. It is called the Digital Negative specification or DNG. The saved file will have a .dng extension. Unlike JPEG and TIFF, no universal standard existed for raw files for some time, making it nearly impossible for every raw conversion and/or processing software application to read every camera's raw format. In the long run, these incompatibilities would have caused serious problems with archived files. Now camera manufacturers are considering and/or adopting DNG, with the option of building DNG file format into their cameras and even adding their own proprietary metadata as well. Camera-specific raw formats are converted into a Digital Negative or .dng file. Owners of existing cameras without DNG may use the Adobe Digital Negative Converter or other converter software to convert their raw files into DNG files (Digital Negatives).

More about DNG

The Digital Negative comprises actual image data and the metadata that decribes the image file. The major feature of DNG is its handling of metadata, the information that stays with a file about camera and lens used to capture the file, camera settings, and more. DNG is designed to work with a wide range of camera designs and features and will evolve with introductions of new cameras and technology within them. The Digital Negative specification helps ensure your images are accessible and readable in the future.

The DNG Specification is now integrated into printer and software products for .dng standardization throughout the digital imaging workflow.

Shooting raw offers a completely different level to image data access. In a sense, shooting raw is somewhat like shooting negative film where there is more forgiveness in

STANDARD JPEG	RAW
May be opened with most image-processing software. Batch process those JPEGs and save them to CD/DVD/external storage devices and then convert "keepers" to TIFF for image processing.	Requires special Raw converter and processing software, often provided with and proprietary to your camera's manufacturer, saving as TIFF and then working in Photoshop. You can also open raw files in programs such as Adobe Photoshop CS (or 7.0 with a plug-in). Batch features in most raw software; use Actions in Photoshop (See Chapter 12).
Lossy: Loses information on compression	Inherently Lossless compression.
8-bit grayscale with a Bit Depth of 256 tones (see Chapters 1, 10 and 16).	16-bit grayscale with a Bit Depth of 65, 536 tones, up to 48-bit image. (See Chapters One, Ten and Sixteen).
Image degradation occurs with manipulation.	Files may be manipulated without image degradation.
Limited Dynamic Range	Increased dynamic range, available in post processing.
Web-ready (JPEGs are perfect for web sites, email attachments and other online uses) Be sure to convert and save to TIFF format right away before processing and getting ready for printing output. Re-opened TIFFs generally are not lossy.	Raw+ JPEGs may be selected in-camera or you may shoot only raw and then save a TIFF and even extract a JPEG.
Write speed is typically faster than raw capture.	Write speed is slower than JPEG capture.

Figure 3.1 JPEG versus raw. © Yvonne J. Butler All Rights Reserved.

STANDARD JPEG	RAW
If selected, is ideal for:	If selected is ideal for:
• Small Prints (lose some info on substantial enlargement, even using special programs, like Genuine Fractals.)	• Large Prints
• Web and online uses.	• Dual Purpose: high quality image and availability of thumbnails and JPEGS are in workflow.
• No Major Post-processing required or desired.	• Full control and flexibility of images in post processing: exposure setting, white balance, and others.
• High volume image capture with fast write speed.	• Memory card storage, write speed and quantity of images are not issues.
• Capture and Post-Processing Workflow components and card space are considerations.	• Batch conversions of same alterations to multiple images, i.e. changing color temperature to all files on a card with one command.

Figure 3.1 Cont'd

exposure. For many of us, shooting raw is better than shooting film. We particularly value having post-capture access to exposure compensation and white balance through raw file conversion software (Figure 3.2) and the advantages of working with large, uncompressed files. During file processing in any file format you lose a little bit

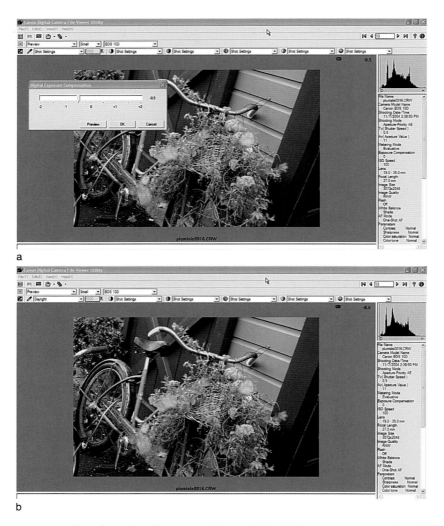

a

b

Figure 3.2 Processing a raw file in Canon Raw. Tab settings at top are (left to right): exposure compensation, click white balance, select white balance, Kelvin, contrast, color saturation, color tone, sharpness, and color space. Original image © Yvonne J. Butler. a. Exposure compensation is adjusted. b. Original image was captured with White Balance marker set to Shade. White balance is tested and displays in real time, this one at Daylight (sunny).

Figure 3.2 Cont'd c. White balance changed to Cloudy. d. Back to desired setting of Shade with Contrast set at Mid-High.

Figure 3.2 Cont'd e. Contrast tested at High. Note changes to histogram throughout. More work should be done.

of data due to data clipping, and the advantage of working with high-bit data is clear. The more bits you have from the start, the more data you will end up with when you produce the final image.

Advanced Features of Raw

Advanced features found in the various raw conversion programs are useful as well. For instance, in the Canon Raw utility you can adjust the amount of lens vignetting and chromatics aberrations (Figure 3.3).

Exposure compensation can be adjusted in camera-like increments in Adobe Photoshop CS Camera Raw and many other raw file processing software. Tonal values also may be adjusted. Color temperature (in Kelvin) is another tab among several for advanced photographers.

Increased Dynamic Range from Raw Files

The dynamic range of your camera is the ratio of the highest non-white value and the lowest non-black value that your digital camera can capture. In other words, it is the range from white point to black point before losing the tonal detail in the shadows, midtones, and highlights.

One major issue among digital enthusiasts is the potential blowing out of highlights in high contrast

Figure 3.3 Save settings to Sidecar "xmp" file. Original image © Yvonne J. Butler.

situations. Film shooters know you can shoot two frames, exposing one for the highlights and one for the shadows, combine them after scanning, and hope for the best. Get to know your camera's exposure characteristics and experiment with getting your highlights to fall as close to the right edge of the histogram (viewed on your computer screen not camera LCD monitor) as possible without blowing them out.

With raw capture, you can accomplish the same principle, only with less hassle and more precision. The Adobe Camera Raw Converter/Processor and Photoshop have shadow and highlight recovery features that allow you to recover shadow and highlight detail. Many other raw converters also have this functionality.

The Phase One website (www.phaseone.com) has a handy solution that involves outputting two versions of the same raw file with exposure compensation applied to the second

file to create a darker image that is in turn dragged over the original (created by exposing for the highlights). See the discussion later in this chapter on Sigma's Fill Light feature.

Adobe Photoshop CS and Camera Raw Converter

Adobe Photoshop CS now offers raw conversion and processing without an extra-cost plug-in. Photoshop Camera Raw now includes new color calibration controls, batch processing when used with the expanded File Browser function, and support for most major digital cameras. Camera Raw and other raw converters allow you to work with 16-bit images.

File Browser

In Adobe Photoshop CS, the Camera Raw (CR) interface allows you to access raw files using the advanced features of the new File Browser (FB). You can create a correction in CR for a file and apply that to multiple images in the FB. Take yet another image and apply a correction and then apply that to a different set of images in the FB. Batch process all the images and the corrections will be applied.

You also now have an option of storing settings for each file as a "sidecar" settings file (like Canon Raw in Figure 3.3) that sits next to its image. This convenience feature makes it easy to archive conversion settings and metadata (which is now editable through the File Browser) when burning CD/DVDs of images. The sidecar file will show you corrections made on a given raw file in Camera Raw while you are viewing the thumbnail in the File Browser. Be sure to identify your camera model and settings in advance (Figure 3.4).

The new File Browser also allows you to access and create Contact Sheets, Picture Packages, Web Photo Gallery, PDF Presentations, Photomerge, and Online Services from the File Browser's Automate menu, even with raw files while using sidecar corrections.

Figure 3.4 Canon RAW browser also requires camera identification. Original images © Yvonne J. Butler.

Capture One DSLR Raw Converter

Phase One, the digital back experts when it comes to raw conversion (and workflow) programs, have a solution for DSLRs as well. Using the Capture One DSLR Raw Converter means you automatically have a raw color-managed workflow and a raw converter in one. When using the software, be sure to identify early on the profile for the camera you are using.

A Raw Processing Sequence with Sigma SD10 files

Here is a raw processing scenario I used when testing a Sigma SD10 camera and its Sigma Photo Pro software. The SD10 generates only raw files.

You can select Auto Mode and let the software do the work for you. I prefer to work in Custom mode, working on perhaps the first image in a series of similar images under similar conditions, and then applying the same settings to subsequent images. Then, after selecting those

Figure 3.5 The Sigma Photo Pro menu (pallete) window has an Adjustment Mode panel for working on tonal adjustments, color adjustments, and histogram.

I wish to keep for my work, I check and tweak each keeper if necessary before saving to a working folder.

Sigma Photo Pro has an adjustment Controls palette and accompanying menu tabs that make it convenient to work with raw files. You have a choice of applying the changes to the original Sigma X3F file and archiving these enhanced files or making changes and saving the files to JPEG, TIFF, and hopefully DNG. (If Sigma and other camera manufacturers do not incorporate DNG in their raw software, you will still be able to convert the files to DNG in Adobe Photoshop, Extensis, and other software and then send them to archives.) One word of caution: when using Sigma Photo Pro be careful not to overlook the possibility of automatically saving a changed white balance to the original X3F file. You can uncheck the automatic white balance save.

The Adjustment Mode Panel (Figure 3.5) contains areas for working on tonal adjustments, color adjustments, and a histogram. Within the tonal adjustments panel you can use sliders to control exposure compensation, contrast, shadow, highlight, and saturation. Sharpness and X3 Fill Light adjustments are optional and should be handled carefully.

Making Tonal Adjustments
The order in which you complete these steps is your choice.
Adjustment 1: Check Exposure
After eyeballing the images and reading EXIF data to
refresh my memory about the settings I used, I like to
start with exposure. The Exposure slider (Figure 3.6) in
Sigma Photo Pro gives you latitude of two stops (+/–2.0)
in each direction. That is, you can under- or overexpose
an original image by up to two stops to affect its overall
brightness. Be sure to know the exact increments the
exposure slider in your program represents; in the Sigma
software each 1/10 increment of the slider is 1/10 of an
f/stop. Obviously, if your original image is way over- or
underexposed, moving the slider two stops will not
salvage the shot. Properly exposing the image

Figure 3.6 Exposure sliders have a range of +/−2 f/stops. Before and after contrast adjustment of 0 .8(8/10 of f/stop). Original image © Yvonne J. Butler.

and bracketing exposures during image capture will help you the next time around.

Adjustment 2: Check White Balance (Figure 3.7)

Normally I check white balance options right after examining exposure and Kelvin temperature (see Chapter 10 for an in-depth discussion of Kelvin) and tint "tabs" on any raw converter software.

Changing white balance of an X3F file is best done by saving each change to a new filename and then applying custom settings. In this software, the change to white balance only visually appears after the file has been completely processed. Nonetheless, the other features for tonal and color adjustments in Photo Pro are powerful enough to overcome this unusual approach to changing white balance. Try various white balance settings and Save As a new TIFF file.

Figure 3.7 Go to Edit>White Balance. In Photo Pro, when white balance is applied the white balance tag is changed to a new setting in the X3F file until you change it again. Original image © Yvonne J. Butler.

Figure 3.8 Once you find a setting that works for contrast, you may save it and reuse it for subsequent files. Original image © Yvonne J. Butler.

Adjustment 3: Check Contrast (Figure 3.8)

The range of the contrast slider is −2.0 to 2.0. Decreasing the contrast "lightens" the blacks and "darkens" the whites; increasing the contrast brightens whites and darkens blacks, all with one slider.

Adjustment 4: Check Shadows and Highlights (Figure 3.9)

The shadow slider affects the blackness of shadows and the highlight slider affects the brightness of the highlights. Both have a range of +/−2.0.

Adjustment 5: Check Saturation (Figure 3.10)

When we adjust saturation we affect the intensity of color in an image. The minimum saturation of −2.0 is pure grayscale. The range of the saturation slider is +/−2.0.

Adjustment 6: Use the Sigma X3 Fill Light (Figure 3.11)

Sigma's fill light slider is a unique feature in Photo Pro. Perhaps similar results may be obtained in other raw software but this convenient feature allows you to directly add extra light into the shadow regions of an

Figure 3.9 Before and after highlights were adjusted. Note the red warning mask over the dahlia showing highlights beyond the acceptable range. Blue (shadow) warning mask is not present. If you need help making this and many other adjustments, you may move the slider until you reach a value where the warning mask disappears. Original image © Yvonne J. Butler.

Figure 3.10 Before and after moving the saturation slider. With the slider set to 1.0, saturation needed to be decreased to 0.4, the value at which the red warning mask disappeared. Original image © Yvonne J. Butler.

Figure 3.11 The Photo Pro Fill Light adjustment feature allows you to directly add extra light into the shadow regions of an image without overexposing highlight regions. Here are two images with fill light added, one with a fill light of 0.3 and another at 0.8. Look at the histogram and the other adjustment settings. Look for any evidence of warning masks. Original images © Yvonne J. Butler.

image without overexposing highlight regions. The range
is also +/–2.0.

Adjustment 7: Check Sharpness

For image sharpening I prefer to go into Photoshop and
work with unsharp mask, channels, or plug-ins from
Nik Multimedia (see Chapter 11). When working with
raw files, separating winners from losers, so to speak,
you can temporarily sharpen the thumbnail to help you
determine the image's fate. If you prefer to complete all
except perhaps cropping, cleanup, and output work
within the raw conversion and processing phase of your
workflow, sharpening the image during the raw phase
may be disadvantageous for you.

Make Color Adjustments

The color adjust wheel in Sigma Photo Pro is similar to
color adjustment wheels found in most other software. It
may be used to change the overall color of your image and
is particularly useful when a color cast exists in the
original. You can click and drag a target ring anywhere on
the colored portion of the circle and begin to experiment
with the effects of various moves. It is helpful, indeed, to

Figure 3.12 A color wheel commonly found in raw software. Clicking and dragging the target ring anywhere on the colored portion
of the wheel will result in a color adjustment. The color adjustment eyedropper may be used to create neutral gray tones in the image.
Original image © Yvonne J. Butler.

understand color theory (such as that increasing red, green, or blue decreases its complementary color of cyan, magenta, and yellow, respectively) and other discussions on color found in this and other photography books; to be willing to spend a little time getting to know what works for you and when; and to know how to calibrate your monitor to help ensure what you see is what you will get (see Chapter 1).

The color adjustment eyedropper may be used to create neutral gray tones in the image; click on the eyedropper and then place it over the area to be neutralized and click. Photo Pro evaluates the sample and makes adjustments to create a neutral tone throughout the image.

Using the Histogram

The histogram and optional show-warning masks are useful for seeing the distribution of brightness in an image. With the tonal adjustments, color adjustment, and histogram displayed you can see the results of making changes on the histogram. Three readouts are shown as lines of red, blue, and green for each RGB channel. Shadows are on the left, mid-tones reside in the middle, and highlights are located on the right.

Figure 3.13 The histogram has a show-warning-mask box that may be turned on and off to show when a shadow(shown as blue line) or highlight (shown as red line) value on one or more channels falls outside of the values you specified in the shadow and highlight boxes at the bottom.

The histogram has a show-warning-mask box that may be turned on and off to show when a shadow or highlight value on one or more channels falls outside of the values you specified in the shadow and highlight boxes at the bottom. This feature is particularly useful when you want to limit the range and know when you have exceeded it. The warnings are displayed as colored lines on the histogram, for red, blue, and green channels. For example, set the shadow limit to a value of 8 and the highlight limit to a value of 240 and then make the adjustments discussed above until the warnings are reduced or eliminated. After experimenting with raw adjustments and how the final images look after printing, the feature should also help you select the tonal range that works best for your printer(s).

Save Files

Save and apply the adjustments. Make a conscious decision whether to save to source (original) or a new file. In Photo Pro click or unclick the save to original box.

After saving the file as an 8-bit or 16-bit TIFF (Figure 3.14) in a working folder, you can do more work in Photoshop or your image editing software of choice (see discussions throughout this text on the advantages of 8-bit versus 16-bit files and when each is appropriate). If your camera software does not currently allow you to save .dng files, open the saved TIFF files in Photoshop and then save them to .dng on a CD or an external storage device. Cropping, sizing, and other steps may be completed before printing or sharing on the Web. If you have Actions saved in Photoshop you will be able to move quickly through the raw conversion, processing, and outputting workflow.

Figure 3.14 Save and apply custom settings. Make a conscious decision whether to save to the source (original) or a new file. Also consider whether to save as 8-bit and/or 16-bit files. Original image © Yvonne J. Butler.

Working with raw files really seems to help us learn more and more about capture, processing, and output. Working with raw files should help you improve your images and ultimately give you more time in the field to devote to getting world class images.

The decision about whether to shoot raw or JPEG really rests on the type of work you do, personal preferences, and image-capture requirements. There is no cardinal rule that says you cannot switch back-and-forth between raw and JPEG workflows. If you are a serious hobbyist you might prefer to shoot raw for most if not all of your special work and JPEG for casual work.

If you are a professional or semi-professional and not shooting raw, and are obviously always interested in only the best, you should seriously consider modifying your current workflow for raw capture and processing. Most raw image processing software programs and plug-ins allow you to preview, set up keywords and descriptions, organize, and sort through hundreds or even thousands of images before raw conversion and processing begins. Many software products are incorporating the new DNG standards and specifications to help ensure your images will be "readable" by updated or new software well into the future. Raw capture is not just an option for professionals and serious photographers. It is a workable, viable solution for all of us.

Note:
References include product announcement and updates, press releases, web information and other souce materials from original manufacturers, including press releases, manuals, and/or hardware and software documentation from: Adobe® Corporation, Canon® USA, Kodak® Corporation, Phase One® Corporation, and Sigma® Corporation.

Chapter 4

Digital Photography Workflows

Yvonne J. Butler

T he word "flow" has always fascinated me, and apparently others as well. Major dictionaries define flow as an act of flowing, having a smooth continuity or a smooth uninterrupted movement, or the quantity that flows in a certain time. All these definitions relate to the need to have an established set of steps that you routinely follow. Establishing good habits lowers the possibility of errors and omissions, recorrections, and lost data. Having a workflow is just plain common sense.

Photographers need some sort of formal or informal routine for repetitive tasks we can call up without much thought, a routine that will give us predictable consistent results time after time. After all, what we all love to do more than sitting in front of a monitor all day and night—except for the fine artists and painters who have their say later in the book (and even they have a workflow)—is to get out and photograph whatever we can whenever we can. We don't want to reinvent the wheel, making unnecessary mistakes, getting bogged down in a processing sequence, losing location of files and folders, and otherwise wasting time and money. Once we capture, process, and safely store

our original images, we can spend as much time as we choose on creative processing and output. Tasks such as renaming a group of images, batch processing specific changes that apply to all or a subset of images, and storing them in a preferred way such as by date or photo shoot or keyword or event should not be something we manually perform in this digital age.

You have probably noticed that the sections and chapters of this book follow the order of an overall workflow. Part 1 pertains to pre-capture (and scan capture); Parts 2 through 4 pertain to capture, digital darkroom processing, and special processing; and Part 5 pertains to output. The underlying premise of this order is that it is a logical sequence for working from image capture through final print. First, let's take a look at a basic workflow for those of you who like to keep things simple. Then consider introducing color management and raw capture into the workflow, and finally take a look at the Phase One Capture One Workflow software.

Basic Workflow Components

Every digital photography workflow should have an infrastructure consisting of these components: pre-shoot, shoot, file transfer, process, browse and edit, initial backup, storage and archiving, and final output (Figure 4.1).

Pre-Shoot/Pre-Capture

1. Calibration: it is important to calibrate your devices from camera (and scanner) through printer. Many professionals calibrate their monitors at least once a week and check their printers frequently. Build calibration into your pre-capture routine.
2. Color management: select a colorspace and stick with it all the way through your workflow. Colorspace options are sRGB and Adobe RGB 1998.
3. Equipment check: camera, including cleaning image sensor, setting to Adobe 1998, sRGB, and/or custom

Basic Digital Photography
Workflow Components
1. Pre-shoot (Pre-Capture)
2. Shoot (Capture)
3. File transfer
4. Process
5. Browse and edit
6. Initial backup
7. File Optimization,
 Storage and Archiving
8. Final output

Figure 4.1

matrix settings; flash, batteries, lenses, filters, memory cards, portable storage devices, flashlight, and other practical accessories.

4. System: keep track of and identify used and unused memory cards and how you will store them while you are on the shoot. Be sure to estimate the number of cards you will need. Many of us keep used cards on the left side of the professional vest and unused cards on the right side or return the cards face down in the card case when full.

5. Plan: think through the type of shooting you will do, time of day, sunrise and sunset hours, tides if appropriate and be prepared with filters, Speedlite, and other equipment.

Shoot/Capture

1. Select raw or JPEG (within the context of raw capture, select raw or raw+JPEG) and the image quality you prefer

2. Select and set presets, with metering type (evaluative, partial, and center-weighted average), drive mode (one-shot, off-center, and servo autofocus for moving objects, etc.), exposure compensation and bracketing, color temperature, white balance and white balance bracketing, ISO, aperture or shutter priority or programmed mode, or special modes such as automatic depth of field.

3. Set presets, with image processing parameters for low, standard, and high contrast; weak, standard, or strong sharpness; low, standard, or high saturation; and reddish (−1/−2), standard (0) color, and yellowish (+1, +2) skin tone. The image you capture can be processed automatically at these parameters. In many DSLRs you can save three or more sets of parameters with various combinations of contrast, sharpness, saturation, and tone.

4. Check and set lens to automatic or manual. For Image Stabilizer lenses, be sure to check the programmed modes, usually two.

5. Use the histogram on the back of the camera to work on proper exposures while shooting.
6. Preview the shots and zoom-in on detail.
7. Save to memory card (or CD) in camera.

File Transfer
Transfer your images to your computer's hard drive by using

1. Camera to computer using IEEE 1394 cable or your camera's USB cable.
2. Card reader or PCMCIA card adapter to computer.

Process
1. Open up your images in image editing software such as Adobe Photoshop, proprietary software from the camera manufacturer, or, in case of raw, third party (Extensis Portfolio, Phase One Capture One) or manufacturer raw conversion software.
2. Batch rename the folder, using a meaningful name (keyword) or by date or your preference.

Browse and Edit
1. Use the Adobe Photoshop or your software's browser to look at images.
2. Batch process changes that might be needed to a group of images, using Actions.
3. Delete any you could not possibly keep, particularly extra images created during bracketing.

Initial Backup
1. At this stage you have the option of copying some files to a "keeper folder" for later conversion to TIFF for further processing.
2. Burn the original images to CD/DVD including raw originals.
3. Make another backup of your originals on an external Firewire hard drive or storage device. On long trips for travel or commercial photography work, I use a SmartDisk Flashtrax with 4 gigabytes of capacity.

File Optimization

1. There are at least two approaches to file pre-
optimization. One approach is to optimize images at
the same resolution from the camera and resize them
later for output when they are used. Another is to
resize several resolutions and image sizes for expected
output. After raw file conversion, you may elect to save
several versions of the original image at various settings
(image size, resolution, for Web, for print).

2. Work within your image processing software to check
histogram and work on color balance, hue and
saturation, cropping, cleanup (in case your image sensor
was not clean at capture), and other file work.

3. A simple workflow should include at least a check of
Levels, Curves, and Color (Hue and Saturation and/or
Color Balance). Follow suggestions throughout this
book for ways to optimize your image.

4. One of the biggest annoyances in the digital age is file
loading time. Sending an e-mail message with large,
uncompressed, or even zipped image file attachments in
anything other than JPEG or other compressed format
is irresponsible. Loading large files with high
resolutions on your website or on-line auction page is
not "business smart." For Web and e-mail, a resolution
of 72 ppi and a JPEG of at least medium compression
will send or load your images quickly for the viewer.

5. Use optimized JPEG versions of your images for the
Web and e-mail.

6. Use optimized TIFF versions for printing output.

Storage and Archiving

1. Use file management software to manage your files.
Sometimes the file browser in your camera's proprietary
software (such as Canon's FileViewer and
ZoomBrowser EX) may be all that you need most of
the time, particularly when used in conjunction with
Adobe Photoshop CS's file browser.

2. Several storage and archiving programs are available on the market to help you keep track of and manage your images. The iView Media Pro software is one of them. Extensis Portfolio is another. See a brief discussion of these two packages later in this chapter.

Final Output

This part of your workflow is just as important as the previous steps. Getting all the way to the final output stage and not following through with the same color space will lead you down a difficult path.

1. Have a routine for working with your ICC Profiles (see chapters on printing).
2. Be sure to have the latest versions of profiles for paper types (i.e., canvas, glossy, watercolor).
3. Many prefer to sharpen their images right after resizing in Photoshop and before printing and then not save the changes. The file is still saved at its original resolution and image size.
4. Make certain your printer is calibrated and print heads are clean.
5. Keep paper in a properly conditioned environment.
6. Protect your outputted prints.

Formal Color Managed Digital Workflow
Pre-Capture

Follow the suggestions listed in the basic workflow. Also, incorporate formal color management into your workflow. Any workflow should include at least a check of Levels, Curves, and Color (Hue and Saturation and/or Color Balance). Color management ensures accurate and consistent color throughout the digital imaging process. According to the International Color Consortium, color management is "the mapping of differing color space values from one device's gamut to another through the use of a Color Matching Method and individual Colorspace Profiles as based upon the desired rendering intent."

Capture

1. Determine the proper resolution based on the final image dimension and linear resolution you will need. If you do not want to sacrifice any image quality, even by down-sampling copies for multiple purpose use, then shoot images at several resolutions.

2. When appropriate, use a tripod, self-timer, mirror lockup, and/or cable release to minimize damage to image quality and detail through shaking and blurring of the image, particularly at high ISOs and shutter speeds. Consider using lenses, and even the latest digital cameras, with image stabilization features.

3. Take test exposure images and review your in-camera histogram until you have the best histogram possible. If you capture your image in raw format, save it in Adobe RGB 1998 TIFF.

4. Use raw format to save your images from your camera in cases where you know you will have substantial image editing to perform.

File Transfer

1. Copy your JPEG digital images directly onto your hard drive and process them. For raw files, you have a choice of working just with your camera or other raw file converter and processor. If you like to archive images as taken, you can batch convert images to a .dng format and save them in your archives: CD/DVD, external hard drives, or whatever you use for "originals." You can save converted or unconverted raw files to a folder and open files through Photoshop. You can install asset management software such as Extensis Portfolio or iView Media Pro and work within Photoshop with the functions of these software applications. There is a slightly different way to work with these files when you use a program such as Phase One Capture One (see page 85).

Process/Browse and Edit

1. Access your raw images through Photoshop's File Browser or your camera's software. When you go through camera software, often you may make many of the same changes to images you can make in Photoshop. The choice is up to you.
2. Rename your photos using Photoshop's Browser Batch Rename function.
3. Resample images (without interpolation) through the use of Photoshop Actions.
4. Work on black and white conversions and enhancements.
5. Work on fine art studio work.

Initial Backup

1. If you intend to create multiple versions of an image for multiple uses, create copies and downsize and sample with minimum interpolation only as needed.

File Optimization

1. Apply basic color correction to your images.
 a. Work in Photoshop or other image processing software.
 b. Use a color correction method suggested in Chapter 1 or 10.

Storage and Archiving

1. Save full (180 or the resolution at which your camera processes and stores images) unsharpened Adobe 1998 RGB images as archival images to which you can return at any time to make copies for multipurposing. (Increase the resolution at the time of printing within the image processing program, not the print menus.)
2. For raw files, saved optimized DNG files to archives.
3. Make a copy of your archival image(s).

Final Output

1. Convert your images to whatever output color space the final output of your image demands, such as CMYK for pre-press use or sRGB for Web use.

2. Save a copy of converted images in archives, in another
 folder noting enhanced images.

Phase One Capture One RAW Workflow: A Simple Yet Effective Approach

This software (Figure 4.2) works with digital camera backs
(for medium format cameras) and digital SLRs. Capture
One is compatible with DNG raw files. Naming, storing,
and developing image folders are interconnected. Images
may be edited and selected, previewed, and analyzed by
consulting the histogram, making exposure evaluation
simple and convenient. In exposure and contrast
compensation features, you can select a Preserve Balance
option that ensures all three color channels (RGB) are
adjusted simultaneously.

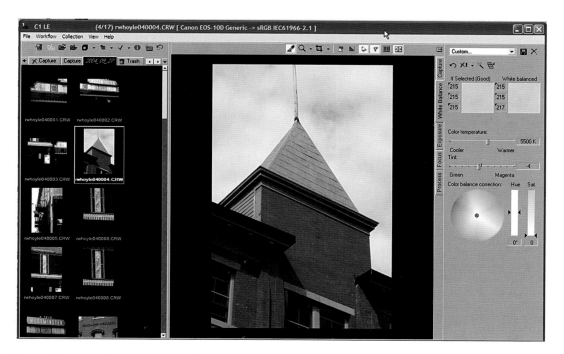

Figure 4.2 Phase One Capture One menus. The various versions of Capture One software provide streamlined workflows that are self-contained, meaning you perform capture to output in one software. Original images © Yvonne J. Butler.

After you have installed the Capture One (C1) software, launch the C1 application. This workflow allows you to "shoot right into the computer" by connecting your camera to the computer or by loading images into the C1 Capture Collection through IEEE 1394 cable or card reader. Before you get started, be sure to identify your camera's make and model. Your camera's profile will be automatically embedded by default into your "developed" TIFF file. Throughout you may develop your own custom ICC profiles..

Here are the steps I follow when using Capture One:

Step 1: Click on an image in the Capture Collection to select it.

Step 2: Perform gray balancing.

Step 3: Optimize your image: adjust levels and curves. Check focus using the Focus tab and even the grayscale version of it.

Step 4: Perform color management by opening the color management command, Show Color Management.

Step 5: Perform cropping.

Step 6: Process the image as TIFF or JPEG.

Step 7: Create CDs/DVDs and Web index, if desired. Save optimized files in .dng format to your archives.

Step 8: Organize your workflow in a destination folder, created inside the Capture Collection folder. Add unique names at this stage. Add image to group to be batch processed.

Step 9: Process the batch.

Step 10: Perform image processing: color adjustments, color editing, cropping, demoirize, and others.

Step 11: Your file is ready for printing.

Finders Keepers: Digital Asset Management

Many of us grew up chanting with our playmates that old favorite mantra, "finders keepers, losers weepers." Little did we know this or a close facsimile would still play and replay in our heads day in and day out: "Capture those

'keepers' but don't even think about 'weepers' (losing or losing track of them!)."

For photographers, losing our work, our prized possessions, would be more than our worst nightmare or even a kiss of death! Often, we cannot recreate the scene or circumstances. We might not have time or the courage to even ask to redo a shoot for a client, for sure. We cannot ask our subjects not to age or change. You get the picture! Having a system in place to organize, locate, and safeguard our precious assets in the best file formats suited to our needs is a no-brainer for photographers, something even the most casual photographer considers or should consider important. Whether you plan and take action now or wait for a disaster to happen is up to you.

A written or mental plan of action may include how to capture, download, file, and archive precious assets—a collection(s) of images, whether cherished memories of family or high school seniors or a special sports event, serious shots of our favorite subjects, formal work for commercial clients, or stock images for repetitive sales well into the future. Decide early on whether and when to shoot raw files; your preferences for raw, JPEG, ERI-JPEG, or a combination of file formats; and the software or approach you will use to store and archive images for easy retrieval for processing. Think about your workflow and tailor it around your decisions. Like any plan, it should be flexible and subject to change as your needs and habits dictate. Just get a plan and follow it!

Several software solutions are available for asset management. Here is a look at a few.

Extensis Portfolio (Figure 4.3) is designed to help you organize your images and archive them for easy access. The program is available for Mac and Windows users. The program lets you rename, categorize, and copy photos from your camera to a computer internal or external hard drive. Most important, the program generates a catalog of thumbnail images for your folders wherever they may be stored, and it is raw file friendly. You

Figure 4.3 Extensis browser. Figure courtesy of Extensis.

may search through the folders using thumbnail images or by key words that you have assigned to a particular set of images. Prior to converting raw files, you may preview, scan, assign keywords, organize, and sort thousands of images. Web templates and contact sheet creation are available as well.

The Extensis Pro Photo Raw Image Filter generates high-quality thumbnails and previews from the unprocessed raw files created by your digital camera. The filter is compatible with the DNG specification. The filter is driven by Bibble Labs' raw imaging technology, with its simplified workflow, one-click white balance tool, and a Photoshop plug-in for direct, in-Photoshop access to open raw files.

Before going to image optimization and enhancement you can extract EXIF metadata from the raw files, create thumbnails for displaying the images in Portfolio catalogs, and generate high-resolution JPEG previews for detailed viewing, printing, slide shows, and even QuickTime® movies. Portfolio works with DNG files.

iView MediaPro 2 (Figure 4.4) also DNG-friendly, is also a solution for cataloging and archiving your image files. Its claim to fame is its quick-paced creation of thumbnails and image previews for Raw format images, including performing batch renaming. Like other programs, you can batch convert the raw files to scaled-down JPEG images. You can also catalog up to 128,000

Figure 4.4 iView menus. Figure courtesy of iView Media Pro.

images, add key words unless they originated in Photoshop, and perform standard functions such as making contact sheets and Web galleries.

Workflow Savers

Finally, I would like to leave you with a list of helpful suggestions and tools to streamline your workflow.

1. Wacom Intuos graphic tablet and stylus and Cintiq LCD monitor that allows on-screen editing. Some professionals say using a Wacom monitor or tablet has cut up to 30% or more of their workflow.
2. ExpoDisc is a new product on the market that is used during pre-capture, if you will. The premise is that you can take a custom gray/white balance shot with this filter-like product placed over your lens to get a white balance for the lighting conditions, producing a "grayframe." What you are doing is placing this disc over the front of your lens and creating a custom preset white balance. ExpoDisc claims to produce a perfect R128, G128, B128 image when gray balanced in Photoshop, and this gray image becomes the basis for correcting color casts and slight color shifts. You then take all your shots. Later, in processing, you open the camera-generated ExpoDisc gray frame. Open the image you want to correct in the same window and match them, so to speak, and then batch process the rest of your images that were captured under the same lighting conditions. See the www.expodisc.com for instructions, recommendations, and links.
3. Use keyboard shortcuts and Actions in Photoshop!
4. Batch process whatever you can.

Note:
References include product announcements and updates, press releases, web information and other source materials from original manufacturers, including press releases, manuals, and/or hardware and software documentation from: Adobe® Corporation, Canon® USA, Celartam/Extensis®, Phase One® Corporation, and Wacom Company.

Part 2

DIGITAL CAPTURE

Chapter 5

Digital Light and Lighting

Lou Jones

Photography is in the midst of another new and exciting revolution, the digital revolution. The debate over digital versus film has stirred up all sorts of changes in the way we gather images. However, aside from the exciting changes and options before us, the fact remains that most of "the fundamentals" of light and lighting are still applicable.

The word photography means "writing with light." The adventure we embark on as photographers requires that we make peace with light and/or the lack of it. No matter what kind of camera we use—film or digital or large format or compact—and whether we shoot black and white or color, light is the main ingredient in any photograph. In photography every characteristic of light can be used, controlled, altered, and/or recreated. Creatively recording light and dark is the definition of a good photographer. The better we are at recognizing and modifying it, the better our pictures will be.

Whether you are committed to editorial photography and small format cameras or nature photography with medium format or landscape photography with large format equipment, you may never need to supplement

your vision with artificial lighting. However, the average person cannot wait for perfect weather or ideal natural light and may have to substitute for Mother Nature. Most still life, commercial, portraiture, and advertising work requires knowledge of tungsten and strobe lighting.

In this chapter on light and lighting, in a digital context I continually emphasize the limitations of exposure and how critical it is to be aware of the dynamic range of digital sensors. I discuss how, when you photograph in the studio, you arrange the lights to harness contrast. I share my insights on shooting on location to capture an image that you suspect has sections outside the dynamic range. I provide diagrams of the use of light and lighting equipment for specific assignments and design and use lighting to achieve what is required for world-class shots.

Exposure and Digital Lighting

For decades photographers have been trying to harness light, mold it in artificial ways, and attempt creative, albeit unusual, techniques to improve their pictures. Digital lighting is a young technology, and any discussion about digital lighting must begin with exposure.

To fully comprehend the physics and aesthetics of light means to measure it. The prevailing wisdom is that exposure for digital photography is just as critical as with film. Perhaps exposure for digital is even more so. For all practical purposes, the dynamic range of transparency film is about five stops and the useful range with digital mediums is about the same. Outside of this range lie overexposure and underexposure. You can choose to shift one end of the curve by increasing or decreasing exposure, but "for everything you gain, you give up something." Therefore, proper metering is always critical, whether shooting in raw or JPEG mode. Whatever format you use—small, medium, or large; film or digital—carefully executed traditional metering prevents lost data.

Metering

Advanced TTL (through the lens) and evaluative meters in SLR cameras have improved substantially over the years and are crafted for optimal results. The in-camera light meters segment a scene in myriad ways, and the algorithms make their recommendations. Typically, a digital SLR camera will have evaluative, partial, and center-weighted average metering. They can be relied on in most situations.

The evaluative metering mode is an all-around metering selection that is functional even for backlit subjects. The meter finds the main subject's position in the extensive number of metering zones normally to which automatic focus points are linked, as well as brightness, background, and front and back lighting conditions, and then sets an exposure for you. Evaluative metering uses all the zones, sometimes 35 to 40 or more, on the camera's photocell to measure the light entering through the lens. Center partial metering mode will work automatically when the background is brighter than the foreground subject. The part of the scene that falls within the circle in the center of the viewfinder is metered; typically, this center is only a small percentage of the viewfinder area so it operates like a traditional spot meter. The center-weighted metering mode will be weighted at the center and gives you an average exposure for the entire scene. Although the automatic systems make the task of proper exposure easier, great caution must be taken to interpret the information properly.

Exposure Controls

Digital cameras have alternative exposure mode features that allow you to fine tune what the meter selects for you. Use the exposure lock feature, for example, to lock in the exposure in one area of the scene (by holding the shutter halfway down), recompose, and then take the shot. Use exposure compensation to lighten or darken your images, using ranges of +/−2 stops in 1/2- and 1/3-stop increments or other combinations. When you select auto-exposure bracketing (AEB), usually found on your camera's menu

for custom camera settings, the camera will take three exposures: one at the recommended exposure setting, one lighter, and one darker, in up to +/–2 or more stops in 1/2- or 1/3-stop increments. These exposure mode alternatives are useful in indoor, outdoor, and studio settings.

Histogram

The most inventive and useful new tool that digital photography has introduced to help us perfect exposure evaluation is the histogram. The histogram is a graph of brightness along the horizontal axis (x-axis) and the number of pixels at each brightness level on the vertical axis (y-axis). It is basically a mapping of the colors in an image, and it allows the photographer to see the accuracy and spread of the exposure over the camera's dynamic range. A histogram shown while in Preview or Review mode (and in post-processing) gives a good indication whether the choice of aperture and shutter speed is overexposing or underexposing and whether exposure compensation can improve the situation. In bright sunlight, camera meters measure average subjects and scenes well and need no compensation. In shaded areas or on overcast days, most TTL meters are biased to underexpose, so you need to "add light." Learning to read the data is essential.

Modern metering systems have been improved so much that they outperform handheld meters in many situations. They work exceptionally well during very long exposures and interpolate when you are mixing different light sources, doing it instantaneously, but they are not foolproof. Experience and the histogram will dictate which ways to override the automatic readings.

Equipment

Some of the less expensive integral lens (point-and-shoot) cameras have small flashes built in. Most of the time this light is intended for use in some kind of automatic mode. Your equipment may allow you to select shutter speed, aperture settings, or ISO, but the camera determines the

rest. On-camera flash solves the contrast dilemma by front lighting everything, but the final product tends to be rather static and unnatural. When used as fill, on-camera flash "enhances" and merely "supplements" nature. This system cannot be faulted for either convenience or portability. For most commercial and studio applications, separate small, medium, and large strobe units make for better creative options. A discussion of electronic flash (Speedlite/ Speedlight) use is also included in Chapter 6.

Speedlites

Here are some basic points you should "have in your toolkit" before you pursue studio and complex lighting techniques.

Synchronization and AutoFocus

Synchronization is the mechanism that has the shutter of a camera wait until it is open fully before the Speedlite or flash is allowed to fire. The shutter space has to be completely open or you get a black cutoff on the image where it was covered during brief flash exposure. With focal plane shutters there is a limit to how fast the shutter speed can be for this to happen. Some cameras are approximately 1/250 second and some are 1/500 second. If you are shooting in manual mode the fastest shutter speed you can use and get full coverage of the frame should be noted. But all DSLR cameras now prevent you from making the mistake in any "automatic" mode.

The autofocus in the camera is integrated with the autofocus assist beam from the matching Speedlite in order to tell the DSLR how far away that part of the subject matter you are focused on and therefore are most interested in is, and where the light from the flash will initially strike something and report back to the camera.

The camera's computer is therefore calculating the distance they are apart in order to make a more "educated" and adjusted exposure if they do not coincide.

Full Auto Flash

Today's DSLRs are sophisticated enough to make calculations based on multiple factors: film speed, lens choice, distance flash is from subject, where you are focusing, color and/or contrast of subject and surrounding environment while in fully automatic mode in order to make the best typical exposure. This can be done with aperture priority, shutter priority, or programmed mode. It optimizes all the factors to reduce camera shake and provide the best depth of field.

Evaluative Metering

All DSLRs are capable of making very accurate exposures from any scene and ambient lighting. When you add a highly technical light source the two have to be coordinated to get a realistic balance. The flashes are also equipped with "metering" capabilities. Evaluative metering allows the camera to integrate both together to get a pleasing result.

High-Speed Sync and Focal Plane Flash

Light exposure is evaluated on the focal plane. Whether you tell the camera's meter that you want spot metering or matrix metering the exposure is measured through the lens and the aperture right where all the metering is done for the TTL (through the lens) meter. Rather than the Speedlite measuring in a sensor on the light, the camera measures all the contributing light sources at the same place, i.e., the focal plane.

Flash Exposure Lock

You can lock in any predetermined exposure. In automatic modes you are able to point the camera at a gray card or a part of the scene that you are most interested in and lock in that evaluation rather than allow the camera to make a spurious reading from an unimportant section of the scene.

Flash Exposure Compensation

The Speedlites will allow you to override the default exposure at the point buttons on the light itself. If you want to have the flash's influence more obvious or more

subtle you can turn the Speedlite independently up or down. Even though you change the ratio or the light the final exposure will still be perfect in relation to what you did rather than overexposed or underexposed. The Speedlite can be given more or less influence as compared to the ambient light while still producing a well-exposed shot. The artistic choice you make does not offset the perfect exposure.

Flash Exposure Bracketing

There is no such thing as a "perfect exposure." Perfect exposure is always a matter of personal preference. Therefore your vision may be to have high key pictures or dark dramatic ones. Also you may be faced with a complicated scene where the camera can be "fooled." You can bracket the Speedlite's exposures as well as bracket the camera's exposures. By changing the Speedlite you are bracketing the artificial and added light on your subject. By bracketing the camera's exposure you are changing the ambient light on the background. The two bracketing moves can be handled independently and will make dramatic differences in the final outcome.

Wireless Autoflash with Multiple Speedlites

You can attach a device to the Speedlites that will allow you to use a few additional lights for multiple lighting setups, and may be done wirelessly. The "slave lights" can be set up around the scene and set off by the "master" which is usually near the camera. This is where exposure override can play a major role because you can dial in the exact amount of light from each source. The only caveat is that you have to have the detector pointed at the master light AND the secondary lights must not flash directly into the camera or it will throw off the original exposure. With the preview screen on DSLRs you can see exactly how much each light contributes and how to adjust accordingly.

Strobe Units

The smaller battery-powered rechargeable units are designed for wedding and event photography and can be

adapted for traditional three- and four-light portraiture. In combination, small portable flashes can be used for commercial location work too. Match them up with external batteries and you virtually eliminate recycling delays.

Because flash is not continuous, it is hard to estimate exposure. There are light meters designed to respond to instantaneous impulses from flashes. The best ones act like incident meters. Aimed from the vantage point of the subject back toward the camera, you can take readings off each light separately or in combination. If you want classic "ratio-ed" portrait lighting, you can balance each light.

Larger versatile power packs outfitted with several strobe heads are more appropriate in the studio and with large format cameras and may be taken on location to light almost any assignment. With multiple heads, these power pack–driven strobes are the building blocks of digital lighting. The quantity, color, quality, and direction, with experience, may all be adjusted to suit any need. Make the time to learn and practice strategic application of various types of modifiers.

There are unlimited choices with strobes. They give off so much light they permit use of very small apertures for maximum depth of field. However unmodified, the quality is harsh and "contrasty." With different degrees of parabolic reflectors to direct the light, this "point source" of light is the perfect solution to "throw" a lot of light a long way.

Starting with strobe heads as our basic unit, we can fashion devices that make them more usable. Because digital is so much more sensitive to contrast, it is recommended that we favor large, low contrast light sources. There are many ways to accomplish this.

Bounce

The theory behind bouncing light is to spread out the concentrated light from handheld flashes and strobe heads. Either may be softened by bouncing them off a ceiling or wall. This spreads the "point source" light over a wider

surface, reducing shadows and lowering contrast dramatically. You can be a bit more flexible by introducing white cardboard or a collapsible reflector exactly where you want and bouncing the light off of it.

The bounce method is quick and easy but not necessarily efficient. A lot of power is lost into the surface texture, and sometimes the light has to travel farther, reducing the amount that actually hits the intended subject. The light is not very directional, and much light spills onto other areas. Also, you need to pay close attention to ensure the wall is white or you will get undesirable coloration.

Umbrellas

Umbrellas are a vast improvement over bounce. Umbrellas come in all shapes and sizes and are designed to more efficiently point the light where you want it (Figure 5.1). With different parabolic reflectors on the strobe heads, you can accurately contain and direct a large pleasing light. The closer you move the umbrella, the larger the light is, relative to the subject. Place it just outside of camera frame for maximum utility or set back from the subject matter when you have a wide-angle shot. You can bundle several umbrellas for an even wider spread and more power.

The three main types of umbrellas are differentiated by their inside surface: white surfaced, silver surfaced, and translucent white. The first is the most common and is used to bounce the light head off its inside surface. It allows for soft shadows and accurate colorations, and it concentrates the light fairly well. The silver-surfaced umbrellas are much more efficient than white. Silver umbrellas emit a crisp light and are ideal when you need more specular highlights on objects you are lighting or to bring out the texture of a material or surface. Many fashion photographers like the softness of the third type of umbrella because they shoot through it rather than bounce off the inside. There are more specialty umbrellas that are gold or half silver/half white.

Figure 5.1 Various umbrellas, courtesy of Photoflex. Umbrellas come in all shapes and sizes and are designed to more efficiently point the light where you want it.

Figure 5.2 Examples of softboxes, courtesy of Photoflex.

Light Banks and Softboxes

With the invention of the light banks, photography took a giant step forward. In an effort to duplicate the one-source lighting effects of the sun and directional Rembrandt-like window light, light banks have solved the efficiency and directional deficiencies of the aforementioned modifiers. Light banks are fabricated in any size or shape, which perfectly matches them to today's digital cameras. With large light banks photographers may quickly add drama and subtlety to their productions while still controlling contrast during digital capture. The "wrap-around" effect they produce enhances stylized portraiture and also lends itself to group portraits.

Light banks also fill a need in portrait and product work where there are reflective surfaces, such as glassware or automobiles. The light can be so evenly distributed across the length and breadth of a bank that its reflection in silverware, glossy packaging, and shiny plastics looks natural. Originally made of sturdier wood and metal, today's banks are constructed of lightweight high-tech materials and can be broken down and folded away so easily that size is no longer an issue. Therefore, the generic term for them is "softbox." Figure 5.2 shows a variety of softboxes.

Spots

Under certain circumstances you may not always want big diffused light. Add one more type, the spot, and you have an arsenal of tools that can, separately or in tandem, illuminate virtually anything. A spot grid applied to the front of your flash converts a strobe head into a spotlight. The tighter the "egg crate" shaped grid, the narrower the spot—that is, a 10-degree spot concentrates the light more than a 30-degree spot. Be aware that you also reduce the light output as the openings in the grid get narrower.

Spots (Figure 5.3) are the ultimate solution for creating drama. They may be used when you have to put just a small amount of lighting on your subject or to open up a small area in a bigger scene.

1-Full Diffusion Panel
(#5141)

1-White/Black Reflector
Panel (#5144)

Figure 5.3 An example of a spot grid, with full diffusion and white/black reflector panels, courtesy of Chimera Systems.

Reflectors

Using the major types of reflectors, you can design lighting schematics to flood a space with color or pinpoint a small product. You can produce high key or low key photographs, and you can be as crazy or conservative as you like. You can easily add light until it is overdone and obvious, but reflectors are devices that can "move light around" without actually adding another shadow.

Reflectors (Figure 5.4) are simple tools that can be bought or makeshift. Almost any reflective item will suffice in a pinch. Name-brand reflective products or just white typing paper will redirect the light from your main source onto another surface, open up shadows, or emanate their own light. They also introduce or remove detail and add or subtract dimension. Mirrors bounce nearly the full power of a light, whereas dull matte show cards diffuse softly. Supplement all your lighting with reflectors and you can literally shape a world of your own making.

Figure 5.4 An example of reflectors, courtesy of Photoflex.

Gobos

Gobos, or go betweens, are nearly the opposite of reflectors. They are normally placed between a light source and the subject to keep light off some portion of it. Or, you may put gobos in front of the camera to eliminate flare. Barn doors that attach directly to a light are a

version of a gobo. A lens hood might be considered another.

Design

For digital photography, we have unprecedented instruments to make perfect pictures. However, the process starts with the design. Most of the lighting theories we have learned for film-based photography work when using digital. And we can also add several new tools. Rather than performing complicated calculations and formulas, designing attractive lighting should be intuitive. Learning to integrate multiple light sources and methods is mastery of lighting. You have to meet each project anew.

A useful exercise is to pre-visualize how you want the final scene to appear. Then start with simple reproducible methods and build on that. The best "textbook" is every photograph you see in a publication. If you like it, try to figure out how the artist arranged the lights and make mental notes. Begin by supplementing the existing light and, with experience, graduate to more complicated schemes. Instinct will eventually take over.

Preview

Designing the setup is the first step. After placing the lights, you have to make sure the design is correct. The ability to preview what you have designed is a big advantage in digital and is all important. It is your safety net. With small format cameras, you can preview using the LCD screen on the camera back. For larger formats you may be tethered directly to a computer on set or on location. Both scenarios allow you to "build" your light step by step and to analyze it before you commit the rest of your resources. The convenience of scrutinizing your laptop and being able to tweak each component gives the artist enormous control. There is little guesswork. Evaluating the histogram and LCD correctly ensures usable printable images.

This unprecedented advance in technology makes it easy to review the influence of mixed lighting. The main

lights can be adjusted against fluorescent lights and other noncontinuous light sources. You can introduce motion or other special effects and not have to wait until the film comes back from the lab to know if you got it right.

Sometimes when you mix strobe with ambient light or have a video or computer screen that is important to read, you need to "drag the shutter." That is, in a darkened room, determine the strobe's influence with the aperture setting and balance that to the light from the screen with a longer shutter speed to "burn" it in. With the LCD you preview exactly what is correct and eliminate most of the bracketing that was necessary in the past.

The preview stage is also a perfect place to address color temperature. It is a most elementary part of successful photography. Our brain, after millions of years of evolution, makes instantaneous adjustments to "correct" our vision of different light sources. It makes us believe we are seeing "white" light whenever possible. Neither film nor digital is quite as adept as that. Fluorescent lights affect film or digital sensors differently from the sun. Modern noncontinuous halide or mercury vapor gives unnatural casts to recording mediums. Candles and lightbulbs have their own distinctive color too.

Digital cameras are balanced for daylight. You have to override that bias with the camera's presets to tell the sensors what kind of lights you are encountering. This works well until you have several different sources of mixed lighting. The high-end digital cameras give you options. You can "gray balance" by focusing on an 18% gray card set up in the same lighting or, as in video photography, you can "white balance" on any white surface in the scene.

Execute

It is difficult to codify lighting. What passes for good technique is largely a matter of personal preference. Rules that were inviolable a few years ago are fashionable today. But armed with all the requisite lighting equipment, metering systems, and sampling processes, you are ready to

actually take pictures. If you are a truly versatile photographer, you should let subject matter dictate your next step. Whether it is cheerful or frivolous or somber and serious may mandate how it is handled. You have creative control because you decide what to illuminate and what to leave in the dark. You can emphasize what is important in your image by making it brighter. Conversely, what you choose to hide remains in shadow.

Daylight

The most common light source is daylight. Because it is the first source we encounter, we often find the best practitioners trying to duplicate it even when they have every piece of equipment at their fingertips. If you are a photojournalist, travel, or nature photographer, it may be the only light source you ever need. It is simple and abundant but unreliable. Besides being unpredictable, available light can have color temperature inconsistencies. With transparency film this is a major problem, but it can be overcome with presets on most high-end consumer and professional digital cameras. This is a definite advantage digital has over film.

Daylight may be plentiful, but often it is "contrasty." And because digital is more sensitive to contrast extremes, we need to keep it in check. One way to lower contrast is to design your shooting to be done under cover or in open shade. You can set up on the shady side of a building or cover the scene with large "butterflies," which are translucent sheets of material that artificially produce shade. If this is too much trouble, you can wait for better conditions, such as weather or time of day. Or you can resort to light modifiers, such as reflectors and diffusers, to even out the light.

As we know, waiting can be inconvenient. The sun is cheap and ubiquitous but not very mobile. If we desire mobility, we need to bring our own. Strobes solve many of those problems. Their light is portable, consistent, and repeatable.

The image of a military officer taken outdoors involved the use of one strobe light in a soft box (Figure 5.5).

Figure 5.5 The outdoor lighting setup for an image of a military officer uses one strobe light in a softbox, with the subject standing under trees in open shade. Image © Lou Jones.

I positioned the subject under trees in open shade. The exposure was balanced so that the shutter speed controlled the exposure on the background (i.e., the helicopter and trees) and the aperture controlled the light contribution of the soft box. Several hundred feet of power extension cords were run from the building in the background. The image appeared in an insurance company calendar.

One Light

If you embrace the kind of photography that demands mobility, you may not be able to carry or have the time to set up extensive equipment. An affinity toward editorial, photojournalism, sports, or event photography may never allow your style to use more than one light. But you can still work that light for all it's worth.

Figure 5.6 This is the simplest of lighting setups, with one large light bank directly overhead and aimed down. The yellow polishing cloth was added for color. Image © Lou Jones.

The image in Figure 5.6 represents the simplest of lighting setups. I used one large light bank positioned directly overhead and aimed straight down. The light puts a highly complimentary light on the reflective object, the flute, which is in focus, and lights the craftsman, who is slightly out of focus. Captured on location, the subject is far enough from the background so that the background remains dark but not black and is not a distraction. I added the yellow polishing cloth because the image needed color. This shot was made for a brochure for a flute manufacturer.

Two Lights

The portrait of a beautiful young girl in Figure 5.7 was created for a drug company. I used a two-light setup with a

Figure 5.7 The two-light setup is supplemented with a reflector and a mottled painted background positioned behind the subject. The model is shot in total darkness, using flash and blurring techniques. Image © Lou Jones.

large light bank on the left of the subject, a white reflector on the right of the subject to fill the right side of the face, and a tungsten hot light on a mottled painted background. The model posed in total darkness and was lit by instantaneous flash. The camera was moved back and forth while "dragging the shutter" with a long shutter speed of approximately 1 second to add the blur created by continuous light source on the background.

Multiple Lights
Commercial, advertising, architectural, and still life work may require more lights. The permutations of using multiple lights increases exponentially with each new one you add. Start with a main light and build. There are some formulas for 3:1 or 5:1 portrait lighting, but everything else is

experimentation. With trial and error, as soon as you master one technique, you should add another. There is no limit.

The image shown in Figure 5.8 was commissioned by a pharmaceutical company to convey to the viewer that one will be able to lead a normal life by using the company's medication. The shot was set up with one vertical light bank on the left side, lighting the dancer and the dance instructor. The side lighting was set up to be dramatic. Another strobe light, a strobe head with spot grid and yellow gel, puts the spotlight on the back wall. Shot in the studio, the simple addition of a ballet barre created a dance studio setting.

If you have large areas to flood with light, you can start with the umbrellas. To illuminate large backgrounds behind the main subject, umbrellas are perfect. You can

Figure 5.8 This lighting setup involves two strobe lights. One is a vertical bank light for side lighting to create drama. The other has a grid spot on the back wall. Image © Lou Jones.

arrange several to light interiors, such as factories and offices. They can be used in tandem to evenly light large surfaces and rooms or individually to accent areas.

Most large strobe units are outfitted with an electrical circuit called a "slave." This permits each master strobe to fire off all the auxiliary strobes without wiring each unit together. The instantaneous impulse from the main flash triggers all the others. If your supplemental flashes do not have slaves, you can attach external ones.

Again, start with the main light. Second lights are initially necessary to add dimension, fill shadows, and balance the overall dynamic range. Remember, with digital photography we have to be cognizant of over- and underexposure.

Of course, spotlights will accentuate areas even more dramatically. They will also separate the main subjects from the background and can be accurately aimed if you do not want distracting sections of an interior to be overwhelming. Cover the light heads or flashes with heat-resistant gels and you can introduce pleasing colors where there were none. Spots are good for backlighting a subject too. Or it may be necessary to put light through a material to emphasize it. With a spot you can aim the light almost into the lens and the grid spot will reduce the chance of flare.

The shot of technology in action in Figure 5.9 was made in an industrial clean room for a company annual report. Creative use of lighting made attractive what had appeared unattractive on initial observation.

The industrial clean room image was made using a relatively complex lighting and computer setup, shown in Figure 5.10. If you integrate your lighting with existing lighting, the techniques used in the industrial clean room shot (Figure 5.9) emphasize the differences in color balance. Of course, you can place gels over your lights to match the objectionable fluorescent lights and place complementary filters over the camera lens to correct back to white light. This is similar to how you correct with transparency film. In digital you can slightly overpower the noncontinuous light sources or through the white balance

Figure 5.9 Industrial clean room: "drag shutter" for computer screen and fluorescent lights in background. Image © Lou Jones.

controls make the adjustments in post-production, particularly using raw file processing.

With normal light you can choose to make the foreground or the background brighter, but with digital the softer the light, the better the reproduction. With lower

INDUSTRIAL CLEAN ROOM

Equipment included:
- a. 3′ × 4′ Soft Box on floor (A).
- b. 2′ × 3′ Soft Box on stand (B).
- c. Spot Grid on stand with blue gel (C).
- d. Spot Grid on stand (D).
- e. Spot Grid on floor (E).
- f. 35mm SLR on tripod.

Soft Box A lights the electronic machine. Soft Box B set on a stand lights the two technicians. Soft Grid C on a stand lights the back wall and adds lighting contrast to separate the main machine from the wall. Spot Grid D on a stand lights the console and backlights the electronic machine. Spot Grid E on the floor bottom-lights the console.

Figure 5.10 Lighting diagram for industrial clean room. Lighting design © Lou Jones; graphics Yvonne J. Butler.

light levels, there is "grain" caused by electronic noise, and the color may be less saturated.

Complex Multiple Lighting

Production of this color photo illustration of a jazz club (Figure 5.11) was done completely in my photography studio. We set up and fabricated everything for a jazz club set. Pre-shoot preparation required contracting with subjects, most of whom are actual jazz musicians; gathering and treating props, including bottles, table, and glasses; period clothing of the 1940s and 1950s that fit the subjects; musical instruments, including a piano; neon signage appropriate to the time; and a smoke machine.

First, I developed a concept and design. Then, all the components of the shot had to be put into the design layout, assembled for the shot, and then staged with an elaborate lighting setup, displayed in Figure 5.12.

In conclusion, today's digital cameras are manufactured with the most sophisticated photographic recording devices in history. Light-sensitive binary chips are quickly replacing silver, allowing us to make better pictures. Owning a good camera is just the beginning. To get the most out of your equipment, you need to understand it is merely a tool. Take the time to learn the characteristics of light—color, quantity, direction, and quality—and what they mean. Cameras merely record what you ask them to. After learning to see and identify all types of light, you may believe it necessary to control it and modify it in various ways. Then ultimately you may actually want to try to recreate it.

Figure 5.11 The Jazz Café © Lou Jones.

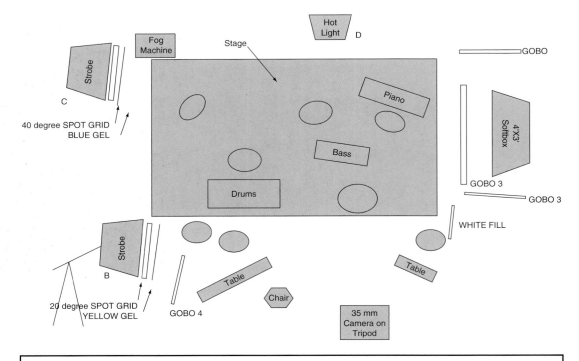

The equipment used for the The Jazz Café image (Figure 5.11) included:

a. 4′ × 3′ Soft Box lights (A). High.
b. Strobe with grid (B). High.
c. Strobe with grid (C). High.
d. Hot light (D)
e. Neon sign (E).

Soft box A lights the stage, piano, saxophone players and dancers. A is positioned high. Strobe with grid B lights the man with the hat and the liquor glass and bottle and is positioned high. Strobe with grid C backlights drums, spectator, and smoke. C is positioned high as well. Hot light D is used to separate the stage from the background and is positioned on the floor. Neon sign E is located in the upper right corner of the scene.

The lighting-related components were as follows:

1. Gobo 1 to keep light from soft box off back wall. On stand.
2. Gobo 2 to keep light from soft box off man in hat sitting at table. On stand.
3. Gobo 3 to keep light from soft box off lower half of saxophone player. On floor.
4. Gobo 4 to keep light from B off tablecloth of man with hat. High on stand.
5. White fill puts highlight into saxophone. On floor.

Figure 5.12 Lighting diagram for The Jazz Café. Lighting design © Lou Jones; graphics Yvonne J. Butler.

Chapter 6
Digital Portraiture

Steve Anchell

Portraiture begins in the home. Indeed, the greatest gift a photographer can give to family members, friends, even to strangers, is a portrait that records a moment that will never come again. A portrait does not have to be flattering. Take the series of portraits made by Richard Avedon of his terminally ill father, Jacob Israel Avedon. These portraits are a powerful document of two men's struggle with mortality, Richard and Jacob. Viewers today see a testament to the human spirit and the complex relationship between father and son.

Another photographer, Judy Gelles, has been documenting her family for over 20 years (Figure 6.1). Every year since she began the project, her family has gathered on a golf course near her parents' home in Florida for the photograph. It is a remarkable series in which one can see the growth and change in each person, the arrival of new faces, and the disappearance of others. This is a wonderful project that more photographers should consider. Don't wait for 20 years to pass before beginning with your own family!

Florida 1982 ©Judy Gelles Florida 1998 ©Judy Gelles
a b

Figure 6.1a Florida 1982. (©Judy Gelles. Courtesy of Stephen Cohen Gallery, Los Angeles.)
Figure 6.1b Florida 1998. (©Judy Gelles. Courtesy of Stephen Cohen Gallery, Los Angeles.)

Portraiture is my favorite form of photography. Whenever I meet someone I like, I invariably want to photograph him or her. I have portraits going back at least 30 years, and each one contains a special moment in my life as well as the life of the subject. For example, Figure 6.2 shows the photo of Myron Graham made in 1974. Myron was the owner of Graham's Art Supply in San Luis Obispo, California. To me, he represented an Alfred Stieglitz-type mentor, holding court in his shop, talking about art and life. Neither Myron nor the art store exists any longer, except in my memory and photographs. Of course, the photo of Myron was made with film, with digital imaging as we know it not even dreamed of in 1974. But the technique and intent to record the essence of another life and what it means to the photographer remain the same.

The very day I received the invitation to write this chapter I was scheduled to photograph the Jones family as part of a personal project. The Jones family represents

Figure 6.2 Myron Graham, San Luis Obispo, California, 1974. The original image was made with 4 × 5-inch black and white film. An Epson Perfection 4870 photo scanner was used to import the negative into Photoshop. Image © Steve Anchell.

four generations of jewelers in the small town of Alamosa, Colorado. The image was made with a Mamiya 645AFD with a Leaf Valeo 6 digital back. I prefer medium format for group portraiture and formal wedding photography. The 6-megapixel image equates to an 18-megabyte image file, in 16-bit format. The medium format ensures over 65,000 tone levels in each channel, extremely low noise levels, and a wide dynamic range. All this allows me to make an excellent enlargement of at least 20 × 24 inches.

However, it is not just enlargement size that matters. Medium format images, from film or digital cameras, capture significantly finer detail and create smoother

tonality. If you want to see an immediate improvement in the quality of your images, move up in size to medium format. If you are a pro, or thinking of turning pro, and want to provide your clients with the best possible quality, then medium format is definitely the way to go.

The image of the Jones family (Figure 6.3) was lit with one monolight and umbrella. The light and umbrella were placed to the left of the camera, and an aperture of f/16

Figure 6.3 Four generations, the Jones family. A Profoto Compact Plus 1200 moonlight with a Photoflex umbrella was placed to the left of the camera. Camera: Mamiya 645AFD with a Leaf Valeo 6 digital back. Image © Steve Anchell.

was used to ensure adequate depth of field. Exposure determination was made using a Gossen Luna Star F meter. The image was taken with a Mamiya 645AFD and a Leaf Valeo 6 digital back.

Getting to Know You

Good portrait photography does not require expensive equipment, nor does it require a medium format camera. What it requires is sensitivity for the subject. Even Diane Arbus, who is often accused of exploiting her subjects, had a deep concern for each of them. Actually, Diane did not so much exploit her subjects as she chose subjects she knew would make interesting photographs. She then became involved in their lives, sometimes for weeks, months, even years, getting beneath the surface, in an attempt to record their pain and anguish, both physical and mental, in a way others could understand.

Getting to know your subject is often the key to good portraiture. In the case of family and friends, this is usually not too difficult. In the case of strangers, someone who walks into your studio, someone you meet and want to photograph in their space, such as Myron Graham or the Jones family, you will want to take a little time to know them before taking a photograph. I take this approach even with friends and family. If I am in my own space, say my home or studio, I offer them a cup of coffee, tea, or soft drink and sit and chat for a while. If I am in their space, I usually place my camera bag and tripod on the floor and engage them in conversation before taking the camera out of the bag and setting it upon the tripod. While we are talking I casually look around the room for the best light and background.

The subjects are nearly always unaware of what I am doing—putting them at ease while trying to find out more about them so my photographs will capture the space between who they are and how they wish the world to see them. When it is time to photograph, I ask my subjects to move where I have determined the best background and lighting to be.

One of the benefits of this method is that we get to know people better, even our own family, and are able to connect with them in ways not otherwise possible—this is one of the reasons portraiture is my favorite form of photography (Figure 6.4). (As a side note, if you do not know how to relate to people, are shy, introverted, or just plain afraid to reach out, actively pursuing portraiture can help you overcome your inhibitions.)

Four Flavors to Choose From

I like to divide portraits into four very general categories: informal, formal, environmental, and group. There is crossover in all four. When you meet someone in a park and you respond by making a photograph that is clearly about them and not about the park, you have an informal portrait. Informal portraits are often more about the

Figure 6.4 Vicki and David in their home. A Profoto Compact Plus 1200 monolight was bounced off the ceiling. A white card was placed to the left of the subjects. Camera: Olympus E-1. Image © Steve Anchell.

photographer and their perceptions of the subject than they are about the subject.

A formal portrait is one that is arranged. This is the kind of portrait we think of when photographing a President, a bride, or someone who comes into our studio for a sitting. It often involves only head and shoulders but can include more if the photographer chooses. When subjects come in for a formal portrait, they are often wearing their Sunday best. Always photograph them first looking their "formal" best. By photographing them the way they want to be seen or believe they need to be seen, you avoid making them feel foolish for dressing up! Then, if you want to go deeper, have them loosen their tie or let their hair down, if the situation warrants.

Celebrity or personality portraiture is one of those gray areas that crosses over between formal and informal portraiture. Consider an album or magazine cover where the celebrity is seen in an unusual pose or wearing unusual clothing. On the one hand, the portrait is formal in that the celebrity is often invited into a studio with lights and backdrops or photographed in his or her home with carefully placed lighting. On the other hand, there is nothing at all formal about the photograph.

Make the time to study album and magazine covers and spreads in celebrity magazines. Try to incorporate some of the posing and lighting techniques in your own work. This is especially fun to try with your children (Figure 6.5), who will often do things celebrities would never think of doing!

Environmental portraiture is my favorite of all. I like to visit the subjects in their home or place of business. I am perpetually fascinated by how other people live, work, and play. Other artists are especially rewarding subjects to photograph, but not the only ones. Environmental portraiture allows the photographer the opportunity to engage subjects in conversation, walk around their home, studio, or shop, look at what they do, find out what interests them. It allows the photographer the opportunity to discover the space between the subjects' perception and reality.

Figure 6.5 Nicole. This was lit with an Olympus FL-50 with a white card taped to the back (see Figure 6.10A). Camera: Olympus E-1. Image © Steve Anchell.

Although there is no rule but the ones you invent, I like to show the subject's hands in portraits of this kind. After the eyes, the hands are the most expressive part of a person and tell a lot about what they do and how they live their lives. (Figure 6.6).

Figure 6.6 Deborah Easely, an artist in her home. A Profoto Compact Plus 1200 monolight with a large Photoflex soft box was placed outside the window, camera right. A white card was placed behind the subject. The image was recorded with a Mamiya 645AFD and a Leaf Valeo 6 digital back. Image © Steve Anchell.

The fourth form is group portraiture. This is perhaps the hardest because you must position everyone in a pleasing composition and keep an eye on each to make certain they do not blink, shake, make rabbit ears behind someone else, or disappear. The rule for large groups is to tell them that if they cannot see the camera lens clearly, the camera cannot see them! You must also be careful that anyone too close to the edge of the frame does not expand and end up looking like a puffer fish. This is especially true with wide-angle lenses but can be just as challenging with a normal lens.

Whether they are clearly seen or discreetly placed in the background, backdrops are an important element of portraiture. I have a collection in a variety of colors and styles. The backdrops in Figure 6.7a and later in Figure 6.13 were both made by Backdrop Outlet, www.backdropoutlet.com.

a

b

Figure 6.7a Class of 2004, Moffat School, Colorado. Three monolights with umbrellas were used: two placed on either side, one at half power, and one for fill at camera left. Camera: Olympus E-1. Image © Steve Anchell.
Figure 6.7b Hugo Macias and his crew. Available skylight illuminates this image. Camera: Olympus E-1. Image © Steve Anchell.

Lights, Camera, Action!

Even though good photography is not all about equipment, it does help to have some. You do not need a ton of gear. Pick a system and a format and work with it until you know it backward and forward and are ready to move on. In addition to your "serious" camera, I also recommend a lightweight point-and-shoot to carry with you everywhere. Currently, I am using the Minolta DiMAGE A2 as my "go anywhere" camera to record casual images of people and places that I would otherwise miss. The 8-megapixel A2 has raw capture, custom white

balance, and many features found on pro SLRs and some, such as built-in anti-shake for low light photography, that are unique to the A2 (Figure 6.8).

Raw capture is the single most important feature in a digital camera. Although there are times to use JPEG, such as "Christmas with the family snapshots" and action photography where recording speed may make the difference, for best quality always use raw with the camera's ISO set at 100. An analogous situation in film would be the choice between using fine-grained ISO 100 film and ISO 800 film. Using raw is like using ISO 100 film, JPEG

Figure 6.8 Fran & Wade at Beltane 2004. Images like this happen only when you always carry a camera with you. A full-size SLR is often too much to carry, so a point-and-shoot with raw capture feature is a good alternative. Camera: Minolta DiMAGE A2 with Vivitar 285HV Speedlite. Image © Steve Anchell.

like ISO 800. Of course, you can use ISO 800 film for everything, but the quality of your images would suffer. On the other hand, if you had an assignment to photograph a rock concert, ISO 800 film would be the obvious choice. Because you would not be able to successfully record the concert on ISO 100, film quality becomes a secondary consideration.

I also use an Olympus E-1. The E-1 is an SLR aimed at the pro market. The E-1 is the first digital SLR designed from the ground up with lenses made specifically for digital photography. It has all the features required by pros: interchangeable lenses, depth of field preview button, 2-second self-timer for mirror lock-up, three frames per second advance, and a 12-frame buffer in raw mode. The E-1 will also record both raw and JPEG files simultaneously.

In addition to cameras, some basic lighting equipment is a good idea for the serious portraitist. Although much can be done with available light, it is often desirable to augment what is available. At the basic level, a 3 × 4-foot piece of white foam core is invaluable. Of course, this is not something you are going to carry in your pocket, so if you find yourself on location and do not have a 3 × 4-foot piece of foam core, use the principles behind reflecting light into the shadows and locate a substitute. Sometimes, just placing a piece of white paper off to the side or under the subject's chin will work. I have seen a number of fine portraits, made in low light, where the photographer opened a book under the subject's face.

Because we see in color, black and white is a step closer to being abstract. As a result, we tend to become involved with the subject's psychology rather than his or her personality, which is more evident in a color image. Having the subject wear black against a black background is another way to create intimacy with the viewer. This technique was used with great effect by John Szarkowski, the director emeritus of the Department of Photography at the Museum of Modern Art, New York.

The image in Figure 6.9 was converted to black-and-white from an Olympus raw file color original using nik

Color Efex Pro™ 2.0, www.nikmultimedia.com. The advantage of using the Color Efex plug-in is that you can control the filtration with a set of sliders that work across the spectrum. You can also control the contrast and brightness of the image.

If you are feeling flush, invest in a Speedlite, also known as handheld flash. Almost every camera manufacturer offers a Speedlite dedicated to their camera system, and there are many after-market Speedlites, such as Metz, Vivitar, and SunPak, that are quite excellent. Speedlites can be used on the camera, either aimed directly

Figure 6.9 Marv Mattis. The main (key) light was a skylight above Marv's head. A white piece of 3 × 4-foot foam core was placed on the table below. Camera: Mamiya 645AFD and Leaf Valeo 6 digital back. Image © Steve Anchell.

at the subject, bounced off a white card, or through a diffuser. If the light is aimed directly at the subject, it should be used as fill, not as the main light. As a general rule, cut the light in half. If your camera's ISO is set at 100, set the Speedlite at ISO 200 or even 400. Even if you are using a reflector or white card, you may wish to cut the power of the Speedlite to create a more natural ambiance.

It is important that you are able to use your flash off camera. This allows you to hold your flash high and to the side to obtain more interesting and flattering shadows. Try holding the flash (linked to the camera by either a long cord or an infrared triggering device) as high and far away from the camera as you can. Hold the flash to the shadow side for fill if the subject is lit from the side by a strong light source such as the sun or to the side you want the main light to be on if the subject is backlit.

There are several after-market diffusion devices made for Speedlites (Figure 6.10b). If you do not have a diffuser or white card, try bouncing the light off a wall or ceiling—but beware, the light will pick up the color of the reflecting surface. If the walls are green and the ceiling white, use the

a b

Figure 6.10a Olympus FL-50 speedlite tilted slightly forward with a white card taped to the back.
Figure 6.10b Olympus FL-50 speedlite with a diffuser attached.

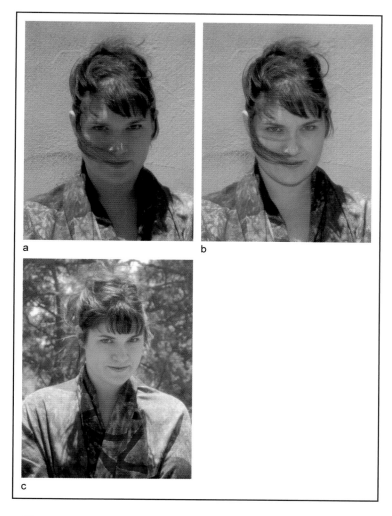

Figure 6.11a Deana. Bright sunlight, no fill. Camera: Minolta DiMAGE A2.
Figure 6.11b Bright sunlight, direct flash at half power. Camera: Minolta DiMAGE A2 with a Vivitar 285HV speedlite.
Figure 6.11c Backlit with speedlite and gold diffuser. Camera: Minolta DiMAGE A2 with a Vivitar 285HV speedlite. Image © Steve Anchell.

ceiling! Many Speedlites tilt. Try taping a small piece of foam core or white card behind the light and tilting it slightly forward. If the head does not tilt, use a synch cord to take it off the camera and tilt it yourself with the card taped to the top (Figure 6.10a).

Now that you have mastered the concept of electronic flash, I will let you in on a secret. Some of the best indoor light is available light (Figure 6.12). Even so, beware of light sources, particularly fluorescent tubes, which are

Figure 6.12 Nicole and Loretta. The key light was a large window to the right of the subjects (camera left). Fill was created using a piece of 3 × 4-foot white foam core to the subjects' left (camera right). Camera: Mamiya 645AFD with a Leaf Valeo 6 digital back. Image © Steve Anchell.

directly over the subject. These will cast shadows under their eyes and emphasize the bags many of us have, yours truly included. This is where either a flash or white card can be used as fill to open the shadows and create a more flattering image.

Although diffused window light is a photographer's best friend, an overcast sky is equally good. Overcast skies soften shadows and wrap around the subject, creating a flattering light. Studios spend tens of thousands of dollars to create the effect of overcast lighting. A highly successful

child photographer in Santa Monica, California, only photographed outdoors and would cancel the session if it was not overcast. She was in so much demand that she could afford to work only during the foggy season!

The drawback to overcast light is that it can be too low in contrast or have a blue cast. A Speedlite used for fill can increase the contrast. An 81A or 81B Orange filter taped over the Speedlite (use 3 × 3-inch gelatin filters) will help to warm the subject during capture. Other filter options are Tiffen® Color Enhancing filters or the Tiffen 812 filter, which is a combination of an 81 Orange and skylight filter.

The Short and the Long of It

There is a lens effect in photography of which the portrait photographer needs to be aware. It is known as foreshortening. When an image is foreshortened, objects such as the nose, which are closer to the lens, look disproportionately large. Objects such as the ears look disproportionately small.

Many photographers believe foreshortening is a function of the lens—it is and it isn't. Foreshortening is a function of the distance between the lens and the subject, regardless of which focal length is used. In other words, a 24mm wide-angle lens used at 3 feet from the subject will create foreshortening. The same lens used at 8 feet will not. The problem, of course, is that at 3 feet you can fill the frame from the waist up; at 8 feet you will include the foreground and ceiling.

The opposite effect is the flattening of perspective. Although not as obvious as foreshortening, this too is not the way to create the most flattering image of a person. Flattening perspective is accomplished by using a long lens at too great a distance. A secondary effect of a lens that is too long is that it places you too far away from the subject. Any chance you may have to engage your subject will be lost.

There is a camera distance for portraits captured from about waist level, or even higher, that creates a pleasing and natural perspective. That distance is between 6 and 12

feet. As mentioned above, you can move 6 to 12 feet away with a wide-angle lens, but you will have a full body portrait, not a classic head and shoulders image. The focal length most photographers choose for portraiture when using 35mm format is between 85mm and 135mm, which places the subject only 3 to 6 feet away for a full-frame head and shoulder portrait (Figure 6.13). However, it places the subject 6 to 8 feet away for portraits from the waist up, which is where a lot of portraits happen. For the Olympus E-1, which uses the 4/3 proportion, that would be 43mm to 65mm. At 6 × 4.5 cm, a common size for medium format digital cameras, that size equates to approximately 120mm to 200mm.

Some top portrait photographers choose to use longer lenses for portraiture. Photographer Greg Gorman often prefers to use a 70–210mm f/2.8 lens to create his dynamic

Figure 6.13 Jen. This image was made from about 6 feet away using a 100mm lens (50mm on the Olympus E-1) to obtain a pleasing perspective. One light was placed below the subject and bounced off a white card, another was placed with an umbrella to her left (camera right) and high. Camera: Olympus E-1. Image © Steve Anchell.

portraits of movie stars and celebrities. I have often used a 300mm lens at a distance of 10 to 12 feet to create slightly compressed but "in your face" head and shoulder portraits in the studio. With that said, it is quite possible you may wish to create a distorted or flattened image of your subject for creative reasons (see Figure 6.14).

Flattery Will Get You Everywhere

The reality is that people are not physically perfect. If it is your goal to make people look their best, use a soft focus filter or apply one in your editing program. A good add-on that contains soft focus effects is nik Color Efex Pro 2.0, mentioned earlier, or use Gaussian Blur in Photoshop. Even so, you may wish to work with soft focus filters on the camera lens rather than in an editing program (Figure 6.15).

When using on-camera filters, buy them in matched sets of increasing softness, and in this way you can learn to predict the results. Tiffen makes a line of soft focus filters called Soft/FX® in densities from 1 to 5, 5 being the

Figure 6.14 Ben Brack, local hero: structure firefighter, EMT, wild lands firefighter. This triptych demonstrates the creative use of foreshortening. A 28mm lens (14mm on the Olympus E-1) was used from about 3 feet away. A Vivitar 285HV speedlite with a white card taped behind it (see Figure 6.10A) was used. Camera: Olympus E-1. Image © Steve Anchell.

strongest, and another called Black Diffusion/FX®. Both are available in neutral and warm tone versions. Choose one and learn to use it.

When deciding which soft focus filter to use remember these two general rules:

1. The closer you are to the subject's face, the stronger the filter needs to be.
2. For any given distance, use less soft focus for men than women. For example, if you would use a number 3 filter for a woman, chose a number 2 for a man. Although a man may believe it is cool to appear tough, rough, and downright macho, women generally want, and expect, their portraits to be flattering.

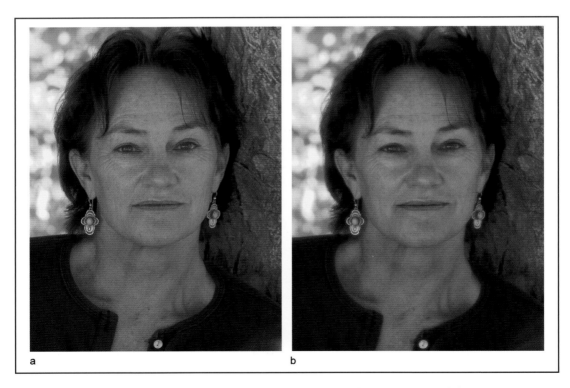

a b

Figure 6.15a Marcia. No filter was used. The lighting was open shade. Camera: Olympus E-1. Image © Steve Anchell.
Figure 6.15b This image was made using a Tiffen Soft/FX 3 filter over the lens. Image © Steve Anchell.

The Eyes Have It

With or without a soft focus filter, the eyes are the window to the soul. If the eyes are sharply focused, almost any portrait will succeed to some extent. If the eyes are out of focus, your photo will most likely fail. If you are not certain, set the camera at f/8, focus on the nearest eye, and release the shutter.

There is an exception to every rule, and some photographers have used blurred and out of focus eyes to create their statement. However, before you start breaking rules, use them—then you can strive to become a latter day Ralph Eugene Meatyard or Duane Michaels.

It may seem obvious to you when you read this, but there are only two places that a person can look—either at you or away from you. The direction makes all the difference in the world. If the subject is staring straight at the viewer, the viewer becomes actively engaged with the subject in the photograph (Figure 6.16a). Look at Yosef Karsh's famous photographs of Albert Einstein, Winston Churchill, and Ernest Hemingway. In all three the subject is staring intensely at the viewer. Occasionally, though, a subject may achieve a glazed look in the eyes, which gives the impression of looking through the viewer, somewhat like a dreamer or visionary.

When the subject looks away from the camera, viewers feel as if they are observing a private moment (Figure 6.16b). The subject could be looking up, which conveys lofty emotions, looking down, which conveys introspection, or looking straight ahead (though not at the viewer), which conveys farsightedness. We are programmed through generations of art and observation to recognize these emotions.

Knowing these few simple rules of face and eye placement, we can use the camera to convey what we have discovered about the subjects' characters when we engaged them in conversation at the beginning of this chapter!

a

b

Figure 6.16a Donna and Simone. The subject is looking straight into the camera. The viewers feel as if they are engaging the subject in this image. Camera: Rolleiflex TLR. The 6 × 6-cm negative was scanned using an Epson Perfection 4870 photo scanner. Image © Steve Anchell.

Figure 6.16b The gypsy. The subject is facing away from the camera with a distant unfocused gaze. The viewers feel as if they are watching a private moment in her life. Camera: Rolleiflex TLR. The 6 × 6-cm negative was scanned using an Epson Perfection 4870 photo scanner.

Chapter 7

Digital Macro Photography

Taz Tally

There are a few interesting key characteristics about shooting digital macro photography that differ from shooting analog (film-based) macro photography. The key characteristics pertain to previewing requirements, image resolution, image dimensions, image stabilization, file formats, resampling, and use of unsharp mask. In this chapter I focus on these key areas that vary slightly or significantly between film-based and digital macro photography. I also discuss ways you can maximize your image quality and ease of capture when shooting digital macro. First, let's think about macro equipment and its uses.

Selecting and Using Macro Lenses

If you are making the move to the digital world from the analog world, you may notice a wider variety of choices for shooting with digital macro lenses than you may be used to. Following is an overview of what you will find in the marketplace and some suggestions of what to use.

Macro Combo Lenses

This type of macro lens capability is built into another lens that is used for normal shooting. The macro may be built into a zoom lens or a fixed focal length. The best characteristic of these lenses is their convenience. You can go directly to macro mode without switching lenses. The down side to these lenses is they tend to be less flexible, in terms of both focus and f/stop range, than more dedicated macro lenses (see Focus Distance and Depth of Field, below). Combo lenses are quite common because many digital cameras only have one lens, so the manufacturers have tried to provide as much flexibility as possible out of their single cameras.

Dedicated Macro Lenses

Dedicated macro lenses are made specifically for macro photography. As such, these lenses will provide a wider range of controls for both focus and f/stop range. Dedicated macro lenses are becoming more common, with the development and proliferation of digital SLRs that usually work with interchangeable lenses. You will find dedicated lenses available in both zoom and single focal length versions. As with conventional lenses, the zoom macros provide greater flexibility, whereas the single focal length lenses will typically provide more consistent quality. (Note: Zoom lenses of all flavors tend to have some flat spots in them where their focus is not as good at some focal lengths as at others. I use both types of macro lenses (combos and dedicated). In fact, I tend to use my combo lens the most because it is the most convenient, but for those shots that I really want to be at their best, I'll stop and swap—if I have my other camera with me that is!)

New Stabilized Lenses and Cameras

A new digital technology that is proving a real benefit to macro enthusiasts is the image stabilization feature that can be found on an increasing number of lenses and cameras. This anti-shake technology is really a benefit when trying to shoot a handheld macro shot when a tripod is not available or practical to use. Most image stabilization capabilities are currently being built into individual lenses. However, the

current trend is to make image stabilization a camera-specific rather than a lens-specific function. So look for this capability the next time you are in the market for a new macro lens or camera.

Other Macro Gear
New Types of Ring Lights

Although not strictly a digital issue, ring lights are an important tool to have in your digital macro tool belt. Ring lights provide lighting in tight macro environments. Most manufacturers offer ring lights that are specifically made to work with their cameras. Examples of these include the flash ring lights seen in Figure 7.1, a Macro Ring 1200 and a Twin Flash 2400, which are made by Konica-Minolta for their Dimage7 camera. Flash ring lights put out a lot of light and are good for stopping action, but flash rings also tend to be a bit pricey. With the advent of the digital age we are seeing a new wave of simpler and easier to use ring lights that may be fixed to the front of a variety of cameras. An example is the Samigon Halo Ring Light (Figure 7.2), a fluorescent ring light that can be attached to a variety of cameras. This fluorescent light is color balanced at 5000 K, and because it is not a flash, you do not have the problem of creating unexpected shadows. At under $200, this Samigon is about half the cost of most flash ring lights. Both types of ring lights have their place.

Figure 7.1 Conventional ring lights like these Minolta ring lights are flashes that provide lots of light and are good at stopping action.

Digital Macro Capture Issues and Techniques

Perhaps the two most important issues I think about when I am shooting macro shots are focus distance and depth of field. In general, of course, a dedicated macro zoom will provide you with the widest range of both variables. If you are using a combo lens you will have less flexibility over focal distance.

Focus Distance and Depth of Field

Here are the key things to think about. The closer you get to the subject, the tighter your crop and the less cropping you will need to do post–image capture. But, the closer you shoot, the shorter your depth of field will be. So you need to

Figure 7.2 New fluorescent ring lights are less expensive and easier to use than conventional flash ring lights.

consider this for any given shot, if depth of field is important. For instance, in Figure 7.3 controlling depth of field is more important in images of the aster than in the shot of the frozen leaves. As I have mentioned, combo macro lenses tend to have restricted f-stop ranges (f/3–4 to f/8–9 is not uncommon), whereas dedicated macro lenses may offer far more expansive f-stop ranges (f/2.8 to f/22). So if you like

Figure 7.3 Images © Taz Tally.

to shoot macro images that require considerable depth of field control, this requirement may dictate your lens selection.

Preview note: Many digital cameras do not offer a preview of the depth of field, but this is a very handy feature (offered in most analog SLR lenses). As digital cameras become more sophisticated and digital SLRs become more common, this depth of field preview will become more standard. For now, it is a good idea to ask about this capability before you buy. One other thing you will notice is that even if you have a depth of field preview, most of the LCD displays will not provide a very good preview of the depth of field. Thus, you will usually find me looking through the actual viewfinder to preview my depth of field in critical shots.

Practice for Focal Distance

To become more comfortable and competent shooting digital macro images, shoot a series of images with various focus distances (crop). Be sure to include some shots that require you to control depth of field. You will quickly learn the capabilities and limitations of your macro equipment, become better at controlling what you have, and of course establish all sorts of reasons why you need to have a new and better macro lens!

Trembling note: It is always best to shoot macro images with a tripod. Camera shake is very evident in macro images. However, for those circumstances where you want to shoot macro and you do not have a tripod, having a lens (or camera) with built-in image stabilization is a huge benefit!

Previewing Images

One of the really nice capabilities of shooting digital photography generally and digital macro photography specifically is the ability to preview your images. Previewing your macro shots immediately after shooting them is a real bonus. It's great to be able to see not only the compositions but also, most importantly in macro photography, the depth of field of your focus. Nearly all digital cameras allow you to view your image after you have taken it. But not all digital cameras are created equal

when it comes to the quality and characteristics of your preview. Following is a list of key characteristics that I look for when I am hunting for a digital camera that I intend to use for macro photography.

- Preview screen large and clear enough to easily see your images: The preview dimension you need will depend on individual needs and preferences. Those of us who are getting up in years need larger previews than those who are still under 30. Try to spend some time looking at the preview image. Take a few macro shots under various lighting conditions to make sure you will be able to see your images. There is a wide range of preview image dimension and quality so this is well worth paying some attention to. Making sure you can see your preview clearly will remove much frustration and therefore enhance your shooting enjoyment later.
- Zoom preview: One feature to look for in your digital camera's preview capability is the ability to zoom in on your image overview. This is especially handy for seeing image details and checking the depth of field. So make sure that your camera's software will allow you to perform at least a 3× zoom-in on your preview image.
- Lightened, shielded, and/or tilted preview: One of the common problems you will likely encounter when shooting macro shots, and particularly when shooting with a tripod, is difficulty in seeing the preview at all. Most digital cameras offer you the option of viewing your preview image either though the viewfinder window or on an LCD panel on the back of the camera. When you set your camera up on a tripod, and particularly if you are shooting close to the ground, you may not have easy access to the viewfinder preview. Because your LCD preview screen is often facing the sun, viewing the image may be nearly impossible. So here are a couple of solutions: 1) adjust your image preview brightness up several levels so that your image will be visible on the camera's LCD screen; 2) place a light-shielding tube over the LCD screen (I use a piece of 12–18-inch long × 2-inch diameter PVC pipe, or if you are strapped for cash or

really cheap you can use a paper towel roll core). Using the tube will both shield the direct sunlight and allow you to remain at least partially erect when viewing the preview screen. Some cameras have tiltable preview screens that are a godsend when working in tight and low macro shot positions.

• Bright and high contrast, especially in low light: In addition to the preview checks above, be sure to check your camera's preview in low lighting conditions. Some LCD preview images fall apart in low lighting conditions. Some will even revert to grayscale and become grainy. Make sure this is not the case with any camera you purchase for shooting in low light conditions.

• Histogram view: One other very handy feature to look for and use is the histogram preview. A histogram shows the distribution of your image data from highlight to shadow. Normally, a properly exposed image will display a complete set of image data ranging from highlight to shadow, whereas a poorly exposed image will display significant blanks in the histogram (Figure 7.4). In some low light conditions achieving proper exposure may be difficult, so you may be forced to create an image with a less than perfect histogram. But knowing this allows you to perhaps reshoot with a different set of exposure values, and/or you may decide to shoot in high bit depth raw mode so that you have plenty of data with which to capture your image (for more information on shooting macro in raw, see File Formats for Your Macro Images, below).

Image Resolution and Dimension Requirements

One of the real fundamental differences between film and digital image capture is the concept of building blocks of the captured images. Film-based images are typically captured on emulsions at a specific dimension (35mm, 4×5, etc.). To be used in a computer-based processing system, film-based images must be scanned to be digitized (converted to pixels). Digital cameras create pixel-based images to begin with, and the dimension and resolution can be controlled during capture. Once an image is

Figure 7.4 Histogram displays showing high quality (a) and low quality (b) exposures.

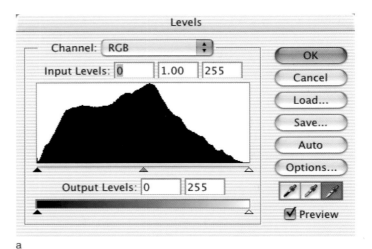

a

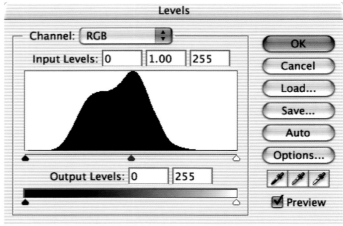

b

captured, it can be resized and resampled, but resizing and resampling usually involve interpolation of the image's pixels, which in turn usually results in the softening of the image and a reduction in its image quality. This interpolation-based softening is most apparent in high detail images, such as those often captured in macro shots (Figure 7.5). Note: Be sure to capture your images in an uncompressed format (see File Formats for Your Macro Images, below).

Resampling-related softening can be prevented or at least minimized by paying attention to the following:

For maximum image quality which requires no resampling of your images, capture your image with just enough pixels to use your image at the dimension and linear resolution at which you intend to print or use it. Because many digital cameras deliver their images at a linear resolution of 72 ppi, a little math is necessary to determine the proper image dimension that will yield the image you want after you adjust the image dimension without resampling (Figure 7.5). Here is an example of how you would do the math:

1. First determine the final resolution you want for your image. Here we will use 300 ppi.
2. Determine the dimension you want for the final image. Here we will use 4 × 5 inches.
3. Multiply the final image dimensions (4 and 5 inches) × 300 ppi = 1200 ppi × 1500 ppi.
4. Select the camera resolution that most closely matches this 1200 ppi × 1500 ppi to use for your image capture.

Note: On most digital cameras a resolution of 1200 × 1600 will be the closest resolution.

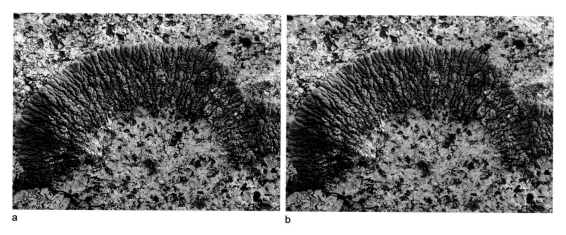

a b

Figure 7.5 Sharp unsampled image (a) versus softened sampled image (b). Image © Taz Tally.

Input versus Output Aspect Ratios: Minimizing Interpolation

There are slightly more pixels in the long dimension than you actually need (1600 ppi vs. 1500 ppi). This is due to the mismatch that exists between the aspect ratios of your CCD, typically 2×3, versus the aspect ratio of common print output sizes, in this case 4×5. I typically plan for these extra pixels when I shoot my images, knowing that I will be cropping them out during final output.

Once an image has been captured, you will want to minimize the resampling interpolation that occurs when you resize your image. Here is how you should do this:

1. Open your image in Photoshop.
2. Make a copy of your image to preserve the integrity of your initial image.
3. Select the Image size dialog (Image > Image size). When initially opening a digital image, your linear resolution will typically equal 72 ppi, and its image dimension will be very large, here 22×16 inches (Figure 7.6).
4. Uncheck the "Resample" check box. This will prevent any pixel resampling from occurring when you resize your image. Note the top portion of the dialog box will freeze, preventing the pixel dimensions from changing and thereby preventing any interpolation (Figure 7.7).
5. Be sure that the "Constrain Proportions" check box is checked (Figure 7.8).
6. Adjust the height image dimension to 4 inches. The width will automatically resize to 5.33 and the linear resolution will rise

Continued

Figure 7.6 Initial Image Size dialog will show a linear resolution of 72 ppi and an image dimension of 17×13 inches.

Figure 7.7 Image size setup: check constrain proportions, uncheck resample.

Figure 7.8 Image size adjustment: lower either width or height and linear resolution will rise.

Continued

to 300 ppi (Figure 7.8). This adjustment occurs without interpolation (note the Pixel Dimension has not changed throughout this adjustment).

7. If the resulting resolution is satisfactory, click the "OK" key and you are done. Note: If you have performed the math properly (from page 147) and set your input resolution to match your final output dimension and resolution requirements as we discussed, you will indeed be done. But if you need to adjust the linear resolution you can now check the "Resample Image" check box and adjust the linear resolution to match your needs.

8. If you do affect any resampling of your image, you will want to follow up with some application of sharpening (see Unsharp Mask Use: High Detail Images, below). This prevention, or at least minimization, of resampling based interpolation will pay you big benefits in terms of helping you retain image detail and focus.

Improving Image Sharpness

There are several processes in your standard digital workflow that can lead to unwanted softening of your macro digital images. Of all the photographs I shoot, my macro images are my most demanding in terms of details and sharpness. So at every turn I guard my pixels like a mother hen. In the previous section we discussed how to minimize softening of your images that can result from resampling-based interpolation during resizing. What many do not realize is that just the process of digitizing (capturing) your image will soften your image, and this is softening that you cannot prevent, but you can mitigate.

Nearly all digital images require some sharpening to return them to the focus apparent in the original lens view of the scene. But high detail images found in macro images require special attention to sharpening. This issue of image sharpness is also covered in Chapter 11.

Before we proceed through some sample sharpening steps, you need to know just a few more details about the softening process and how it occurs during image capture. This knowledge will help you make better decisions when applying sharpening to various types of macro images.

When your image is softened during the digitizing (capture) process, your image is not uniformly softened. High contrast edges are typically softened more than low contrast areas. This asymmetrical softening requires that we be prepared to apply sharpening in an equally asymmetrical manner. Otherwise, oversharpening of low contrast areas may result in the imposition of unwanted patterns in these low contrast regions of your images. So we need to not only control how much sharpening occurs, but also where in the image the sharpening occurs. One other useful bit of information about sharpening is how it works. Sharpening is basically an edge contrast enhancement tool. Sharpening increases the contrast between pixels and particularly along high contrast edges—that's how we control focus in a digital image, by controlling the contrast of pixels along high contrast edges in our images.

There are numerous sharpening tools that can be used to affect the sharpness (edge contrast) of our images. The preferred sharpening tool is usually an unsharp mask (USM) tool, which allows us to control not only how much sharpening but where it will occur in our image. The following two macro image examples (one with many high contrast edges and one with few) will help demonstrate the decision-making process and settings.

Unsharp Mask Use: High Detail Images

- Open an image with lots of high contrast edges. Here you will see how Unsharp Mask (USM) can be used to sharpen the lichen image shown in Figure 7.9.

- Make a copy of this image. It is good practice to keep an unsharpened version of your image.
- You would resample and resize the image as we discussed earlier, minimizing any resampling based softening. It is important to raise the linear resolution of your image before applying sharpening.
- Zoom in on a visually important area of your image that has high contrast areas. When working on the lichen image, you would focus on the ridges in the lichen.
- Launch the USM tool: Filter menu > Sharpen > Unsharp Mask (Figure 7.9).
- Set an initial sharpening amount of 100%. This will determine how much (in this case 100% increase) contrast enhancement will occur between affected pixels.

Figure 7.9 Here you can clearly see the results of the application of USM. Left is the unsharpened image preview, and right is the sharpened preview. Original image © Taz Tally.

Note: In this case if there is a 5% difference between pixels before sharpening, there will be a 10% difference after sharpening.

- Check the Preview button to see the results of your sharpening (Figure 7.10).

Note: Be careful not to apply too much USM. Oversharpening can create ugly edge halos.

- Experiment with USM amount values of between 100% and 200%. Here I have applied an amount of 150% USM (Figure 7.10).

Note: For better results you might try applying USM in 50% increments (this one was executed three times at 50%) while carefully watching your edges.

- You can also experiment with the radius of the USM, which controls the width in pixels to which the USM will

Figure 7.10 Original image © Taz Tally.

be applied. Higher numbers translate into more obvious sharpening. I typically use a radius of 1 for most of my print-oriented images with resolutions in the 200–300-ppi range. For Web-oriented images, with resolutions in the range of 72 to 100 ppi, I usually use a radius of 0.5. Higher resolutions generally require higher radii.

Unsharp Mask Use: Protecting Low Contrast Areas

- Now open a macro image with fewer high contrast edges and more low contrast areas. Here you will see one of my macro shots of a flower (Figure 7. 10).
- Again make a working copy, zoom in and open the USM filter. In this image of the lavender flower (Figure 7.10) there are some areas such as the high contrast edges of the pistils and stamens that can benefit from a bit of sharpening, whereas the smooth lower contrast areas of the lavender flower petals should be protected from the USM.
- Experiment with various amounts of USM.
- Set the threshold at 3–5 (here 5) to protect the lower contrast image areas. A threshold of 5 requires that adjacent pixels have a difference of at least 5 grayscale values, before the USM is applied to these pixels, which effectively protects the lavender petals in Figure 7.10, for example, from any unwanted graininess that might be introduced through application of sharpening to low contrast image areas.

Controlling sharpness is another creative tool available to the digital macro photographer. Here, applying a pretty hefty amount of USM to the high detail areas (pistils and stamen) while protecting the lower contrast petal areas allows you to create a sharpness contrast within the image that enhances both the high and low detail portions of the image.

File Formats for Your Macro Images
JPEGs

As we have already seen, the quality of your macro images is controlled and affected by numerous variables. One

Figure 7.11 Lossy JPEG compression will reduce the quality of your images through posterization and loss of image detail. Note the pattern of squares that are typical of JPEG posterization.

important variable is the file formats in which you capture and work with your images. By default, many digital cameras will save images in compressed JPEG format to allow you to save more images to your storage media. But there is a hefty price to pay for this saving in file size. When saved in JPEG format, your images will be compressed using what is known as a "lossy" type of compression. To significantly reduce file sizes, lossy JPEG compression averages data, which can lead to posterization of your images and severe loss of image detail (Figure 7.11).

TIFFs

The TIFF format is perhaps the best general file format in which you should save your digital macro images. TIFF is an uncompressed open pixel-based file format that will retain all the image quality you save to it. Unlike the JPEG format, there will be no loss of image data or lossy compression-related posterization. In addition to being a high quality graphics file format, TIFFs are also good file formats for sending your images across platforms. That is, both Macs and Windows computers readily accept TIFF formatted graphics. For the most compatible setting, save your TIFFs with both Mac and Windows previews, without any compression, and with a PC byte order (Figure 7.12).

PDFs and Other Distribution Formats

PDF is a terrific format in which to save copies of your macro images for showing them in a slide show, placing them for downloading from your website, and sending them across the Internet. In addition to being highly flexible, cross-platform compatible, and Internet safe, you can also easily apply security protection to your PDFs. From Photoshop you can save groups of your macro images in a variety of formats, including PDF, digital contact sheets, Web photo galleries, and more, right from the Photoshop browser. Just select the images you want to include from the browser preview window and choose your display preference from the Automate menu (Figure 7.13).

Figure 7.12 Saving your macro images in TIFF format with Mac and Windows previews, without any compression, and with PC byte order will provide maximum quality and cross-platform compatibility.

Raw Format

As discussed in Chapter 3, raw format files are typically uncorrected files, containing all the image data originally captured by the camera. Raw format files also often contain additional grayscale values (more than 8 bits, 10–16 bits, per pixel) than non-native formats such as TIFFs. The additional uncorrected grayscale values allow you to perform extensive image correction adjustments, while still maintaining adequate image data for output. In a macro photography context, raw format is most appropriately used when you know you will have significant image editing to perform on your image, post–image capture, for instance, when an image was shot in low light conditions and a substantial highlight and shadow adjustment will need to be applied. This could be determined by examining the histogram for the image in

Figure 7.12 Cont'd

the camera before final image capture. Images initially saved in raw format for editing should ultimately be saved out in a full quality noncompressed format such as TIFF.

Macro Image Workflow

We have discussed a variety of important specific variables and techniques that affect the quality of your macro images. In this section let's step back and take a larger look at your workflow when working on macro photography. It is always advisable to establish and use a consistent workflow. Having an established workflow helps protect the integrity of the image data of your original images and enables the multiple uses of your macro images.

Following is my standard digital macro photo workflow that you might use as a starting point for yours.

Figure 7.13 From Photoshop's browser, you can select and save your macro images out in a variety of display formats. Original images © Taz Tally.

Figure 7.14 With the Photoshop Camera Raw plug-in, you can open and edit native digital camera format images. Original image © Taz Tally.

- Determine the proper resolution based on the final image dimension and linear resolution you will need. If you do not want to sacrifice any image quality, even by down-sampling copies for multiple purpose use, then shoot images at several resolutions.
- Use a tripod to shoot your macro images to minimize damage to image quality and detail through shaking and blurring of the image and to help establish the crop you want.
- Take test exposure images and review your in-camera histogram until you have the best histogram possible. If you capture your image in raw format, save it in Adobe RGB 1998 TIFF.
- Use raw format to save your images from your camera in cases where you know you will have substantial image editing to perform. Note: Some photographers prefer to shoot raw for all their images because of the completeness of the image data.
- Copy your digital photos directly onto your hard drive.
- Access your images though Photoshop's File Browser.
- Rename your photos using Photoshop's Browser Batch Rename function.
- Resample images (without interpolation) through the use of Photoshop Actions.
- If you intend to create multiple versions of an image for multiple uses, create copies and downsize and sample with minimum interpolation.
- Apply basic color correction to your images.
- Save full resolution, unsharpened, Adobe 1998 RGB images as archival images to which you can return at any time to make copies for multipurposing.
- Make a copy of your archival image.
- Crop your image to suit your compositional and output dimension needs.
- Apply USM to suit the composition of your image.
- Save your duplicate image out as a TIFF.
- Convert your image to whatever output color space the final output of your image demands, such as CMYK for prepress use.

Chapter 8

Digital Travel Photography

Rick Sammon and Yvonne J. Butler

Introduction
Yvonne J. Butler

Digital travel photography is certainly at or near the top of my list of favorite forms of photography. Whether photographing locations or destinations close to home or far away, travel photography gives all of us an opportunity to enjoy ourselves and pursue what we love and strive for every day—scoring that perfect shot. Getting out and about for a week, a month, or even a day gives us time to work on one or more areas always in need of improvement or fresh new approaches—composition, creative use of light or lack of it, in-camera cropping and framing, capturing subjects we have not explored regularly, such as more street life or environmental portraiture, avoiding blown-out highlights or shadows, finding new ways to photograph an icon or traditional subject, and so much more.

Part of the allure of travel photography is its potential for diversity of form on each occasion. Just about any form of photography—portraiture, nature, landscape, wildlife, black and white, street, close-up, action,

commercial—may present itself. Whether you are off to see the world for commercial or business purposes or for personal pleasure, a location or destination becomes your classroom or studio in the field for advancing your repertoire, particularly for this discussion, your digital photography repertoire. Even places and events in your own backyard are golden opportunities.

In the first half of this chapter, Rick Sammon discusses the ins and outs of going totally digital on vacation or location. In the second half, I help you explore some options for developing a proposal for a travel story. Let's have some travel fun!

Part 1: Going Totally Digital on Location or Vacation
Rick Sammon

When I have a travel assignment for the Associated Press (AP) Special Features, I go totally digital—packing my Canon EOS 1Ds, Canon lenses, Canon G5 point-and-shoot camera, and accessories and leaving my film cameras at home.

Shooting with a digital SLR has several advantages over film, one being that I can see if I "got the shot" and another being that sharing my pictures with a subject via the camera's LCD monitor makes my photo sessions much more interactive. Perhaps most important, because I use Photoshop CS, my images equal, and sometimes surpass, film images.

The AP Travel Features are fun to shoot and write. The articles, which usually run in the Travel sections of Sunday newspapers, are picked up all over the world, in print and on the web (see www.google.com > Rick Sammon, Associated Press). I share one "clip" with you because I actually got started in photography by pitching an article on one of my travels (to Lake Baikal, Siberia) to the Lifestyle editor at my local newspaper. If you go

Figure 8.1 Images © Rick Sammon.

Figure 8.2 Image © Rick Sammon.

someplace interesting and get some good pictures (and of course an interesting and accurate story), why not pitch a story to your local paper (Figure 8.2)? Remember: editors need to fill up space, and they are usually interested in promoting local residents.

Before we get too deep into this chapter, I must tell you something. It may "rain on your parade," so to speak, when you are traveling. It has happened to me on more than one occasion. But don't let the rain get you down! You can still shoot and get some great shots, as illustrated by the two pictures in Figures 8.3 and 8.4. Just keep your gear dry—perhaps using a plastic sandwich bag with an opening cut for the lens.

Here are just a few items that are found in my traveling digital photo kit (Figure 8.5): Mac iBook, Canon digital

Figure 8.3 Image © Rick Sammon.

Figure 8.4 Image © Rick Sammon.

Figure 8.5 Image © Rick Sammon.

Figure 8.6 Image © Rick Sammon.

SLR, digital point-and-shoot camera, SanDisk USB memory card reader, and writable Memorex CD-R discs.

Other items in my kit that are not shown include several SLR zoom lenses, camera and flash batteries, all of the CDs for imaging and computer software, diagnostic CDs, camera battery recharger, additional 512 MB memory cards, surge suppressor, and a camera cleaning kit (Figure 8.6).

Even if you don't have a professional digital camera, remember: cameras don't take pictures, people do! You can use my tips and techniques no matter what kind of digital camera you have. For example, Figure 8.7 was taken with my point-and-shoot Canon G5.

So let's get started. Here's how I go totally digital when I hit the road. You'll also see some suggestions as to what you can do if you want to go filmless on a trip.

Packing Up

Going digital for the first time can be a bit scary. To reduce the "fear factor," make a checklist of all the essential items you'll want in your gear bag.

Figure 8.7 Image © Rick Sammon.

Digital Camera

If you must come back with great shots, take along a backup digital camera. And test all your cameras before you leave home to become familiar with all their controls so you'll have no questions about camera operation once on site. However, take the instruction book along just in case you forget a particular camera function. I occasionally do, so don't forget to pack the instruction book!

Memory Cards, Sticks, and CDs

Take more memory than you believe you'll need, even if you plan to download your pictures onto a storage device or your laptop computer at night. You never know when you'll find yourself in a situation when you want to take lots of pictures.

Extra Batteries and Battery Recharger

You may find yourself in a location where there are no convenience stores to buy batteries or no electrical outlets to plug in a battery recharger. Therefore, you must be self-powered, so to speak. Also, if you rely on a recharger, take a backup recharger just in case of a power surge, which can zap rechargers. Of course, taking a mini-surge suppressor is a good idea, too. One-socket surge suppressors are available at Radio Shack.

Figure 8.8 Compact Flash™ memory card.

Figure 8.9 Here is a shot taken in the hills of Mexico during the world-famous monarch butterfly migration. I used my 16–35mm lens set at 28mm. Image © Rick Sammon.

165

Accessory Lenses

When I travel, I like to travel light when it comes to my SLR lenses. My basic in-the-field lenses for my SLR digital are a 16–35mm zoom, a 28–70mm zoom, and a 70–200mm zoom. With those lenses, I can cover just about all assignments.

If you are shooting with a digital camera with a built-in zoom lens that has a limited range, add-on wide-angle and telephoto lenses will help expand your photographic horizons—not to mention the focal length range. By the way, an accessory telephoto lens will, in most cases, give you a sharper picture than a digital zoom—because the digital zoom only uses (zooms in on) part of the image captured on the camera's image sensor. When you make a print, the pixels in your image will be larger, which makes a picture look grainy and soft. I never use the digital zoom feature. Rather, I crop my picture in the digital darkroom and then use a program (now distributed by Lizzard Tech) called Genuine Fractals to increase the size of my image before printing.

Storage Devices

I travel with an Apple Mac iBook laptop computer that's loaded with Adobe Photoshop. One note on toting a laptop with you: pack all your original software, your imaging software, and computer diagnostic software such as Alsoft's Disk Warrior and or Micromat's TechTool Pro or the Lite version. I've had to use all the above when my computer crashed. If you take a laptop computer, the fastest and easiest way to get your pictures from your camera to the computer is via a USB cable.

If you take a laptop computer, you may want to look into a hard case for protection, such as the briefcase-style cases offered by Pelican Products. If your computer gets a hard knock to its top cover or if too much pressure is applied to the top cover, your screen could crack—as mine did when I was on assignment in China. If you open your computer and power it up and your screen looks like the one in Figure 8.10, you will know your screen is cracked. I hope you never see a scene like this!

Figure 8.10 A cracked laptop computer screen. Image ©
Rick Sammon.

Camera Bag

I use Lowepro AW (all weather) camera bags that keep my
gear safe and dry, even when it's pouring rain in Panama.
Choose a bag that will protect your gear and give you easy
access to your camera and accessories.

Camera Cleaning Kit

Clean cameras give clean pictures. Lintless cloths are your
best choice for cleaning your lens. And a blower brush is
essential for cleaning dust and specks off the image sensor
in an SLR digital camera.

Portable Printer

Canon and Olympus offer small portable printers. If you
want to make some prints on site for your subject, you
may want to pack a compact printer.

Shooting on Site

Shooting with a digital camera on vacation (or
assignment) has several advantages over shooting film.
Mainly, you can check your camera's LCD screen to see
whether you got the shot. But those little images can be
deceiving. They don't really tell you that an image is in
supersharp focus or if there is a bit of camera shake.
What's more, if your LCD screen does not have a
magnifying feature, you may not be able to tell whether a
subject's eyes are open or closed. That said, be sure to take
some extra shots of scenes you really like.

The flip side of taking extra shots is to refrain from deleting pictures that you believe are flops. In many cases, slightly over- or underexposed pictures can be saved in the digital darkroom. And, even with a picture that is out of focus or appears to have other problems, you may be able to add a creative digital filter, such as the filters offered by nik ColorEfex Pro, to salvage an image that might otherwise be lost!

When you are actually taking pictures, you have a few decisions to make about your camera settings. I recommend the following tips:

1. Shoot at the highest JPEG or raw setting for maximum image quality. Use raw when you want or need to pull out as much as possible from a digital negative.
2. Set your white balance to match existing light conditions. Sure, you can adjust color later in the digital darkroom. But why not start with the best possible image?

Figure 8.11 Image © Rick Sammon.

Figure 8.12 Image © Rick Sammon.

3. Use the LCD preview screen for composing only when necessary, as in close-up photography. The LCD screen eats up lots of battery power, so use it sparingly even to review your pictures in the field.

4. Think about the ISO setting. The higher the ISO, the more noise, the digital version of film grain, you'll get in your pictures. But don't let the possibility of a lot of noise stop you from taking a picture. After all, a noisy picture is better than no picture at all. Digital noise can be reduced later by using a Photoshop-compatible plug-in, such as Noise Reduction, in the digital darkroom. The shot shown in Figure 8.13 was taken in the hotel in which I stayed during a trip to Mexico City. The ISO on my camera was set to 400. The shot is a bit grainy, but, as I said, it's better than no shot at all.

5. Make sure that your camera will not die in the field. Keep more batteries with you than you believe you'll need. You just never know what picture opportunities may arise or if you will stay out longer than anticipated.

6. Save your files. Every night I download all of the day's image files via my SanDisk USB card reader to a Mac

Figure 8.13 Image © Rick Sammon.

iBook and burn CDs of those images. Before the sun rises the next day, I have my files saved in two places in folders on my hard drive and CD, just in case my laptop quits.

After I download my images, I check some of them out—for, among other reasons, to see if a tiny speck of dust or lint has landed on my camera's image sensor and needs to be removed (with a blower brush). Yes, I've had

to clean the sensor on more than one occasion. You don't have to worry about cleaning the image sensor if you have a built-in zoom that can't be removed. Specks of stuff can only get onto the image sensor in digital cameras with interchangeable lenses.

I do not make any post–capture image adjustments on site. Pictures look very different on my laptop than they do on my calibrated home monitor. Hotel room light may not be as constant as it is in my digital darkroom at home and affects how a picture looks to a large degree.

When You Get Home

When you are back home and comfortably seated at your computer, is time to transfer your files to your hard drive. My advice is to open each image, save it as a TIFF (lossless image quality) file immediately, and then copy your files to another storage device. I save my trip pictures on CDs and on a LaCie portable 30 GB FireWire (IEEE 1394) hard drive (Figure 8.14). Again, my pictures are saved in two places.

After my originals are saved, I get to work on image editing (on my color calibrated computer system), never touching my originals.

I usually crop and then selectively sharpen and adjust the color, contrast, and brightness of every image. For example, see the before (Figure 8.15) and after (Figure 8.16) versions of an image. By selectively, I mean adjusting only those parts of the image that need adjusting. A big mistake of digital image makers is to apply adjustments to the entire image.

Safe travels!

Figure 8.14 LaCie portable 30 GB FireWire (IEEE 1394) hard drive and Back-UPS Pro.

Figure 8.15 Image © Rick Sammon.

Figure 8.16 Image © Rick Sammon.

Part 2: Building a Digital Image Storyboard for Travel Publications

Yvonne J. Butler

Our pleasure travel work typically is biased toward our personal preferences and interests, whereas business (commercial) travel work takes into consideration the prospective or contracted client's requirements and the audience to which the images must appeal. No matter how much homework you need to do to get into the swing of becoming a professional travel photographer, traveling and taking travel shots using digital cameras is fun and highly rewarding. Planning, executing, and landing your first travel story is icing on the cake.

If you have a potential publication in mind, thoroughly study the publishing philosophy and submission guidelines. To improve your chances of getting your work published in a magazine, it is essential to know the magazine's overall theme (i.e., nature, sports, history, geographical area); the elements of frequently selected stories that seem to "sell" the acquisitions editor; targeted audience(s); layout style, including typical image sizes, use of small images at paragraph breaks or indentations; editorial schedule and what topic(s) will be featured during the upcoming year; and the lead time for submission for the topics you elect to vie for.

Many publications now accept digital media rather than slides and transparencies (the day *National Geographic* agreed to go with digital capture and accept digital images, we knew the digital age was official!). However, specifications for files submitted on digital media are strict and must be followed to the letter or you risk getting kicked out before you get to a decision maker's desk. Many if not most magazines provide information on their websites to help submitter and recipient avoid wasting time.

Also, if you are thinking about submitting images to a stock agency, getting accepted by Getty Images, Corbis,

or one of the other big houses would obviously be sweet. Check their websites for guidelines as well. I suggest you put together an on-line portfolio or link to a slide show, representative of your most promising work and versatility. You never know!

Traveling Light

Obviously, the biggest advantages when shooting digital for travel are 1) you have myriad possibilities for ISO (film speed), although you will use mostly ISO 100 to keep down the noise, and creative settings, 2) you can shoot scores or even hundreds of images and fill up your memory cards each time out, and 3) you get instant feedback on your works in progress before you go home. There also is a nice economy with digital as well: the days of carrying around two camera bodies, one loaded with black and white film and the other filled with some speed or type of color film that's invariably not the best one for the situation you want to capture at the moment, and worrying about x-ray machines at airports are just about over for those of us who have embraced digital full- or even half-tilt. Many of us now carry a main digital SLR body or even two, if packing space and airline or travel conditions permit such (for example, many African safari outfits insist on soft baggage only), a few lenses and accessories, and a credit-card size point-and-shoot camera with 4MP or 5MP for times when we want to shoot casually for fun or must defer to safety precautions.

When pressed to the wall on international travel expeditions, I try to get away with going through security with one DSLR with a nice focal range zoom around my neck, wearing a photo vest with pockets full of accessories and even a teeny "digicam." The Lowepro All-Weather (AW) photo backpack I use as a carry-on contains my second DSLR and whatever else I do not want to baggage check. I also like to take along my Leica Digilux® 4MP camera as well, using it mostly for macro work. Often I'll shoot the Digilux® in TIFF format at the highest image

quality setting for highest possible file size. The Lowepro AW bag also serves me well when it has to be gate-checked. I remove its full daypack attached to the front and carry it on the plane as a "handbag."

On a travel shoot, we can just punch the menu button on the back of our camera, select a pre-saved custom function and/or preset parameter mix (for contrast, sharpness, saturation, and color tone), change ISO (film speed) on the fly, and bracket exposure and white balance. We can shoot in raw mode at the commonly suggested ISO 100 and our other preferred settings and then make corrections later in the digital darkroom after raw file conversion or stick with the highest quality and size JPEG setting at our preferred ISO, exposure, white balance, aperture, and shutter speed for the subject. It's an exciting time to be a photographer and to capture the beauty of the world around us.

Getting Started on the Travel Story

We all have to start someplace, and there is no better place to get started than in your own backyard. You can practice your skills at or near home and then pitch your work to a local or regional publication editor. Working right in my own backyard is not a problem for me. I live part of the year on Cape Cod, Massachusetts, the origin of my paternal ancestors, and I travel frequently throughout the year to other beautiful corners of the world, both domestically and internationally. Just about every day of the week when I'm on Cape Cod, in clement and inclement weather, I find something to shoot for my ever-growing archive of the "Lower and Outer Cape." When I am away, I spend just about every morning and late afternoon hour carefully composing and amassing shots that may be used for travel publications, fine art pieces, and commercial purposes. Collecting and then selecting images that tell a story in pictures is one of the best ways to assemble a pitch (proposal) to a magazine.

Having a Mission

Your mission (should you choose to accept it) is to find elements for a story that let the reader in on the *essence* of the place you are portraying with your photographic eye. Essence is that which makes a thing what it is and distinguishes it from other things, a definition I learned many moons ago that has served me well. In this chapter I use images from my archives of Cape Cod and other parts of the world to demonstrate tips and pointers for capturing the essence of a place and telling a story. However, don't get hung up on following a checklist while shooting. Leave room for serendipitous encounters and go with the moment. My colleagues always say you have to know the rules first before you break them. So, take a look at some of my personal "rules" and then bend or break them after you've tested them out. Let's get started.

1. Go for the gusto and keep trying to find that one great image you believe might be a cover or feature image. One good way to accomplish this is to locate some scenes that lend themselves to a cover photo: see it first and then frame and compose it in your camera. I like to leave plenty of room for copy at the top of the image for magazine name or title of article and in the middle and/or bottom areas for captions. The Provincetown Dory image (Figure 8.17) seems to fill the bill: we have a dory in the foreground with a view of Provincetown's harbor and the moored boats and main wharf in the background that lead your eye through the scene. The sky allows room for magazine title; harbor water above and below the dory and sand at the bottom leave plenty of room for cover copy. The image was shot on the vertical, perfect for magazine covers.

 The beach at Sodwana Bay (Figure 8.18) in South Africa is more than beautiful. I walked around all day with a Canon EF 70–200mm f/2.8L IS USM (image stabilizer) lens on a cannon EOS 10D. Late in the day, I happened to turn around and spot just the right composition of stark sand dunes against a cloudless sky littered with

Figure 8.17 Provincetown Dory. A potential magazine cover taken in my own (summer) town, with room left for cover copy. Image © Yvonne J. Butler

mannequin-like bodies almost frozen in time. I grabbed the shot and loved it. Obviously, the image was not taken with a wide-angle lens or even a panoramic camera like the Hasselblad Pan-X. I cropped the large file to panoramic proportions in the digital darkroom and selectively sharpened it with nik Multimedia Sharpener Pro software.

2. Shoot high and low, narrow and wide. Don't forget to take notes on all your shots. If you do not know the names of something in nature, find out from a local or check a reference book. Often you will need to provide specifics about location and subjects. This image of Lee's Ferry (Figure 8.19a) was actually taken with the camera positioned down low along the water's edge. I composed

Figure 8.18 Sodwana Bay, South Africa. A panorama might get picked up for a double-page spread. Image © Yvonne J. Butler.

Figure 8.19a Lee's Ferry. Shoot high and low, narrow and wide. Image © Yvonne J. Butler.

the shot to show off the cool reflections of the clouds in the perfect sky and to mirror the cliffs above the horizon. Notice the horizon is in the top third of the frame: some photographers tend to always place the horizon in the middle when shooting a reflection image. I like to mix it up.

Take notes (Figure 8.19b)!! Carry a small pocket recorder to dictate comments or jot them down on a small pad. Your memory probably isn't what it used to be.

You never know when you will have to identify what is pictured in your image. Grabbing landscapes like this one is also a perfect opportunity to use various lens filters, including circular polarizing to deepen and intensify blue skies, UV for lens protection and UV absorption, neutral density, graduated, warming, and enhancing filters. This

Notes on Lee's Ferry

Lee's Ferry is located outside of Page, Arizona, famous for the Antelope Slot Canyons, Glen Falls Dam, and Lake Powell. Lee's Ferry sits down river from Glen Canyon Dam between the Glen, Marble, and Paria canyons. The cliffs are white Kaibab limestone on top of soft sloping Hermit shale.

Figure 18.9b A paragraph from my notes on Lee's Ferry.

shot was made with a Canon EOS 10D DSLR with only a UV filter over the wide-angle lens. Also, find the very highest point in the place you are describing and take shots from on high. Do this early in your shoot schedule. Obviously, this high vantage point gives you a perspective you do not have on the ground upon arrival, but the added value is you can identify potential subjects of interest for later capture. Take a ski gondola ride up a mountain in summer. Ride a tram. Climb a path. Do whatever you have to do to capture the broad vistas.

Figure 8.20a Me shooting you shooting me; a view of Provincetown from a schooner on the way out to sea. Image © Yvonne J. Butler.

Figure 8.20b Stormy skies provide an interesting backdrop from offshore. To make this image, I walked out into the sand flats at low tide. Image © Yvonne J. Butler.

3. Go out to sea and grab a shot looking back toward the inland (Figure 8.20a). (This might be perfect for a camera company add.) Find other unique vantage points for capturing wide landscapes. If you have studied magazine, newspaper, and travel guide stories on the location, you probably will not want to replicate what has been "done to death." Look for another point of view: farms, valleys, hills, harbors, and city or village centers are all interesting landscapes from on high or from a boat out to sea (Figure 8.20b).

4. Experiment with vignettes. Find unusual and small details and shoot close-in to create a large file. Cropping a portion of a file later will yield a smaller file. Vignette, not lens vignetting, is the term I use to describe a small scene or simple uncluttered subject I capture in-tight that is perfect for inserts or insets in stories. If you study travel magazines like I do, you are familiar with a simple vase, architectural detail, wall pattern, single flower, or even one person sitting at a sidewalk café table or a crop shot of a colorful fruit stand. I call them vignettes (Figure 8.21). The vignette shot is closely cropped in-camera by you or afterward by production people and inset at a paragraph indentation or somewhere on the page for useful filler or added value. When you are shooting vignettes, this is a perfect time to work on filling the frame and use macro and zoom techniques. If you happen to practice this work in shaded areas during mid-day hours when the sun is high, experiment with white balance settings and lens filters.

5. Capture local color. This includes getting people shots. I like to check local listings for events like parades, cultural and Renaissance festivals, or holiday activities. I also make the most of what may be considered "re-enactments" of yesteryear. Sometimes this means having to take what you can get in bright sunshine, as shown in Figures 8.22 and 8.23. I had no choice, nor could I pull out any reflective or flash accessories to work with the light, a move that would have broken my continuity and rapport I had just built.

While traveling abroad in South Africa, I visited a Zulu enactment village, called a cultural village or kraal. After asking permission to photograph the young people who were working there and getting them to sign model releases, I made a lot of eye contact and engaged them with my smile. I did not know the language. After they all relaxed a bit, I began to get in tight without being too obtrusive and take my shots. The young people in these photos are performers who are

Figure 8.21 In the mid-day hours when the sun is high and surfaces abound with dramatic shadows, capture small and large vignettes of local or universal interest, all cropped in camera (a) a still life of a sidewalk sale table in front of a bookstore; (b) architectural detail on the Bug Light(house) in Portland, Maine; (c) view of levers and gauges on a rusty antique fire truck; (d) shadows and pipes on an old abandoned truck; and (e) two crewpersons aboard The Black Dog schooner. Images © Yvonne J. Butler.

Continued

Figure 8.21 Cont'd (f) and (g) shadows on textured walls and doors; and (h) and (i) close ups of hosta leaves and stems. Images © Yvonne J. Butler.

accustomed to photographers taking pictures of them during performances only. This image of young Zulu women (Figure 8.22) relaxing outside of the staging area has elements of interest and certainly portrays the "local color." The second image (Figure 8.23) has a uniquely colored sky, and overall tone resulting from use of a Tiffen® Sepia Two Filter. If you find the sepia tone too dark or not to your liking, check out photography books on Zulu tribes; you will find the tribes are often portrayed in sepia 1 and 2 tones.

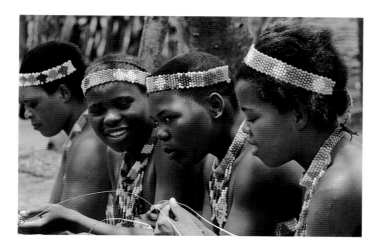

Figure 8.22 Young Zulu women taking a break from their work. Image © Yvonne J. Butler.

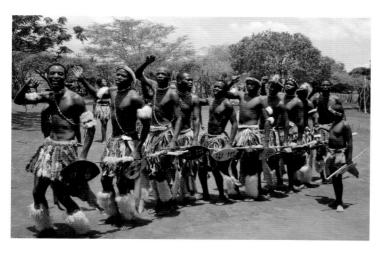

Figure 8.23 Young Zulu men practicing their dances in mid-day sun. I used a Tiffen® Sepia Two Filter over a UV filter over a Canon EF 70–200mm f/2.8L IS USM on a 10D handheld. Image © Yvonne J. Butler.

6. Find local attractions, amenities, and places of interest. Restaurants, hotels, B&Bs and inns, gardens, parks, colorful modes of transportation, and local architecture are all great images for the story you are conveying. Find a way to present these "regulation" shots from a new vantage point or perspective.

7. Find a special feature of a nearby town or village for the part of the story that suggests other places to visit. Also show tourism in action. My travels to South Africa were allegedly dedicated to finding and photographing wild game and architectural shots of a resort for brochure and Web pages. On a day off I ventured to Sodwana Bay on the Indian Ocean and had a "field day" of travel photo opportunities. SCUBA diving is popular on this bay and activity is high, as seen in Figure 8.24. To show you a sample scene of a nearby town shot, I captured what I hope is the essence of Truro's harbor late in the day, as seen in Figure 8.25.

8. Don't forget the indigenous flowers, plants, animals, and birds of your locale. This giraffe (Figure 8.26) is one of my favorite South Africa safari images. Just about everyone loves special animals shown in their natural environment.

9. Back up all your images as soon as you return to your hotel or home, even what you may deem lousy at the time. Select the "keepers" and move them to a folder for processing. I prefer to save all original images in case I am too critical at the time of capture about a shot's merit or potential use. After processing and renaming the keepers in a special folder labeled by date with a file prefix by location (during file transfer or download using my camera's software I might use something like Toronto and then each subsequent file is named sequentially as Torontoxxxx that tells me where and when the shoot took place), begin to organize them in some sort of order or what we often call a storyboard to which you may attach lively text and formulaic paragraphs on where to stay, eat, get a great ice cream

Figure 8.24 SCUBA workers at Sodwana Bay, South Africa. Image © Yvonne J. Butler.

Figure 8.25 Truro harbor boats in an adjacent town near my Cape Cod home. Image © Yvonne J. Butler.

Figure 8.26 Don't forget the animal shots, particularly these shown in their natural habitat. Image © Yvonne J. Butler.

sundae, and more. Of course you can rename the folders, assign keywords for searches, and more depending on your image editing (such as Photoshop) and/or digital asset management (such as Extensis Portfolio) software. Your story should begin to unfold before your eyes, and you are well on your way toward landing a publishing contract.

If you are not a writer, consider sending sample images to an editor "on spec" based on its posted editorial schedule of topics. Editors are often in a bind when they need a particular shot of a special location that was not taken by the assigned photographer. In other instances, you just might get the attention of staff and get asked to submit your work for further consideration or even try out an assignment. They can only say yes (or if they say no, try, try, try again). Good luck!

Chapter 9

Digital Infrared Photography

Eric Cheng

Near-infrared radiation consists of the wavelengths of light just beyond visible red light (wavelengths greater than around 780 nm). A useful way to think about near-infrared light is to think of it as the color of the rainbow next to red that is invisible to the human eye. An important distinction is that near-infrared radiation is not the same as thermal radiation, or what we normally think of as heat. Although thermal imaging techniques do exist, the equipment necessary is highly specialized and is not covered in this book.

Near-infrared images have distinct properties that give them an exotic antique look. Healthy green foliage becomes a brilliant white juxtaposed against stark black skies, and human skin becomes pale and ghostly. Resulting images, such as the one in Figure 9.1, look so foreign that photographs of common things take on a different light and warrant closer inspection.

The near-infrared spectrum was discovered in 1800, but its application as a commonplace photographic technique was not perfected until the 1930s. Imaging techniques remained confined to film until charged-coupled devices

Figure 9.1 An alien lettuce field (Nikon Coolpix 950, Kodak Wratten no. 87 gelatin filter). Image © Eric Cheng.

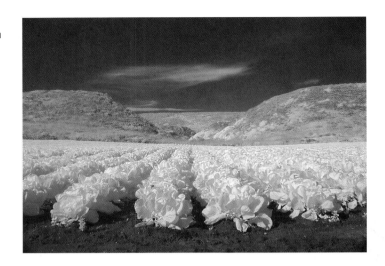

(CCDs) were used by Bell Labs for digital imaging in 1970. CCDs and similar sensors are nearly as sensitive to near-infrared light as they are to visible light. Because of this, CCDs are commonly used in night-vision imaging equipment (e.g., surveillance cameras and starlight scopes).

Digital cameras available on the consumer market use CCDs and similar sensors and are able to capture infrared images. However, because consumer cameras were designed to capture visible light, all models have internal filters that double as an anti-aliasing layer and infrared-blocking filter (also known as a "hot-mirror" filter). Although virtually every digital camera on the market is sensitive to infrared light, experimentation is necessary to determine whether your camera can produce usable images.

Cameras and Accessories

The necessary equipment is as follows:

- A digital camera sensitive to infrared light;
- A visible-light blocking filter;
- A means to attach the filter to your camera;
- A tripod;
- An image-editing program like Adobe Photoshop.

A quick way to test whether a digital camera is sensitive to near-infrared light is to point a common infrared remote control (e.g., the remote control for your television) directly at the camera's lens. Push a button on the remote control, and you should see it flash in the camera's live preview area. If there is no live preview area on the camera, your only hope is to capture the beam by taking a picture of your remote control while depressing one of its buttons. If the end of your remote control isn't lit up in the captured image, the camera probably isn't suited for infrared use out of the box. Removing the camera's hot-mirror filter is a possible solution, but to do this you must disassemble it, which will certainly void the camera's warranty (more on camera modifications below).

As digital cameras have evolved, their hot-mirror filters have become more and more effective. Early 2-megapixel cameras are significantly more sensitive to infrared light than are 3-megapixel cameras, and consumer digital cameras on the market today have become even more effective at filtering it out. Having said that, capturing an infrared image with more recent cameras is still possible and usually only involves selecting a suitable visible-light filter.

A variety of filters, as seen in Table 9.1, are available on the market, effective to varying degrees in blocking out both visible and near-infrared light.

The most common filter used with today's consumer cameras is the Wratten no. 89B filter, which blocks out enough visible light to produce the typical infrared "look" while letting in enough light for a usable exposure. Exposure times with the no. 89B filter attached to a newer digital camera can be between 2 and 4 seconds in full sunlight. Filters that let in more visible light than the no. 89B does (e.g., the no. 70 or no. 29 filter) are hard to use because cameras are so much more sensitive to visible light than they are to infrared.

For cameras more sensitive to infrared light, a Wratten no. 87 filter is preferable. The no. 87 filter effectively blocks out all visible light while letting in plenty of infrared. Most modern digital cameras cannot effectively use the no. 87

Table 9.1: A selection of visible-light filters

Wratten	Schott	B+W	Heliopan	Hoya*	Tiffen	0%	50%	Remarks
#25	OG590	090		25A		580 nm	600 nm	Really a deep-red filter
#29	RG630	091				600 nm	620 nm	Dark red
#70	RG665					640 nm	680 nm	Very dark red
#89B	RG695	092		R72		680 nm	720 nm	Almost "black," but not quite
#88A			5715			720 nm	750 nm	
#87	RG780		5780	R80	T187	740 nm	795 nm	Cuts off all visible light
#87C	RG830	093	5830	R85		790 nm	850 nm	Usually called "black"
#87B	RG850		5850			820 nm	930 nm	
#87A	RG1000	094	5100	RM90		880 nm	1050 nm	Blocks even some of infrared

*equivalent Wratten numbers listed on Hoya filters are not accurate

filter because their hot-mirror filters are so effective, but a camera like the 2-megapixel Nikon Coolpix 950 used with the no. 87 can still achieve shutter speeds of up to 1/15 seconds in full sunlight. Modified cameras can use the no. 87 filter very effectively.

Obviously, you must also have some way of attaching a filter to your camera. Many cameras without threaded lens barrels have accessories available for purchase that allow the attachment of threaded filters. If your camera has filter threading with a smaller diameter than the filter's diameter, you will need to purchase a step-up ring.

Filters are available as polyester or gelatin sheets and as circular threaded glass filters. Polyester and gelatin sheets are less costly but normally require a compatible filter holder. However, if you use an external wide-angle adapter with your camera, a convenient way to block out visible light is to place a gelatin filter cut down to size between your camera's lens and the adapter.

Visible-light blocking filters can easily be found on-line or at larger photography stores. If you do not want to purchase a filter, you may make one by developing a roll of

Figure 9.2 Nikon Coolpix 950 with Kodak Wratten no. 87 gelatin filter in a filter holder.

unexposed E6 color slide film. One or two layers of the exposed film can be used to filter out visible light.

Camera Modifications

Hot-mirror filters in some digital cameras can be removed (typically by an after-market company), producing a camera that is very sensitive to near infrared light. Although you should expect shutter speeds between 1/15 and 30 seconds with an unmodified camera, a modified camera will typically yield shutter speeds of 1/125 seconds or faster!

There are a few problems associated with hot-mirror removal:

1. Your camera will no longer be able to capture normal-looking visible-light images without the use of an external hot-mirror filter (because you have removed the one inside the camera).
2. Hot-mirror filters in digital cameras double as anti-aliasing filters, which "smooth out" the captured image. If you remove the anti-aliasing filter from your camera, images may not look as smooth.

3. For optimal images, the hot-mirror filter needs to be replaced with glass of similar quality (e.g., size, refractive index, pass band).

Note that disassembling your camera will absolutely void the warranty. We do not take responsibility for damage done to your camera if you take yours apart.

Capturing Near-Infrared Images

In theory, all you have to do to capture infrared images with a digital camera is to place a visible-light filter in front of your lens. In practice, getting a usable image out of the camera isn't always so straightforward. Because of the effectiveness of hot-mirror filters, shutter speeds while shooting in infrared will be on the long side, necessitating the use of a tripod.

After you have obtained a suitable filter and attached it to your camera, turn off the flash and take a photograph while outside in broad daylight, letting the camera decide what exposure to use. After snapping the shutter, an image with the signature infrared "look" should appear in your camera's review screen. Digital infrared photography has an important

Figure 9.3 Ginkgo leaves against the sky (Nikon Coolpix 950, Kodak Wratten no. 87 gelatin filter). Image © Eric Cheng.

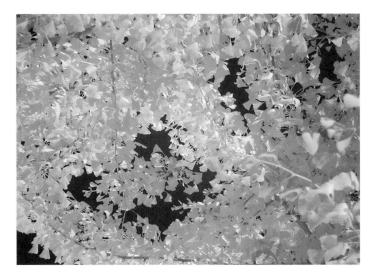

advantage over film: cameras with preview screens can actually be used for a live infrared view of the world!

Post-Processing

Near-infrared images straight out of the camera do not always look good and usually are not as dramatic as film-captured shots. Luckily, captured images can easily be corrected and improved in post-processing.

Scenarios

Take a look at your raw infrared image. If your image is

- Blurry, you need to shoot with a faster shutter speed and/or with a tripod. Typical exposure values may be between 2 and 8 seconds in broad daylight, so a tripod is absolutely essential.
- Too dark, you need to increase your exposure by shooting with a wider aperture or a slower shutter speed. You can also increase your camera's ISO setting. If you have hit the limits of your camera's exposure settings, you may want to consider trying a filter that lets in a bit more light (in the visible-light direction of the spectrum). However, if you are already using a no. 89B filter and your images are still too dark, your camera may not be suitable for infrared photography.
- Cast with strange colors (usually red, purple, or green), you will probably find the image more pleasing after converting it to a black and white or sepia-toned image. You can convert the image to black and white in Adobe Photoshop by desaturating the image or by using the channel mixer with the "monochrome" box checked (see Chapter 13). Sensor response to infrared light is unpredictable and changes significantly between camera models, so there is no way to predict what a false-color infrared image will look like from a given camera. Shooting raw images and fixing colors in post-production is the best solution because shooting in raw mode

Continued

Continued

maximizes the amount of information captured. You can also white balance with a white or gray card or, if your camera supports it, shoot in black and white or sepia mode.

- Very noisy, make sure you are shooting at a low ISO setting, and if your camera has a noise-reduction feature, turn it on. High ISO and long exposures can both produce a lot of noise, and sometimes there isn't much that can be done to clean up the images in-camera. If resulting noise levels are unacceptable for your tastes, try using third-party noise-reduction software.
- Severely washed out, the filter may be of low quality or a bad match for your camera. Try using a higher quality filter or one that lets in more light.
- Showing a hot spot, you may be suffering from internal lens reflections, or your lens may contain some sort of anti-infrared coating. If the problem stems from internal reflections, a possible solution is to move the filter closer to your camera's lens.

Equalization

After removing unpleasant color casts from your image by using one of the techniques described above, equalize the image by stretching out the level's histogram or by using the "Auto Levels" command in Adobe Photoshop. This will make blacks blacker and whites whiter, resulting in a more dramatic image.

Focus Shift

Depending on what filter you use, your camera might back focus a bit because light waves of differing wavelengths behave differently when passing through a lens. Plenty more about how to adjust focus when shooting in infrared can be found on the Web (do a Web search for "focusing with infrared"). As a general rule, if your images are not sharp after using your camera in autofocus, focus a little

bit closer. If you cannot manually focus, use a smaller aperture for a greater depth of field. Different lenses combined with different filters will behave differently, so experimentation is necessary to yield optimal results.

Small Apertures

When light passes through very small holes, the waves diffract, or spread out, according to wavelength. Diffraction is much worse with infrared light than it is with visible light, so stopping down to very small apertures can yield soft images. As a general rule, try not to stop down to minimum aperture when shooting infrared images.

Light Leaks

It is very important to ensure that no visible light is leaked into the sensor area of the camera during exposure. Because consumer digital cameras are so much more sensitive to visible light than they are to infrared light, even very slight light leakage can prevent the capture of usable infrared images. Filter attachment assemblies should be sealed from outside light. If you are using an SLR, be sure that the eyepiece is covered during exposure.

Halo

Anyone who has seen film-based infrared photography is no doubt familiar with the trademark "halo" effect. Although the visible halo is actually an anomaly of Kodak's HIE film and not something specific to the infrared spectrum, reproducing it in digital images can evoke a nostalgia that makes infrared images more effective. Fred Miranda's Digital Soft Focus Action (http://www.fredmiranda.com/SF/) is a great Adobe Photoshop Action that approximates the infrared halo effect in post-processing.

Digital False Color

Digital false-color infrared is best defined as the color image a camera produces when exposing in infrared. Because every digital camera model behaves differently

when capturing infrared light, each model will have a unique false-color signature.

Traditional color infrared film yields a false-color image by mapping infrared light onto the red channel, green light onto the blue channel, and red light onto the green channel. The false-color film look can easily be approximated in software post-processing, but you will need both infrared and color images of your chosen subject. Use a tripod, so the framing is exactly the same.

Steps to approximate color infrared film with a digital camera:

1. Take two photos of the same subject: one in infrared and one in visible light.
2. Open both images in Adobe Photoshop.
3. In the visible light image, click on the Green channel in the Channels window, Select All, and Copy.
4. Click on the Blue channel and Paste. This replaces the Blue channel with Green channel information.
5. Click on the Red channel in the Channels window, Select All, and Copy.
6. Click on the Green channel and Paste. This replaces the Green channel with Red channel information.
7. In the infrared photo, convert the image to grayscale (Image > Mode > Grayscale).
8. Select All and Copy.
9. In the visible-light image, click on the Red channel in the Channels window and Paste. This will replace the Red channel with information from the infrared photo.
10. The resulting picture in your visible-light image now approximates what you would have captured with color infrared film!

Figure 9.4 Visible light (color). Image © Eric Cheng.

Figure 9.5 Visible light (black and white). Image © Eric Cheng.

Figure 9.6 Infrared. Image © Eric Cheng.

Figure 9.7 False-color infrared; film approximation in post-processing. Image © Eric Cheng.

Interesting Subjects

The most obvious subject that infrared shooters gravitate toward is healthy green foliage, which reproduces as brilliant white and contrasts well with the pitch-like blackness of an infrared sky or body of water. Incandescent light sources (e.g., lightbulbs, glowing coals, fire) also emit copious amounts of infrared radiation and begin to glow in the near-infrared spectrum even before visible light is radiated. In theory, it is possible to capture

the infrared signature of an electric heating coil before it starts to glow red.

Humans also make interesting infrared subjects. Complexions clear, skin becomes ghostly and pale, and dark eyes take on a new light. Photographers have for a long time been shooting wedding portraits in infrared for its effects on people.

Closing Words

Digital cameras have provided for the very first time a way to capture high resolution near-infrared images without the hassle of film-based techniques. As with normal digital photography, one of the primary advantages of capturing images digitally is that we are free to experiment to our heart's content. The feedback loop is so tight that we are literally learning between each shot we take.

Figure 9.8 An infrared portrait of Eric Cheng and a friend. Image © Eric Cheng.

Useful Links
More information about digital infrared photography:
http://echeng.com/photo/infrared/

Filter adapters and step-up rings specific to digital cameras can be purchased from CKC Power: http://ckcpower.com/

For information on removing the hot-mirror filter from your camera, see James Wooten's article:
http://www.echeng.com/photo/infrared/wooten/
Gary Traveis (garytraveis@yahoo.com) and IRDigital (http://irdigital.net/) both offer digital camera modification services.

Part 3
ADVANCED DIGITAL DARKROOM

Chapter 10

Advanced Color Correction: The 90% Method

Eddie Tapp

The Big Three

Today's standard in digital image processing has some major advantages in comparison with the days of shooting film. The new digital standard brings with it the opportunity to adopt and maintain a consistent workflow that produces predictable results time after time. For advanced digital photographers, the three areas that are critical to establishing this level of consistency are setting a correct white balance in the camera, creating a good exposure, and establishing matrix settings.

Proper exposure, proper white balancing, and matrix settings will ensure great color, tone, and ability to maintain high pixel quality that, in turn, will yield excellent results and eliminate the need to use what I call the 90% Method of color correction. But the truth is we are human, and invariably we will make mistakes in one or all of these areas. When we do, the 90% Method is the best method I know to remove a color cast from any image as long as we have a white zone and a black zone to source

All images, graphics © Eddie Tapp
Model: Scott Culberson

from. As a matter of fact, this method will work 100% of the time as long as we do have these two reference zones. Naturally, not all images will have these zones, but from years of experience I've found that at least 90% of the images that need to use this technique will indeed have these zones.

First, properly set the white balance in your digital camera. This is done by setting a specific color temperature (use presets, i.e., flash, daylight, tungsten, etc. or dial-ins for color temperature in Kelvin, i.e., 5000 K, 6500 K, etc.) (see Sidebar in Chapter 16, p. 362 for explanation of Kelvin) or creating a "custom white balance." For custom white balance, shoot a gray card (or even a white card reference) and, using the menu on the back of the digital camera, create a white balance that tells the camera the exact color temperature of the light in which you're actually shooting.

Second, make sure you create a good exposure. A digital chip actually has the ability to record a fantastic amount of information on color and tone. However, all in all, we're just going to send this image to a printer that has a smaller color gamut, and to successfully obtain "predictable results" our exposure needs to be right on for the process to have enough data to withstand the digital process itself. Under- or overexposed digital files have a loss of data, and even though we can create images from them, they may be weak in the shadows or highlights, giving way to grainy or pixelized images and/or have limited color spectrums.

The third area is using something on the order of saving various color matrix or custom function settings for the digital camera that you may refer to in certain scenarios. In the camera's menu area, some cameras give you the ability to establish the color space (i.e., sRGB or Adobe RGB) along with a saturation setting and a contrast setting. Establishing this matrix gives the ability to obtain different looks, such as a portrait look or a product look, or perhaps a matrix setting for landscapes. All this is kind of like having the ability to select a different film for various looks, and once we learn the characteristics of

these settings we can select the one that gives us the best results for the type of look we want.

Finally, these settings are most important when shooting in the JPEG or TIFF modes, and I would encourage you to become comfortable with these three areas. Setting the file quality to shoot raw format will give you the ability to change the color balance (white balancing) and tone control (exposure), 8-bit or 16-bit data (pixel depth), along with a matrix look when processing images through a raw file conversion software, such as Adobe Camera Raw in Photoshop CS, or your camera's software, such as Canon's Digital Photo Professional.

The Truth

Processing images on the computer has brought us the responsibility to learn a new way to control color and tone from previous methods of cc filters, densitometer readings, and Polaroids. The ever-progressive evolution of digital imaging and the methods we use to control color and tone will continue to grow and change as time goes by—and become easier too.

For the untrained eye and even the experienced, when an image is opened in Photoshop and appears on the screen, our eyes adjust, adapt, and usually accept the tone and color to a given point. Sometimes a color cast is resident in a file and we don't notice the cast because we have accepted it. Experience teaches us how to look at the color on our monitors and displays. Most will go to Image > Adjustments and select "Brightness & Contrast" and "Color Balance" to improve the color and tone. Although this may be considered an effective way to make corrections visually, it is perhaps the least desired method we may use. What we are seeing on the monitor could be a false impression of color/tone on the image and perhaps have a weak histogram. There are many methods of color correction, but the best possible method to remove a color cast is by the numbers. The 90% Method is just that. The truth is in the pixel.

The Method

To maintain the highest pixel integrity in a weak image, we need to carefully select pure zones (white and black) that are resident in an image, match the numeric data, and then create subjective enhancements from that point.

Processing an image on the computer is an event in which pixel information is thrown away! Okay, so just what does that mean? Let's take a look at what kind of information is there.

Pixel Depth

Look at an RGB image on the monitor. A 24-bit color image consists of 8-bit red, 8-bit green, and 8-bit blue information. Each 8-bit channel has the ability to hold 256 values of tone from black to white and grays in between. The 256 values of red × 256 values of green × 256 values of blue = 16.7 million colors. Whenever we move a slider, such as in brightness and contrast, we are in effect taking the lump sum of tonal values and shifting them one way or the other, resulting in pixel information clipping right off the chart.

The bit depth chart is as follows:

1 bit = 2 tones (white and black)
2 bit = 4 tones
4 bit = 16 tones
8 bit = 256 tones
12 bit = 4096 tones
16 bit = 65,536 tones

Acquiring an image with a 24-bit device does not mean that we get a true 8 bits per channel amount of information. As a matter of fact, once acquired with a 24-bit scanner, for example, the actual bit depth will be closer to 5 or 6 bits of information to disseminate. It is important to use a scanner or camera that allows high bit, 30-bit, 36-bit, or even 48-bit, information. This level of information will allow us to eventually convert the image to the 24-bit mode. Then we have more of a full range of tone in the 8 bits per channel, 24-bit image. Photoshop CS has enhanced 16-bit capabilities, allowing control of images

Figure 10.1 Three-dimensional concept of an 8-bit pixel.

8 bit

12 bit

16 bit

Figure 10.2 Three-dimensional concept of 8-, 12-, and 16-bit pixels.

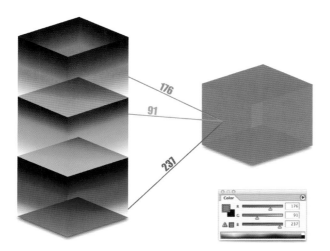

Figure 10.3 Three-dimensional concept of RGB 8-bit pixel data. To obtain the color (on the right), it will require 176 red, 91 green, and 237 blue.

that have 12- and 14-bit digital camera information in a variety of functions, such as Curves and Levels.

Color Information

Color and tonal correction is a two-step process. First, we neutralize the color (remove a color cast, i.e., 90% Method) and then we create subjective enhancements.

Figure 10.4 Macbeth Color Checker shot for white and black zone reference.

Subjective enhancements are where we tweak the color and tone using various commands or techniques if the image needs additional treatment.

In Photoshop, you should become familiar with the "INFO" window and "Color Sampler Tool," a partner to the eyedropper tool, and how they work. The INFO window is like a densitometer and shows us vital information regarding the color and tone of the image. Whenever your cursor is placed over a pixel in an active image, by default the INFO window shows the value of each color in RGB along with the CMYK conversion value percentage. Remember that we have 256 values of tone in

Figure 10.5 INFO window with RGB and CMYK readings.

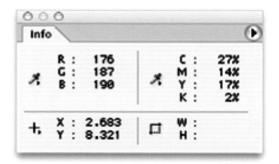

each color channel of an RGB image as we read these numbers, regardless if the image is in 8-bit or 16-bit mode.

Note: I often change my CMYK readings to grayscale to read printable values from 0% to 100%.

Figure 10.6 Color Sampler Tool icon.

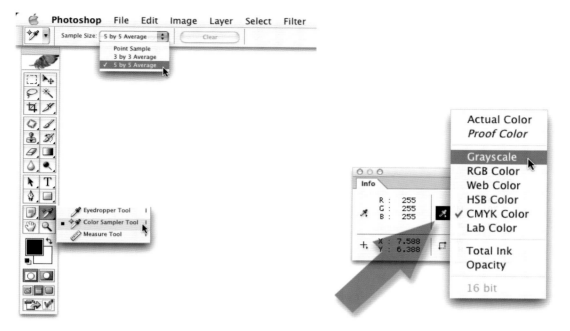

Figure 10.7 Select Color Sampler Tool and establish 5 × 5 average sample size.

Figure 10.8 Select Eyedropper icon in INFO window to change readings.

When you use the Color Sampler Tool several things happen all at once. First, the tool creates a target zone on your image where you click the mouse. If your INFO window isn't open, it will open it for you right away, and most importantly, it locks the numeric values of the RGB data in the INFO window as it expands the INFO window (up to four readable zones).

Figure 10.9 INFO window with Color Sampler Tool readings.

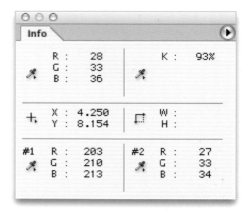

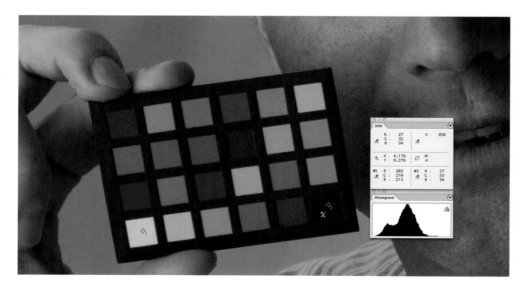

Figure 10.10 Color Sampler Tool targets on white and black zones.

Levels in RGB

As an option, it is possible to convert your image from an
8- to 16-bit image to create color and tonal corrections.
Photoshop CS is very 16-bit savvy and will yield smoother
transitions and a healthier histogram in some cases. To do
this go to Image > Mode and select the 16-Bits/Channel
option.

Figure 10.11 Converting image to the
16-bit mode.

In Photoshop, under Image > Adjustments, you'll find
Levels and Curves. Using Levels or Curves give us the
opportunity to control the color and tone along with
controlling what information gets thrown away, rather than
clipping with no control (such as when using
Brightness/Contrast). We'll use Levels for the 90% Method.
Before you open the Levels command window, make sure
your INFO window is showing on the right (palette) side of
the monitor. You cannot move this window around while
you are in the Levels command window.

You should also become familiar with the Levels
window. The first thing we see is a histogram. The
histogram shows us where tone resides in the image. Think

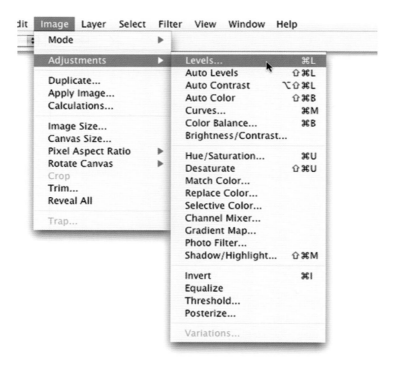

Figure 10.12 Menu directory to Levels.

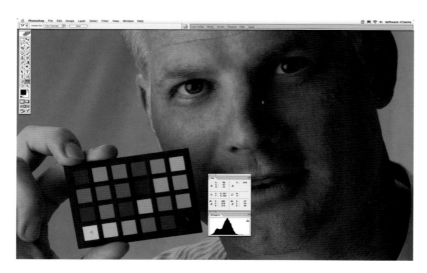

Figure 10.13 Position INFO window to make room for Levels window.

of the histogram as a sonar reading of the exposure of the image. At a glance, we can see whether the image is a high key, low key, or under- or overexposed. The mountain peaks tell us which tone is mostly represented in a given zone value between 0 and 255. Along the bottom of the Input Level are three sliders: the one on the left is the shadow slider representing the value 0, the highlight slider on the right represents the value of 255, and the gamma or mid-tone slider in the middle starts at a value of 127. The three windows (0, 1.00, 255) indicate the amount of change when we move one of these sliders, but we won't be using these windows when matching the numbers. The output sliders at the bottom allow us to minimize or maximize values, but we will not use the output level in this exercise. Also off limits for now are the three eyedroppers and Auto button in the Levels window. Above the Input Level we can access individual RGB channels by clicking on CHANNEL RGB and then onto the Red, Green, or Blue channel. You'll also notice the keyboard shortcut to access the individual channels is command 1, command 2, command 3, and command ~ (control on the PC).

While you are in Levels and your cursor is over the image, the cursor automatically turns into the eyedropper tool. When you click the mouse, the pixel information is transferred to the color window (you'll see this if you have your Color window open), giving you yet another area to read the numeric data. By holding down the Control key (Alt on the PC) and clicking the eyedropper tool, you can establish the eyedropper to a 3×3 or 5×5 pixel reading rather than point sample, which only gives information on a single pixel (use 3×3 or 5×5). You can also establish this option once you've selected the Color Sampler Tool in the Option bar at the top of the screen.

To neutralize an image, we make sure the white point (zone) and black point (zone) have no color cast. This is easy to detect in RGB because a neutral color will show the exact same number in the INFO window, that is, 200 Red, 200 Green, 200 Blue = a neutral gray color; 0-0-0 = black with no detail; 255-255-255 = white with no detail.

Our objective is to neutralize a white zone (where we want detail) and a black zone (where we also want detail). To do this, we must first select a white zone and a black zone using the Color Sampler Tool so the numbers are locked in the INFO window. You can do this before accessing the Levels window (Figure 10.14). However, if you are already in Levels, you can hold down the Shift key and your cursor will turn into the Color Sampler Tool, allowing you to select your zones while you're in the Levels window.

While reading the white zone our attention is focused on the INFO window as we're looking at the RGB values change when the cursor is moved. Our objective is to find the lightest value in the white zone without going over a value of say 242* and then Shift click the mouse to lock the numbers in the INFO window (this is if we have not previously locked the numbers before going to the Levels window). Let's say we found a white zone and the reading was 203 Red, 210 Green, and 213 Blue. Our highest value is 213 Blue. We simply need to bring the Red and Green values to match 213. To do this go to the CHANNEL Red, move the Red channel highlight slider over until the number in the locked INFO window (right column) reads 213, and then go to the CHANNEL Green and move the Green channel highlight slider over until the number in the locked INFO window reads 213. Now that we have neutralized the white zone, we need to neutralize the black point.

This time we'll be looking for the lowest current value.[†] Find your black zone, and while your cursor is over this area, again look at the INFO window. When you find your lowest value in the black zone, Shift click the mouse to lock the numbers in the INFO window (again, do this only if you have not previously locked your numbers in before

* With 256 values of tone, each 2.5 value represent 1%; hence, a 5% dot would require 242 values of tone. A shadow with 95% info would represent a value of 13.

[†]Current value: Once you've locked the numbers in the INFO window, you'll notice when you go to the Levels window there are now two columns. The left column represents the original values, whereas the right column represents the live numbers (I call this column Hot Numbers).

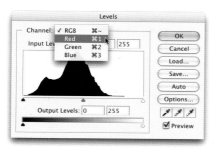

Figure 10.14 Select the Red channel.

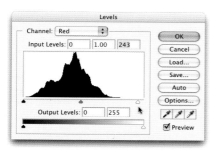

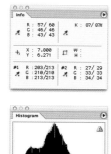

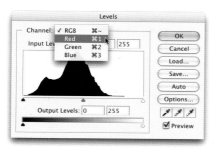

Figure 10.15 Move Red channel highlight slider into the histogram until the Red value reads 213.

Figure 10.16 Move Green channel highlight slider into the histogram until the Red value reads 213.

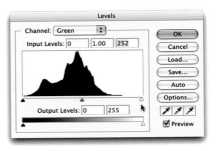

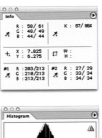

accessing the Levels window). Note that it doesn't matter which color has the lowest (or highest) value. Now go to the CHANNEL(s) with the higher values, but this time move the shadow slider into the histogram until the number in the INFO window matches the lowest current value. Then back to CHANNEL RGB, and you now have a neutral image.

At this point, go back to the RGB channel and adjust brightness, contrast, and tone using the input sliders. In this example, we simply want to adjust the highlight slider until it comes close to the edge of the flat-lined histogram (flat-lined histogram indicates the highlight region is underexposed).

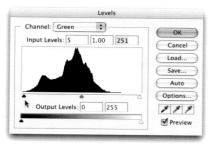

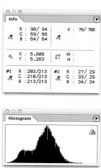

Figure 10.17 Move Green channel shadow slider into the histogram until the Red value reads 29 (the lowest current value).

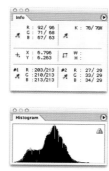

Figure 10.18 Move Blue channel highlight slider into the histogram until the Red value reads 29.

Figure 10.19 Select the RGB channel to control tone.

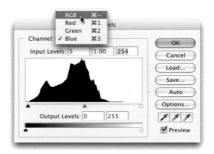

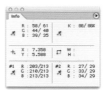

Figure 10.20 Move the highlight slider in to the edge of the histogram to open up the dark highlights. Note: The "K" reading shows 6% printable dot.

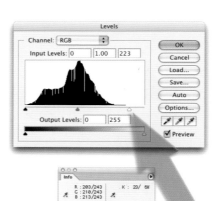

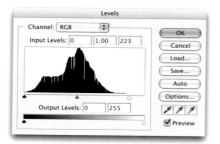

Figure 10.21 Move the highlight slider into the edge of the histogram to open up the dark highlights. Note: The "K" reading now shows 86% printable dot. Also, our highlight Color Sample Tool point reading is neutral at 243 R, G, and B, and our shadow sample point is 33 R, G, and B.

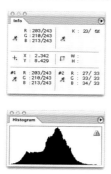

Figure 10.22 Save level adjustment to apply to other images.

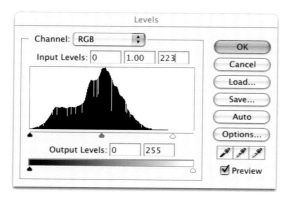

While you're still in the Levels window, select the Save button and save the settings if you need to apply these to other images shot at the same time.

90% Method

If this is your first time with this technique, click OK in the Levels window, and then Control/Command Z several times to see the before and after effect or simply check and

Figure 10.23 Image with the 90% Method applied from Levels.

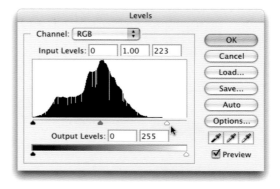

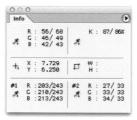

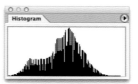

Figure 10.24 Control/Command, showing before the 90% correction.

uncheck the preview button while in the Levels window.
When reading your white zone, avoid specular highlights
such as light reflecting from glasses and windows, be sure
to read a white object, or, better yet, use a Macbeth Color
Checker in one of the images to set your white and black
zones.

In the Histogram window (only in Photoshop CS) you
will notice an exclamation warning. If you click on the
warning symbol it will update the histogram information
for you. The spiked histogram shows where pixel data has
either been thrown away or is weak. This is a normal
reaction when pixel data are removed to improve the tone
and color of an image and is also why it is a good idea to
use the 16-bit mode to make corrections.

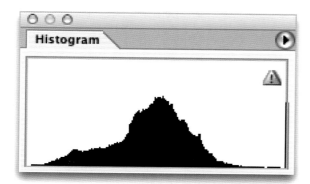

Figure 10.25 Histogram window showing exclamation warning.

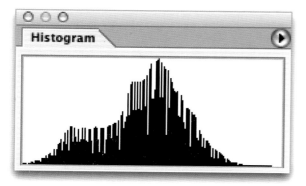

Figure 10.26 Histogram window showing new histogram after clicking on exclamation warning.

Next we're going to open up a new image shot at the same time, open Levels and load the saved adjustment, convert the image back to 8 bit, and then perform any subjective enhancements.

The second stage of color and tonal correction is our subjective enhancement of the image. Several methods are available for enhancing the color and tone of an image, including Color Balance, Hue/Saturation, Replace Color, Selective Color, Curves, Levels, and Variations. Whatever you use, make sure to read the values in the INFO window to see the effect of change. The more we learn about controlling the color and tone of our images, the better quality we'll produce.

Figure 10.27 New image shot at the same time.

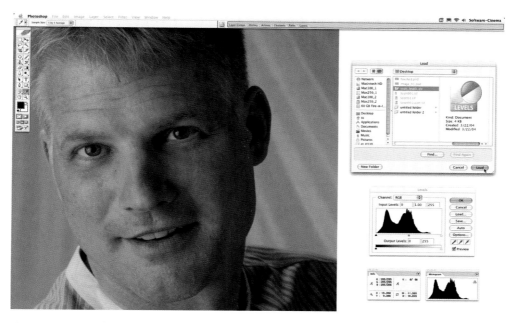

Figure 10.28 In the Levels window, all we have to do is LOAD the SAVED level adjustment from the previous image.

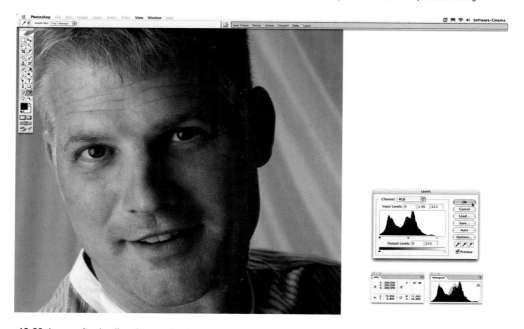

Figure 10.29 Image after loading the saved adjustment.

Figure 10.30 Convert image back to 8 bit..

Figure 10.31 New image with corrections.

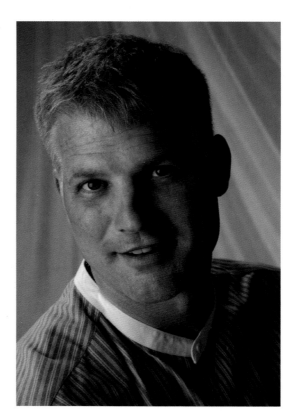

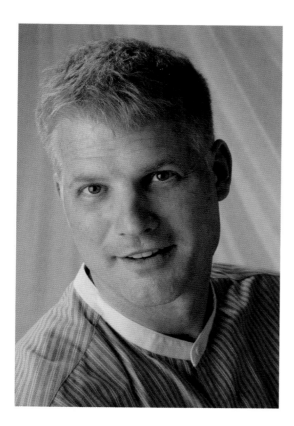

Figure 10.31 Cont'd

When working on a file that has weak data, knowing that we are going to make these data perhaps even weaker, the 90% Method works best. I refer to this as the 90% Method not because it works 90% of the time. The only time this method doesn't work is when there are no white or black zones to neutralize. This is when other methods listed above should be used. The 90% Method is always the best method to use to remove a color cast and maintain the highest level of pixel integrity that a given file has to offer.

Figure 10.32 Final image with Dream Glow and Layer Mask Lighting subjective enhancements. (Dream Glow and Layer Mask Lighting are techniques developed and taught by Eddie Tapp. PDF files can be downloaded from the E:Techniques page at www.eddietapp.com.)

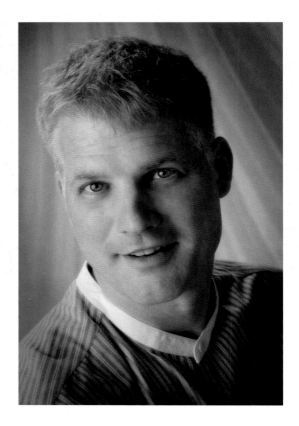

Chapter 11

Sharp Shots In-Camera and On-Computer

Rick Sammon

I n this chapter we discuss several options for sharpening pictures in your computer. Before we get to that, however, here's a review of what it takes to get a sharp shot in your camera.

I photographed this monk (Figure 11.1a) in Cambodia indoors in natural light. The picture looks soft, a common occurrence in most indoor natural light pictures as well as outdoor pictures taken on overcast days. I photographed the young woman (Figure 11.1b) in Vietnam using daylight fill-in flash. As you can see, the strong direct light created a much sharper picture. You'd also get a sharper shot on a sunny day than on an overcast day.

The quality of a lens can also affect the sharpness of a picture. I took the picture shown in Figure 11.2 in Bangkok with my Canon 100–400mm IS lens. It is super sharp, as this photograph illustrates.

The image stabilization (IS) feature, which greatly reduces camera shake, lets the user handhold the camera at relatively slow shutter speeds—much slower than would be possible with non-IS lenses. For example, at the 400mm setting on a non-IS lens, the slowest recommended handheld shutter speed is 1/400th of a second (actually

a b

Figure 11.1 (a) A monk shot in natural light and (b) a young woman shot in natural light using daylight fill-in flash. Images © Rick Sammon.

1/500th of a second because that is the next higher shutter speed on most cameras). That recommendation comes from the basic rule: to avoid camera shake and blur in pictures, don't use a shutter speed slower than the focal length of the lens.

Teleconverters can affect the sharpness of a picture. With some manufacturers, 2× teleconverters are not as sharp as 1.4× teleconverters. And, expensive teleconverters often produce sharper pictures (especially around the edges of the frame) than more affordable teleconverters. I took

Figure 11.2 The quality of a lens can also affect the sharpness of a picture. Image © Rick Sammon.

this picture of a jaguar (Figure 11.3) with a Canon 1.4× teleconverter on my Canon 100–200mm lens set to 200mm on my Canon EOS 1D digital SLR. Before adding the teleconverter, the effective focal length of the lens was already 130–260mm (due to the 1.3× image magnification caused by the digital image sensor being smaller than a 35mm film frame). Therefore, the 1.4× teleconverter changed the effective focal length of the lens to 182–364mm. The subject is very sharp in this picture for several reasons: I focused on the subject's eyes, used a high quality 100–200mm lens, and selected a teleconverter that produces an extremely sharp picture.

Figure 11.3 Teleconverters can affect the sharpness of a picture. Image © Rick Sammon.

Grain in film and noise in a digital image can affect how sharp a picture looks. The higher the ISO film speed or ISO digital setting, the more grain or digital noise appears in the pictures. The nighttime picture of the car (Figure 11.4a), taken in Cuba with the ISO set at 800, shows some grain. The daytime picture of the car (Figure 11.4b), taken in Cuba with the ISO set at 100, shows almost no grain.

Figure 11.4 Grain in film, and noise in a digital image, can affect how sharp a picture looks. Image © Rick Sammon.

a

b

Figure 11.4 Cont'd. Image © Rick Sammon.

The detail in a subject also affects how sharp a picture will look. This image of a man shown in Figure 11.5 was photographed in a temple in Vietnam. The image has lots of detail because the man's face and beard have good detail.

The quality of a filter can make the difference between a sharp and soft picture as well. Use a good (usually expensive) filter, and it will not affect picture sharpness. Buy a cheap filter, and your pictures may look soft. For this picture of a lighthouse in Maine (Figure 11.6), I used a very expensive polarizing filter on my lens to darken the sky. Polarizing filters remove certain light frequencies that pass through them. In doing so, they can (but not always) darken a blue sky and reduce reflections on water and glass and even reduce atmospheric haze.

Many digital cameras offer an in-camera sharpening option, found in the camera's menu, as illustrated in Figure 11.7 with a menu shot from the Canon Digital Rebel. Its boosting of the sharpness and contrast will make a picture look sharper, but I actually don't recommend in-camera sharpening. Why? Because if you oversharpen an image, especially one with a wide contrast range, you'll have a hard time—if not an impossible

Figure 11.5 The detail in a subject also affects how sharp a picture will look. Image © Rick Sammon.

233

time—getting the picture to look "normal" later in the digital darkroom.

Okay. Let's move on to the sharpening options we have in the digital darkroom. I use Photoshop CS and Photoshop Elements exclusively, but you can apply the same principles to other image-editing programs.

An easy way to sharpen a section of an image is to use the Sharpen Tool, found in Photoshop's tool bar, as shown in Figure 11.8. Simply click on the tool, select your brush size, and move the brush over the area you want sharpened. Be careful about the Strength setting, indicated by my red arrow. If you start sharpening at 100%, the

Figure 11.6 The quality of a filter can also make the difference between a sharp and soft picture. Image © Rick Sammon.

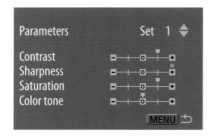

Figure 11.7 Many digital cameras offer an in-camera sharpening option, found in the camera's menu.

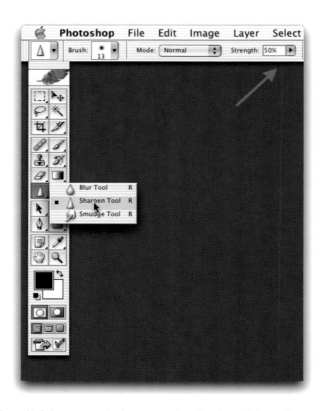

Figure 11.8 An easy way to sharpen a section of an image is to use the Sharpen tool, found in Photoshop's toolbar.

effect will be applied too rapidly and you'll quickly oversharpen an area. I usually start out at 50%.

For this picture of my friend Chandler, I wanted to sharpen only the eyes. In Figure 11.9a the eyes are not sharpened. In Figure 11.9b the eyes are sharpened. You'll need to look closely to see the difference, due to reproduction limitations in book publishing. But it's very evident in an inkjet print.

Under Photoshop Filters you have a choice of three sharpening techniques. It is okay to use Sharpen, Sharpen Edges, and Sharpen More (see Figure 11.10). However, you'll have much more control if you use Unsharp Mask (USM), as most of the pros do. Keep the Radius and Threshold relatively low, and use the Amount slider to achieve the desired degree of sharpness (Figure 11.11).

a
b

Figure 11.9 Image © Rick Sammon.

Figure 11.10

Figure 11.11 Original image © Rick Sammon.

For accurate control, view the image on your monitor at 100%. Of course, a high-definition monitor will help, too!

When using the USM, be careful not to oversharpen an image. If you do, you'll get a very noisy (grainy) image, as illustrated in these examples in Figure 11.12.

Let's take a look at an advanced sharpening technique using USM and Layers. Basically, we will be selectively sharpening part of an image—the reclining Buddha's toes in this case. In my original shot in Figure 11.13a you can see the toes are out of focus. To sharpen only the toes, I used this technique:

a b

Figure 11.12 Images © Rick Sammon.

As shown in Figure 11.13b, I made a duplicate layer. Then I turned off the top layer and activated the bottom layer. I applied the USM to the bottom layer. The amount of sharpening (469%) oversharpened most of the frame—except for the toes.

In Figure 11.13c, I went to the top layer (showing soft toes) and used the Eraser tool to erase the area over the toes, letting the sharp toes show through below. By turning off the bottom layer, I could see the area that I had erased.

Here is the final image in Figure 11.13d, now showing the entire scene in focus.

Figure 11.13 Images © Rick Sammon.

a

b

c

d

For this picture of a woman in Cambodia (Figure 11.14a), I used the same advanced layer/USM mask technique that I used for the reclining Buddha image. In this case (Figure 11.14b), I sharpen only the woman's face, leaving the background untouched.

Now let's take a look at a way-cool plug-in that makes sharpening a picture extremely easy. It's a plug-in from nik

a

b

Figure 11.14 Image © Rick Sammon.

multimedia called nik Sharpener Pro! Here's a shot (Figure 11.15a) I took of a butterfly in Florida. It's a bit soft. After you load a plug-in (Figure 11.15b) into Photoshop (or any plug-in compatible program), it appears at the bottom of the Filters menu (except Genuine Fractals, which we'll get to in a minute). Here's a look at some of the options that the nik Sharpener Pro! plug-in offers.

When you select the option you like, a window opens that gives you control over the sharpening effect (Figure 11.15c). Those controls include Image Width, Image Height, Image Source, Image Quality, Printer, Printer Quality, Eye Distance, and Personal Profile. After you have made your adjustments, click OK and the sharpening effect is applied.

My final image (Figure 11.15d) is sharpened with Sharpener Pro!.

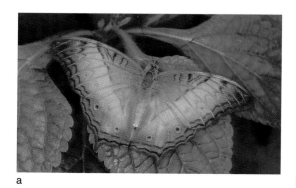

a

b

Figure 11.15 Original image © Rick Sammon.

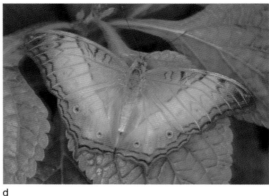

c

d

Figure 11.15 Cont'd

When it comes to inkjet prints, you can control the sharpness of a print in the printer's menu by setting the Print Quality to Fine (or Best or Highest) (Figure 11.16).

Technically, the following method is not about sharpening, but it will give you sharper enlargements from a file. Say you want to make a big print from a file but the ppi is not sufficient for a good quality print (usually 240 ppi) (Figure 11.17). Fear not; there's a plug-in called Genuine Fractals that can help. After you load Genuine Fractals into your computer, and when you go to Save As, GF PrintPro appears as an option (Figure 11.18).

When you select GF PrintPro, a window (Figure 11.19) opens and you need to select Lossless encoding for the best image quality. Click OK. Now your image will be saved as an .stn file.

When you open that file, you'll get a window (Figure 11.20) that shows the image size. The next step is to type in the new image size, shown by my red arrow (Figure 11.21).

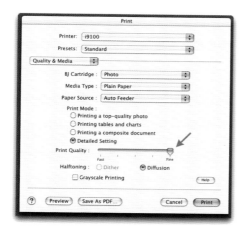

Figure 11.16 Control the sharpness of a print in the printer's menu by setting the Print Quality to Fine (or Best or Highest).

Figure 11.17 Image © Rick Sammon.

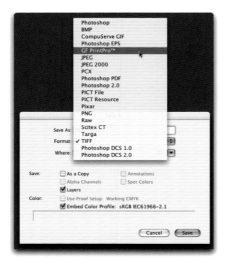

Figure 11.18

Figure 11.19

Figure 11.20 Original image © Rick Sammon.

Figure 11.21 Original image © Rick Sammon.

You need to experiment with size and image quality to get the results you want. For example, you can make a great 11 × 14-inch print from a 3 × 5-inch 27 ppi image.

Have fun sharpening. But please remember: it all starts with the image, so strive for the sharpest original picture possible in your camera.

Chapter 12

Photoshop: Using Advanced and Power Tools

Joe Farace

"The most important secret of working with digital images is to always, always work with a copy of the original file."—
One of Farace's Laws of the Computing Universe

Power tools are small bits of software and can be Photoshop-compatible plug-ins, Photoshop Actions, or selected graphics utilities that make a digital photographer's life a little easier for creating practical or special effects. Much like an electric screwdriver makes household projects go faster than using the old-fashioned hand tool, software power tools let you produce imaging projects quicker and with less fuss than doing it "the hard way."

Lights, Camera, Actions

One of the inescapable rules of digital imaging is that if you have to go through a set of steps *once*, you'll probably have to do it again in the future. Instead of having to keep track of what you are doing by making notes with a pen and paper, Photoshop's Actions palette enables users to record a sequence of editing steps as an "action" that can then be applied to another selection in the same image, another image file, or—in a batch-type operation—to hundreds of different files. Users can play an Action with steps disabled or display selected dialog boxes during playback to interactively adjust settings. The order in

Figure 12.1 Photoshop's Actions palette, shown here in Button mode, provides one-button control over any scriptable function.

which tasks are executed can be edited by dragging and dropping. Multiple actions are displayed in the Actions palette, and sets of actions can be saved and loaded separately. Actions can also be used to batch-acquire images from a digital camera, allowing an entire set of images to be automatically acquired, retouched, and saved. Action sequences can even be saved and shared with others.

All versions of Adobe Photoshop, including Creative Suite, bundle some packages of Actions. You may have to install them (more on that process later) before you can see all the actions that are available. Actions are stored in the Photoshop Preset folder. If you want to save and load them, click on the arrow in the Actions palette and use the "Save Actions" and "Load Actions" command, which will allow you to store your current set of actions in an external "myfile.ATN" file.

Figure 12.2 With Button mode disabled, you can see all the steps involved in the Vignette Action. Writing scripts isn't too hard. In fact, all you have to do is tell Photoshop to watch you work.

Figure 12.3 An image of a Japanese dancer was opened in Adobe Photoshop CS, and then the Actions palette was selected from the Windows menu. Original image © Joe Farace.

Taking Action

How does it work? Let me show you a real-world example. A client's specifications for delivery of digital images to them were as follows: "All files must be uncompressed TIFF files, CMYK, and 300 dpi." Here's how I created an Action for them.

Step 1: Open an original (JPEG) image file captured with a Canon digital Rebel and select Show Actions from the Window menu (Figure 12.3).

Step 2: To create a new action, you must take the Actions palette out of Button mode (the default). I did this by de-selecting Button mode from the palette's drop-down menu (Figure 12.4).

Step 3: To create a new Action, I chose New Action from the same menu. This produces a dialog box that lets you name the Action and assign a function key and even a color to the button that will be created (Figure 12.5). After I made my selection, I clicked the Record button to start the process.

Figure 12.4 To get out of Button mode, I clicked on the Action's palette and then de-selected Button mode.

Step 4: At this point, I went through the steps needed to create a file to my original specifications. I started by going to Image > Mode > CMYK Mode. Then, I went to the Image menu and changed the Image Size to 300 dpi. When this was finished, I saved the file as an Uncompressed TIFF file (Figure 12.6). Finally, I went back to the Action palette and selected Stop Recording. At that point, the Action was complete.

After the Action has been recorded, the next time I have an image to prepare for that client, all I have to do is click the Publisher button and all the steps of the Action will be complete.

Prerecorded Actions

Although you can create your own Actions or find any number of shareware ones, the best place I have found to start is the first commercially available set of actions. AutoCrop (www.autocrop.com) is a package of Photoshop Actions that bills itself as the "easy and affordable way to create wedding albums in minutes!" but will work for any photographer who needs to create composite images quickly. AutoCrop (see Figure 12.7) is different from any template program because you can do *everything* from within Adobe Photoshop. There's no new interface to learn and no need to switch back and forth from program to program to build wedding pages or composites. Included in the package are 168 photojournalistic magazine-style designs, and because of the interactive nature of the Actions, you have the ability to adjust and redesign each and every page design any way you like. Each page has four or more options (producing a total of 840 Actions in

Figure 12.5 The New Action dialog box lets you name it, assign a function key, and give a color to the new button. In this case the name "Client" was chosen as the name of the Action.

case you're counting) that let you change the colors, borders, and effects with one click.

All you have to do is select one of the page designs, choose your photographs, and sit back and watch as the AutoCrop grabs your selected photos, resizes them, and puts them in the appropriate place. Then simply save the page and bring it to your lab for printing or print it yourself. AutoCrop offers square, rectangular, and panoramic album formats. They include a detailed color illustrated manual on discs so you can get started right away, but I took advantage of their How-To QuickTime moves that are on the disc and was making pages in no time.

The Shadows Know

For many photographers it's really shadows that make or break a photograph, but sometimes the results may be a bit more shadowy than we might prefer. Lamont Cranston used mind control taught to him by monks in Lhasa, but nowadays we have Photoshop to control shadows and sometimes highlights too. Although all these tools featured can be used to almost completely eliminate shadows, giving the image a flat and boring look, I prefer to use them to open up detail that might otherwise be lost and sculpt shadows to create shape and dimension. Lots of prerecorded Actions, including Shadow Lifter, can be found on the Internet that enable you to tweak images with a single button click. You can do a Google search to find Shadow Lifter, but it's available in many places, including www.e-10.org/issues/index.

I originally shot the test photo (Figure 12.8a) for model Megan Textor's portfolio. She asked me to make a moody shot with lots of shadows. It was made with a Canon EOS D60 at the largest JPEG setting at ISO 400. Lens was the EF 28–105mm zoom lens at 55mm set at f7.1 at 1/25th of a second. Natural light was provided through a narrow window to the left with mini-blinds opened to minimize harsh light on the model. This is not the image she used

Figure 12.6 The final action includes Change Mode to CMYK. Change image size to 300 dpi and then save as a TIFF file.

Figure 12.7 AutoCrop is an amazing package of Photoshop Actions that's specifically designed to produce wedding album pages using a single mouse click, but that doesn't mean you can use it for model composites. Original image © Joe Farace.

for her "book" but one that's more underexposed and full of shadows than might be considered a "normal exposure." Part of the problem with evaluating these kinds of images on digital SLRs is that LCD screens are often brighter with more contrast than the files really are, and although I've tried adjusting the panel's brightness, it doesn't seem to help.

While running the Shadow Lifter Action, the Gaussian Blur Control Panel appears and you have to select a blur "radius" that will be used to determine the amount of blur.

Figure 12.8a This underexposed image that most of us would toss in the bit bucket serves as a perfect test file. All the plug-ins and actions were run on an Apple Macintosh G4 and the Mac OS X version of Adobe Photoshop CS. Image © Joe Farace.

In Photoshop it can vary from 0.1 (hardly any blur) to 250 (maximum blur). It works like many of these products do, although I'm sure some of the program's developers would want to argue about it, by creating a grayscale Shadow Mask and overlaying it on the image to soften and lighten the shadows. Experiment with amount of blur to see what works best to achieve the results you like.

In addition, I used Photoshop's Curves (Image > Adjustments > Curves) (Figure 12.8c) to lighten the overall image slightly to get the final results.

Figure 12.8b After installation, running the Shadow Lifter Action couldn't be easier; click the Shadow Lifter button and watch. Original image © Joe Farace.

Figure 12.8c Use Photoshop's Curves to lighten the overall image. Image © Joe Farace.

Plug Me In

To me, one of Photoshop's most useful features is that it was designed with an open architecture. This open-ended design allows Photoshop to accommodate small software applications called *plug-ins* that extend the features. The use of plug-ins lets computer users increase the functionality of their off-the-shelf graphics programs and allows digital imagers to customize their software to match whatever kind of projects they may be working on.

Don't let the name fool you. You don't need Adobe Photoshop to use Photoshop-compatible plug-ins. Adobe Systems may have defined the standard, but compatible plug-ins can be used with other image editing programs, including Ulead Systems' PhotoImpact, Corel's Painter and Dabbler, Corel PhotoPaint, and MicroFrontier's Color-It!, Enhance, and Digital Darkroom. Even freeware image editing programs, such as NIH Image, support Photoshop-compatible plug-ins. Other graphics programs, such as Adobe PageMaker (after version 6.0), Deneba's Canvas (5.0 and later), Equilibrium's DeBabelizer, and Macromedia's Director and Freehand, accept Photoshop-compatible plug-ins.

Eight Different Flavors

There are eight different kinds of Photoshop plug-ins, some of which you might care about, some maybe not, and even two that have no "public" interface. Here they are in no particular order.

Color Picker (Figure 12.9) plug-ins are used in addition to host program and system color pickers and appear whenever a user requests a unique or custom color.

Import plug-ins, formerly called "Acquire," interface with scanners, video frame grabbers, digital cameras, and even other image formats. Import plug-ins are accessed through Photoshop's File/Import menu (Figure 12.10).

Export plug-ins appear in the program's File/Export menu and are used to output an image, including the creation of digital color separations. Export plug-ins can also be used to output an image to printers that lack driver support or to save images in compressed file formats.

Figure 12.9 Yes, Virginia, the ubiquitous Color Picker that pops up whenever you need to choose a color—for whatever reason in Photoshop—is a plug-in.

Figure 12.10 Choosing File > Import > Epson Scanner brings up this Import that gives you access to either the film or flatbed functions of the Epson Expression 3200 PHOTO scanner, here used to scan a 35mm slide of Maroon Bells near Aspen, Colorado. Original image © Joe Farace.

Filter plug-ins appear in the program's Filters menu and are used to modify all or a selected part of an open image (Figure 12.11).

Format, sometimes called File or Image Format, plug-ins provide support for reading and writing additional image formats that are not normally supported by the program and appear in the Format pop-up menu in the Open, Save As, and Save A Copy dialog boxes.

After saving this file in the .stn format used by LizardTech Software's Genuine Fractals Print Pro, it was opened using the standard Open command (Figure 12.12). When opened, the Genuine Fractals dialog box appears, allowing you to resize the original file that enables you to make larger images and prints than you might otherwise. There's more on how to use Genuine Fractals later in this chapter.

Figure 12.11 Choosing any of Adobe's built-in filters (such as Poster Edges from the Filter > Artistic > Poster Edges) launched Photoshop's CS filter browser function that not only shows you the selected filter and all its controls, but also provides quick access to all the built-in (not third-party) plug-ins as well. Original image © Joe Farace.

Figure 12.12 This file was opened using the standard Open command in Genuine Fractals Print Pro. Original image © Joe Farace.

Selection plug-ins appear under the Selection menu and are used to create shapes or paths—especially when used with text. Then there are the "secret" plug-ins, such as Extension, that are not accessible by the average user and permit implementation of session-start and session-end features, such as when initializing devices connected to the computer. They are only called at application execution or quit time and have no user interface. Parser is another class whose interface is not public and performs similarly to Import and Export plug-ins by providing support for manipulating data between bit-mapped programs and other formats.

Although there are "officially" eight different kinds of Photoshop-compatible plug-ins, I prefer to think there are really four major categories, and here are some of the best.

Acquiring an Image

One of the most useful plug-ins that is built into Adobe Photoshop CS is Camera Raw®, which lets you open the uncompressed high quality images created by digital SLRs (Figure 12.13). The formerly extra-cost Camera Raw plug-in is now part of Photoshop CS and has been improved with a simplified tabbed interface (no more long confusing lists of sliders) that also makes you more productive. Camera Raw now includes new color calibration controls, batch processing when used with the expanded File Browser function, and support for "major digital cameras" (see Chapter 3).

Figure 12.13 Camera raw plug-in in Adobe Photoshop CS. Original image © Joe Farace.

Enhancing That Image

After acquiring an image, I like to enhance it, making it look as good as it possibly can before doing anything else. That's when I reach for Extensis Intellihance Pro (Figure 12.14), which remains the one plug-in I'd want if I were a survivor on a desert island. The plug-in consolidates all your enhancement choices into a single screen-filling dialog box that includes preset settings for images produced with a scanner, Photo CD, or digital camera—with or without flash—and a lot of others. Digital imagers can create and save their own presets that can be used later to apply up to 50 adjustment steps at a time for specific

Figure 12.14 Extensis Intellihance Pro. Original image © Joe Farace.

projects or sets of images. Tools include a Clipped Pixel Display that shows which pixels are too bright, too dark, or too saturated. The Dust & Scratch Removal controls will find dust specks and scratches and remove them without destroying too much detail. The plug-in's PowerVariations feature has a multipane window where a single image can be split or repeated across user-defined previews test strips. With a maximum of five rows and columns, up to 25 variations can be viewed simultaneously. Image adjustments can be made and previewed and a test print sent to any output device. Intellihance Pro contains paper and ink settings that automatically adjust images for output to specific devices. You can download a demo version from Extensis' website (www.extensis.com).

nik Sharpener Pro! (www.nikmultimedia.com) makes image sharpening as simple as it ought to be (Figure 12.15a). The plug-in's interface uses six sliders that address real-world considerations that are easier to use than Photoshop's Unsharp Mask tool. During the sharpening process, nik Sharpener's alias protection process avoids areas where the dreaded "jaggies" can occur and sharpens them to a lesser extent. Similarly, its hue protection process

Figure 12.15a nik Multimedia's Sharpener Pro!. Original image © Joe Farace.

corrects color values in areas that might be distorted during sharpening using conventional digital tools. All you have to do is tell the plug-in if your image was digitized from a 35mm slide, large format transparency, digital camera, or scanner and then define the output device, with choices including inkjet printer, color laser, or even offset printing. The Image Quality slider lets you apply your subjective opinion as to whether an image is average, very good, or even "bad." The Printer Quality setting lets you make similar choices from bad to very good. The company offers a Pro version for those who are really serious about image sharpening.

Kodak's (www.asf.com) Digital ROC Professional Photoshop-compatible plug-in (Figure 12.15b) adds more features and functionality to ASF's original ROC software, enabling you to correct, restore, and balance the color quality of digital images, especially those subjected to wear

Figure 12.15b Kodak's Digital ROC Professional Photoshop-compatible plug-in. Original image © Joe Farace.

and tear from neglect or fading. Digital ROC Professional analyzes all the image's color gradients to remove color casts or tints and restore faded or lost color by generating optimal tonal curves for each color channel. This Pro version provides advanced controls for precise adjustment of both image brightness and image contrast as well as the color tint control. Digital ROC Professional supports the 16-bit color images that are typically generated by high-end scanners and other capture devices. It costs $99.95 for on-line purchase.

It's Still Black and White to Me

Don't pay attention to Paul Simon. Every thing looks great in black and white, and monochrome imaging isn't going away anytime soon no matter what kind of cameras you like to use. Digital photographers have lots of software and techniques that can be used to turn color digital images into monochrome, and everybody has their favorites, but there are not so many ways to get that color image to look like it was shot with a *specific* kind of black and white film (see Chapter 13). Here are some of the best power tools around these days.

The technically oriented will love Silver Oxide's Photoshop-compatible plug-ins (Figures 12.16 and 12.17). These plug-ins emulate specific black and white films, including Agfa's APX 25, 100; Kodak's Tri-X, TMAX, TMY, Plus X, Pan X, T400CN, Verichrome; and Ilford's HP5, FP4, Pan F, Delta 100, Delta 400, and XP2. Recently they've added some new Kodak emulsions, including TMZ, Tech Pan, and Portra 400. Silver Oxide's Bill Dusterwald told me "Tech Pan is the most unusual film that I've profiled. It has half the green response of any film, and a very strong red response. This makes the tonality very different from all the others." Want infrared? Use their SilverIR Filter. All you have to do is take a color image, scanned or from a digital camera, and using the SilverIR filter as part of a process, make an image that looks like a real infrared photograph.

Figure 12.16 Silver Oxide's black and white film emulation plug-ins. Original image © Joe Farace.

Using Silver Oxide is easy: when you select any of the film-specific filters from Photoshop's Filter > Silver Oxide menu, a control panel will appear. The enhanced plug-in includes three color filters, built in, that have been used by black and white photographers "almost as long as there has been film." To change the relationship of tonalities in the image, you can apply the digital equivalent of a Red (no. 25A), Yellow (no. 8), Green (no. 11), or No filter. Silver Oxide modeled each of those filters and does the filtering *before* applying the film model, so the final result would appear just as if you had made the photograph with the filter attached to the front of the lens. Cool huh? Silver Oxide's Photoshop-compatible plug-ins are available for Microsoft Windows and Mac OS 9 or OS X.

Figure 12.17 Another example of Silver Oxide's black and white film emulation plug-ins, for Tri-X. Original image © Joe Farace.

Another way to give a black and white film "look" to digital images is with one of The Imaging Factory's (www.theimagingfactory.com) Convert To B&W plug-ins (Figure 12.18). The basic plug-in Convert To B&W plug-in costs under $40 but does not let you easily emulate a specific black and white film. However, the more technically inclined could easily use its Audio Mixer interface to tweak the tonality to reproduce a specific monochrome film. Oh yeah, Convert To B&W lets you tone the image too.

Convert To B&W Pro (Figure 12.19) has a four-stage control interface including the mixer carried over from the standard plug-in, but also features a pop-up menu that lets you emulate Agfa Pan AFX, Ilford Delta (one of my

Figure 12.18 The Imaging Factory's Convert To B&W Pro plug-in. Original image © Joe Farace.

favorites), Ilford FP4, Kodak T-Max, and Kodak Tri-X. The first level lets you apply a color filter to the image but unlike Silver Oxide is continuously variable instead of emulating "real" camera filters. The next two levels emulate the printing phase of the traditional darkroom process and include sliders for exposure, negative exposure, and variable contrast paper grade. The last level lets you apply infinitely variable toning effects. I always like to apply just a small amount of brown toning to approximate the look of Agfa Portriga paper, which those of you who have spent time in the wet darkroom may remember.

So you say that you're not a photo geek and are just looking for a simple inexpensive way to create black and white images from a color file? If you don't want to

Figure 12.19 Convert To B&W Pro menu. Original image © Joe Farace.

emulate a specific film type, try Luis Gomez's Photo Sharp Black and White Action. I found Photo Sharp Black and White at www.share.studio.com. Although registration is required, it is free, as are many of the thousands of actions you can download.

I started with a photograph of my next-door neighbor, Jennifer. (No, she's not a professional model, but the mother of two charming little boys.) For this portrait, I used a Photogenic Studio Max II monolight, with the umbrella mounted backward, and fired through it to make the light somewhat directional but not *too* directional. Ambient light was very low, and so I shot with a shutter

speed of 1/60th of a second at f/7.1. The camera was a Canon EOS 10D, ISO 200, and EF 28–105mm lens at 105mm lens. With one click of a button on Photoshop CS Action palette, Luis Gomez's Photo Sharp Black and White Action converted the color portrait into crisp black and white. Too crisp for me, so I softened the image (Figure 12.20) with nik Multimedia's Classical blur filter that is part of their Color Efex package of plug-ins.

Figure 12.20 A black and white portrait of Jennifer using Photoshop CS Action palette, Luis Gomez's Photo Sharp Black and White Action, and nik Multimedia's Classical blur filter. Original image © Joe Farace.

Manipulating Your Images

The nik Multimedia Color Efex Pro package comes with 46 different plug-ins, including the Classical Blur filter. It's the first plug-in I've found that produces an effect similar to using a Zeiss Software filter on your camera's lens. Like

a Softar, the image is sharp but is subtly softened, especially when compared with the Blur effects built into Photoshop. A surprising side effect is this filter's ability to obliterate the fine scratches I only recently discovered my camera was randomly inflicting to my negatives in film scans. I also like nik's Sunshine filter that can be used to bring natural-looking but enhanced daylight effects to digital images that may lack the sparkle that was in your mind's eye when you originally created the photograph, like photographs made on a cloudy day.

Some filters in the package are similar to those found in the non-Pro version of Color Efex, and I was glad to see the oddly named but wonderful to use Monday Morning (Figure 12.21) and the Color Stylizer. Color Efex Pro has a set of graduated density filters in 12 different

Figure 12.21 The nik Color Efex Monday Morning Sepia filter. Original image © Joe Farace.

colors, including Gray and User Defined. In addition to offering more sliders in the control panels than the non-Pro version, many controls have yellow "caution stripes" representing optimal settings. Other interface improvements in the Pro version are controls that let images in the Control Panel's preview window be enlarged and dragged, allowing you to see critical portions of an image, such as a portrait subject's eye or shadow details in critical areas of your image. Clicking the mouse button on the preview window shows what the "before" image looks like. Tech-nik bundles nine other plug-ins called Abstract Efex Pro that let you create less realistic even *Peter Max*-like effects. nik Color Efex Pro is available for Mac OS and Windows computers. There are so many wonderful filters that I urge you to visit the company's website to see all of them in action.

Extensis' PhotoFrame, which may be the first Internet-aware plug-in, offers digital imagers over 1000 image frame effects to choose from, in addition to those available for downloading from a companion website that can be reached from within PhotoFrame, and provides access to new frames and borders. You have the option of subscribing to a monthly service offering new content as well as the ability to download additional files from a selection of professionally designed frames. Users can build their own custom frames and edges from scratch or by adapting existing frames, providing for lots of versatility and creativity. PhotoFrame (Figure 12.22) lets you enhance image edges by adding a variety of special effects, including drop shadows, glows, bevels, textures, blur, noise, opacity, and blends. The current version includes real-time preview, and its interface adds dockable palettes to maximize usable screen area. Any combination of settings can be saved, assigned a preset name, and accessed from Photoshop's menu bar without even launching the plug-in. You can download a demo version from Extensis' website.

Figure 12.22 Extensis PhotoFrame, an Internet-aware plug-in. Original image © Joe Farace.

Output That Image

Genuine Fractals (www.lizrdtech.com) Print Pro encodes CMYK, RGB, CIE-Lab, multichannel, and grayscale images as files that can be used to generate any kind of output while remaining small enough to edit, store, and upload. The images have a feature called "resolution on demand," which means you don't have to store multiple copies of the same file—at different resolutions—for different purposes. You can encode an image *once* at

medium resolution and then output it at any size or resolution you choose. Genuine Fractals Print Pro is a heavy-duty file format plug-in that lets you save images in two ways. The *Lossless* option produces a file that uses an approximate 2:1 compression and produces the highest quality enlargements. *Near Lossless* encoding produces a file with 5:1 compression on average but still lets you output an image beyond 100% at high quality. An original 15–20 MB file can be encoded with the Lossless option and can be printed in sizes (for example) up to the Epson Stylus Photo 1280's full printable size of 12.71 × 44 inches.

The number of plug-ins in your toolkit will vary based on the kinds of images you create and how you output them. Plug-ins are fun to use and also make digital imaging easier.

Chapter 13

Black and White Part I: Converting Color for Printing

George Schaub

Practical Matters

Although the artistic aspect of photography may be what motivates many people to become involved, consideration must also be given to certain practical matters. There is no question that the end use of the image plays a strong role in how it is handled. For example, when a print is made for the gallery wall, it should be printed in a different way than if it will be used as an illustration in a newspaper. When an image is created for use on the Web, it requires different steps than when it is used as the source for an 11 × 14-inch print. A number of practical steps are taken in the creation of photographic prints; each step is a stage that builds toward success or that, when improperly done, will definitely impede your progress. Each of these steps is discussed in several places in this book. What follows is an overview for converting color images to black and white for printing.

Step 1: Making an exposure in the camera—be it film or digital—that will faithfully render the brightness values in the original scene and that will result in a source image that is "easy" to print (Figure 13.1). Although automatic-exposure cameras have made this

considerably less of a challenge, there are certain lighting condition and subjects that can cause problems. Reading the light in the scene, and making judgments about how that light best translates to film or digital sensor, is one of the most critical aspects of photography. Although remedial steps can be made to correct exposure errors, a badly exposed image is one of the major headaches in photography. The challenge is to balance the sensitivity of the recording medium with the light values and to do so in a way that emulates a range of those light values on the film.

Step 2: Getting the image into digital form. If you photograph with a digital camera, you've already done this step. You need to be aware, however, that how you set up the camera—especially with the proper resolution—is the key to making the kind of prints you

Figure 13.1 The foundation of a good photograph begins with proper exposure, rendering the lights and darks of the original scene in as faithful a fashion as possible. In this image, proper exposure created texture in the highlights and "open" shadows. Of course, you can interpret your images any way you desire later, but beginning with a tonally rich exposure makes it so much easier to personalize images later. Image © George Schaub.

want. If you are working from film images—color or black and white negatives, slides, or prints—you'll need to "digitize" them by scanning them or having someone scan them for you.

You can source images from digital files captured with a digital camera and from film (of all types) and prints via scanning. This color slide was made on Kodachrome slide film way back in 1976 (Figure 13.2). By scanning today, this old image can be made new and is open to new printing and manipulation techniques (Figure 13.3). Converting color to black and white is a simple matter in the digital darkroom.

Figure 13.2 An old color slide. Image © George Schaub.

Figure 13.3 Once an image is "digitized" it opens the door to all sorts of image manipulation. Image © George Schaub.

Step 3: Making prints, which involves creative decisions about how the light originally captured is to be rendered on paper.

Image Sources for Black and White Printing

Any type of image source can be used for black and white printing. You can use black and white or color prints, black and white slides and negatives, and color slides and negatives. Converting color to black and white is a simple matter. You can use Image > Mode > Grayscale, Image > Mode > Grayscale > Duotone, or Image > Adjust > Desaturate or Image > Channel Mixer. You might believe that the preferred sources for black and white printing are only black and white negatives and slides. Remember, once you digitize an image you can do just about anything with it, so the distinction you once made (choosing only black and white film for black and white prints) is no longer necessary. I have gotten excellent source images from color slide film as well.

Choosing Images for Work

I am a great believer in making life as easy as possible, especially in my creative work. That applies to choosing photos for printing. My philosophy is that if I have to spend all my time correcting a poor image, it leaves less time for creative thought and applications, so, if possible, I choose well-exposed images to make prints. The most troublesome types of images are those that have very high contrast, those that are overexposed, and those with any problems caused by flare or fogging. Guess what—these negatives, prints, and slides are also troublesome when working in the conventional darkroom too. Although in many cases you can certainly fix problems more easily in the digital darkroom, it is not a cure-all. I have heard many photographers voice a new casualness about exposure and technical matters by saying "I'm not worried—I'll fix it in Photoshop." Wrong.

Too often these folks have learned the hard way and have become frustrated by their inability to fix a problem image. These programs are pretty amazing, but working from poorly exposed images means you have to a lot of work just to get them close to being okay, rather than spend your valuable time on creative work. Yes, you can "fix" things in the digital darkroom that would be very difficult to handle in the conventional darkroom, but just because you're now in the digital world you're not exempt from making good exposures and choosing good images to print.

When I choose an image for work in the digital darkroom, I am guided by the "do it easy" method. If I have to choose between two images, I will always work with the one that shows a good range of exposure and not excessive contrast. True, there are some images that don't display these characteristics that I will tackle, but I have learned that quality source images always turn out better in the end. This photograph (Figure 13.4) made in White Sands National Monument in New Mexico displays all the tonal variety and image quality I look for when I edit my images for work.

Figure 13.4 When I choose an image for work in the digital darkroom, I am guided by the "do it easy" method. Image © George Schaub.

Layer Magic

The use of Layers that follows below sounds pretty magical, and it is—that's because Layers are "what if" calculations that you can use on top of an image without affecting the image itself until they are applied. Here's a good way to think of Layers. Let's make believe that we have constructed a tall box with slots. At the base we slide in our image. We then have a large box of filters that can affect nearly every pixel and can change color, contrast, and exposure. To see how each of these filters changes the image, we can slide them in and out of the slots in that box and look down through the top. We also have dimmers on each slot that we can change to alter the intensity or effect of each filter. And, if we want, we can turn the effect of each slot on and off to see if we like them as we work. (In Photoshop we do that by clicking the eyeball next to the Layer on and off.)

The Channel Mixer

To convert the image in Photoshop we'll open Layer > New Adjustment Layer > Channel Mixer. You can change any of the sliders you want, but first check off monochrome. This eliminates (but does not discard) the color from the view of this image. Keep in mind that the green channel affects brightness (luminance), whereas the red and blue affect contrast. The Constant slider affects contrast and overall brightness as well. If you have Photoshop Elements or a similar program, you'll just use the Enhance > Adjust Color > Replace Color routine.

One way to create a "custom" conversion from color to black and white is to work with a tool known as the Channel Mixer. You can do channel mixing as an Adjustment Layer or from Image > Adjust > Channel Mixer (Figure 13.5). When you choose it a dialog box opens (Figure 13.6). Check the Monochrome box in the lower left corner and move the sliders until the preview on the screen matches what you want. (Tip: Green—our color photograph of a table at a flea market (Figure 13.7) was quickly converted to black and white (Figure 13.8) using the Channel Mixer technique.

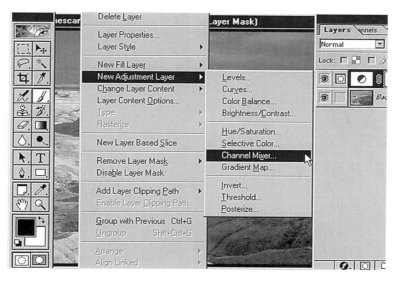

Figure 13.5 Original image © George Schaub.

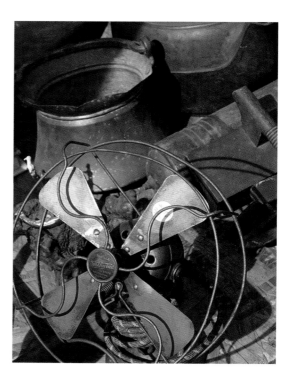

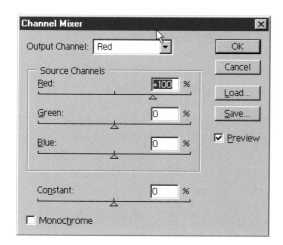

Figure 13.6

Figure 13.7 Image © George Schaub.

Figure 13.8 One way to create a "custom" conversion from color to black and white is to work with a tool known as the Channel Mixer. Image © George Schaub.

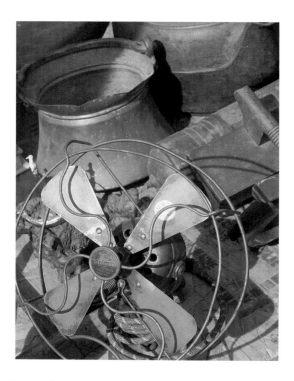

Exposure Controls

It's easy to adjust the exposure of an image. Open up an image and then open the Layer > New Adjustment Layer > Levels menu, and the Levels dialog box opens. You adjust exposure by working with the Blending Modes. These modes are like using exposure time to add or subtract "density" from the image. They are often the basic tools that will get you very close to a final image. These modes work like your exposure control on your camera. Multiply takes away a stop (makes the image darker without affecting contrast) and Screen adds a stop (makes the image lighter) of exposure. If you want to translate from working with negative film on an enlarger in a darkroom, Multiply is like stopping down one stop and Screen is like opening up a stop.

You can refine the exposure using the Layers palette. Note the Opacity slider in the upper right of the dialog box. Click and hold and drag the Opacity slider from the

100% setting and drag it to the left. If you slide it all the way back, you eliminate the Layer effect altogether, although the Layer still exists.

An easy way to work with exposure is to use Blending Modes. In this photo made in the Bisti Badlands in New Mexico (Figure 13.9), we have a pretty good exposure, but I wanted to make it moodier with some darkening. I opened Layers > New Adjustment Layer > Levels and then when the dialog box opened I changed the Mode (lower left) to Multiply (Figure 13.9a). I then clicked OK and ignored the Levels dialog box that followed. The result is an image that is about a stop darker than the original (Figure 13.10).

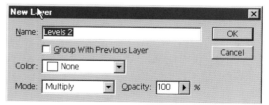

Figure 13.9 Image © George Schaub.

Figure 13.10 Image © George Schaub.

You can easily modify exposure using the Opacity slider in the Layers dialog box. This photograph had a fine exposure (Figure 13.11), but I wanted to make it lighter for a high key effect. I opened Layers > New Adjustment Layer > Levels and changed the Mode to Screen (Figure 13.12), which gave about an additional stop of exposure (Figure 13.13). To modify the exposure to about 1/2 stop, I went to the Layers dialog box and slid the Opacity slider back until I got just the look I wanted (Figure 13.14).

At any time in your work you can return to this Layer and make further adjustments and change the Levels or the degree of the effect you have applied. This is like being able to open up and stop down by a very fine degree or like being able to bracket exposure at f/11, f/11.1, f/11.5, and so on.

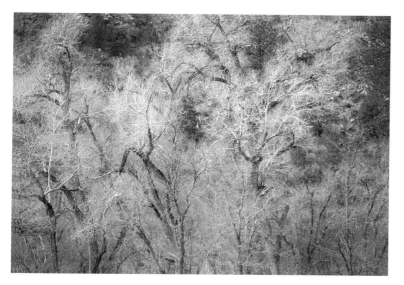

Figure 13.11 Image © George
Schaub.

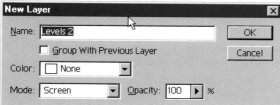

Figure 13.12

Figure 13.13 Image © George
Schaub.

Figure 13.14 Original image ©
George Schaub.

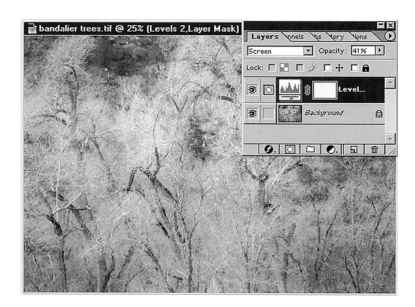

Contrast Control: Levels

There are a number of ways to affect the contrast of an
image—the relationship of the tonal values in the scene. You
can expand them or compress them as you wish. Again, you
should use an Adjustment Layer, but this time leave the
Blending mode as Normal. The Levels dialog box contains a
histogram, a graphic representation of the tonal values in
the image. Every image you work on can use some
adjustment of contrast and the histogram, and the Levels
control allows you to make adjustments easily. In some cases
you can just look at the histogram, make an adjustment,
and that's all you need do to "fix" the image. What if you
want to just refine an image and not change the overall
(black and white) contrast? That's where the middle gray
slider comes in. Once you get a handle on working with
Blending modes and the Levels controls, you have gone a
long way toward enhancing your images. Play with these
controls until you get a good feeling for how they work.

There are many options to choose to adjust image
contrast. Here's a fairly simple one—working with the
Levels control. This photograph was made in the deep
woods and is a bit dim (Figure 13.15). It matches the

lighting conditions in the original scene, but I wanted to open it up a bit. I opened Levels > New Adjustment Layer > Levels and left the Blending mode as Normal. The Levels dialog box showed how the values were skewed toward the shadow areas (Figure 13.16). To "open up" the image and gain more contrast, I simply moved the highlight (right side) slider in to where it just kissed the graphical representation of where the tones resided (Figure 13.17). The result is a contrast adjustment that maintains the feeling of the image but opens up so many more tonal values (Figure 13.18).

Figure 13.15 Image © George Schaub.

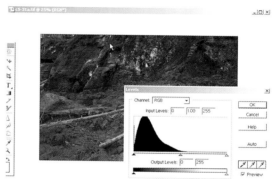

Figure 13.16 Original image © George Schaub.

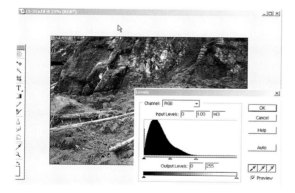

Figure 13.17 Original image © George Schaub.

Figure 13.18 Image © George Schaub.

Selections: Working with Select Areas in Your Images

So far we have been discussing making adjustments to an entire image. This may be just what you want to do with some photos, but there are many times when you'll want to make adjustments to part of an image without changing another part. There are two classic problems that illustrate when this might be necessary. One is the landscape shot where the sky is brighter than the ground. When making the photograph you might have to choose a good exposure for the sky or for the ground or make a compromise exposure that gets you halfway between without giving you a rich image in either section. The other is backlighting, especially with portraits. This is when the subject falls, as it were, into its own shadow. Yes, you can use fill flash, and yes, you can reposition yourself or the subject to avoid this (or just wait for the right light!), but that's not always possible.

There are other cases where you might want to change a part of the image (either exposure or contrast or both) for aesthetic reasons. One of the greatest photographic printers of all time—Gene Smith—was a noted photojournalist and photo essayist who would sometimes spend an entire day (or days!) on one print. He was looking for just the right combination of "revealing and obscuring" to enhance his subject matter. He would look at an image and intentionally darken parts to highlight other areas—to direct the viewer's eye as he wanted. This interpretive approach to printing is greatly aided by the selection tools we'll cover here.

Selection Tools

Just what do selection tools do? Simply, they help you select parts of an image for work and "protect" the other parts from that work. Take a look at your toolbar to see what selection tools you can use. At the top left is a Shape tool, which allows you to draw rectangular, square, and oval selections (the oval tool is "hidden" under the rectangular tool—just click on it and the oval tool will

appear). Right underneath it is the Lasso tool, which also hides the polygon and magnetic lasso tool. To the right of the lasso is the Magic Wand.

To give you an idea how Selections might work, think of a typical landscape photograph where the sky and ground have different exposure levels. First, select the sky using a rectangular marquee. Click on the rectangular marquee box in the toolbar and bring the cursor into the image. Draw the marquee (so called because of the "dancing" edge) from the upper left to the horizon line. When you surround an area with a selection, it means that the area you select is "active" and can be changed without affecting the rest of the image. Now that the sky is selected, you can change it using a New Adjustment Layer. Go to Layer > New Adjustment Layer > Levels and simply move the sliders until you get the tonal value in the sky you want.

Another very helpful selection tool is the Magic Wand. The Magic Wand has a number of options that you should learn. The first is Tolerance, stated in pixels. This defines how wide the identification of a pixel should be for it to be selected. A low tolerance equals very closely matched pixels, whereas a higher number means a wider range of pixel characteristics. Another tool modifier is Contiguous. Checking this means only pixels with a set tonal border will be selected, whereas un-checking it means pixels of similar characteristics will be selected throughout the picture.

The Magic Wand tool (Figure 13.19) shown highlighted here is a great selection tool that allows you to isolate certain tonal ranges for changes. This photo made in White Sands National Monument suffers from lack of contrast due to the exposure meter being "fooled" by the bright sand (Figure 13.20). To reclaim the bright sand values, the Magic Wand was clicked onto the background with a tolerance of 15 and set on non-contiguous. This selected all the bright white values and left the plant unselected. Creating a brighter white was easily done by using Levels on the selected area (Figure 13.21).

Figure 13.19

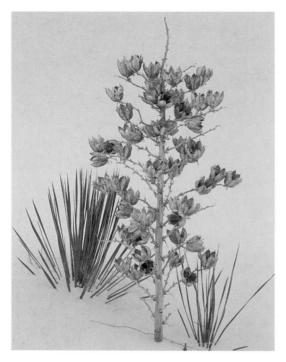

Figure 13.20 Image © George Schaub.

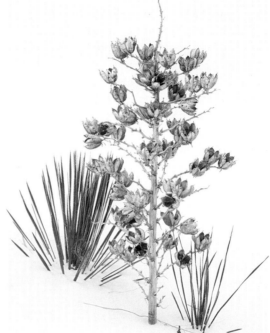

Figure 13.21 Image © George Schaub.

Burning and Dodging

The Burn and Dodge tools work very much like they do in the traditional darkroom. The Burn tool adds density, whereas the Dodge tool reduces it. But unlike the traditional techniques, you can modify these tools to give you very critical control. Click on the Dodge tool and go to the top of the image screen to the options bar on this tool. Look at the Exposure box. This sets up the degree of the effect, and in most cases you'll want to set a low number here and work with cumulative strokes rather than try to get it all done in one stroke. You can set it, for example, at 20% on Mid-tones, 10% on Highlights, or any setting you desire. Use these tools to modify an image and

not for major changes—use the Adjustment Layers and Blending Modes for overall adjustments.

Burning and dodging is a time-honored technique that can add real depth to an image. When you burn and dodge, do so on a new or duplicate layer, created by going to Layer > New. This leaves the original image untouched. This photograph of a sage plant gives you an idea of the potential impact of judicious burning and dodging (Figure 13.22). Most of the work here was done with the Burn tool set on Mid-tones, 15%. You can vary the Exposure and size of the Burn tool "brush" as you work (Figure 13.23).

Figure 13.22 Image © George Schaub.

Figure 13.23 Image © George Schaub.

Working with Layer Masks

One of the chief enhancement tools in the traditional darkroom is the ability to add or reduce density (exposure) in select areas of the image. This was done with burning and dodging techniques. When you burn you add exposure, thus darkening the area of the image you apply it to; when you dodge you lighten the areas of the image. This technique took some careful application, and you only knew you got it right when you ran the exposed print through the developing bath. It might take a number of prints to get it right and required lots of patience and testing. If areas were very small, it was even more challenging and sometimes downright impossible to get right. But burning and dodging were (and are) essential tools for making effective prints.

A mask in photographic darkroom terminology is a thin piece of film or dye that is applied to the negative or slide to block the transmission of light. Masks could be created that would add or subtract density (exposure) during enlargement. It could also be used to completely block the light for silhouetting product shots. Masks could be created from exposed film that was contact printed to the original negative or slide or from dye that was applied to the film or a copy of the film itself.

As we have found out, the digital darkroom often takes a photographic concept and runs with it to extend control even further. When we make a Layer we are applying an effect on top of an image. That effect can result in the image or a part of the image being made darker, lighter, and so forth. The Layer can be modified through various Blending modes and through the Opacity slider in the Layer Palette. With a Layer Mask we can remove parts of the Layer selectively. We can "paint back" to the original, or if we paint back too much, we can reapply the mask selectively. We can control the opacity or translucency of the mask as well.

This "workflow" will give you a good idea of the power of combining exposure techniques with a Layer Mask. This wild iris (Figure 13.24) shows a good exposure, but

I wanted to change the values of certain densities. After converting it from color to black and white with a Channel Mixer, I then used a Multiply Blending Mode to increase density, or to make it darker (Figure 13.25). Because this new version is on a Layer, I can use a Layer Mask to dodge, in effect. I used a small brush to "paint away" some of the density in certain areas, with the brush set on a low opacity so I could control the application (Figure 13.26). Here's the Layers Palette that shows the Layers I worked with—Channel Mixer and Multiply Levels Blending Mode. Note the graphic representation of the Layer Mask in the Layer Mask box in the top layer (Figure 13.27).

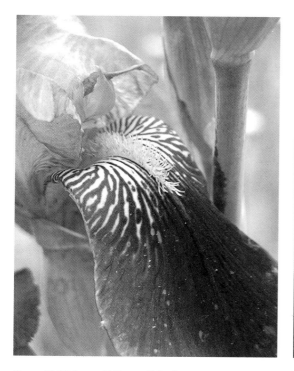

Figure 13.24 Image © George Schaub.

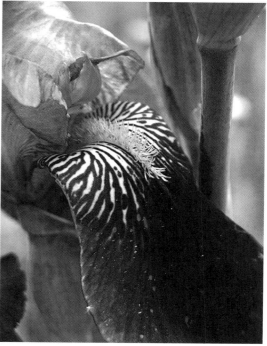

Figure 13.25 Image © George Schaub.

Figure 13.26 Image © George Schaub.

Figure 13.27

Once you have created a Layer, say for adding density, check the toolbar to make sure that black is the foreground color. Next check your Layers Palette to make sure that the mask symbol is next to the active Layer. If it isn't, then click the add Layer Mask icon on the Layers Palette. When the black square is in the foreground, you will be removing the mask. When the white square is in the foreground, you will be replacing the mask or reverting to whatever Blending mode or effect you have applied. You toggle between the two by clicking on the toggle arrows in the upper right of the square where the foreground and background color boxes reside.

You can use any brush at any opacity to make your mask. If you want to revert completely back to the original, keep the opacity at 100%. If you want to modify the mask, make the opacity lower, say 50%. As you work with this technique you'll get a feel for what works best with each image.

Blurring with a Layer and Layer Masks

One of the most exciting tools we have in the digital darkroom is the ability to control background sharpness and even to "clean up" an image using a Blur tool. To use this tool we work with a different kind of layer—a duplicate, or new, layer. Go to Layer > Duplicate. This makes an exact duplicate Layer of the image over the original. The reason we use this Layer is that we can do things with it we can't with an Adjustment Layer, such as burn and dodge and apply certain special effects filters. With the new Layer active, go to Filter > Blur > Gaussian Blur. This will bring up a dialog box. Move the slider to the left until the entire image blurs out (about 75 or so) and click OK. Now you'll see the entire image blurred out on the screen.

Layer Masks are great tools for any number of image altering applications. Here we'll use it to create a soft background that helps concentrate attention on the main subject of the picture. This candid portrait of Kallie Polgrean on an Easter egg hunt shows a distracting background (Figure 13.28). I created a Layer by using Layer > Duplicate. I did not use an Adjustment Layer because such a Layer cannot take the application of the Blur tool I wanted to use. I then went to Filter > Blur > Gaussian Blur and worked the sliders to blur the entire image (Figure 13.29). Because I'm working on a Layer I can use a Layer Mask. I chose a medium size brush and began to "paint away" the blur on the mask (Figure 13.30). When I completed the work, the background stayed "soft" while our subject retained sharp focus (Figure 13.31). Here's the Layers Palette that shows a graphic representation of the mask I created (Figure 13.32).

Figure 13.28 Image © George Schaub.

Figure 13.29 Image © George Schaub.

To paint back to the original and leave some of the image blurred, we'll use a Layer Mask. Create a mask in the layer by clicking on the Create Mask icon at the base of the Layer Palette. Use a brush to "paint away" the blur, keeping in mind that you can always "repaint" the blur by toggling to white in the foreground color in the toolbox.

Figure 13.30 Image © George Schaub.

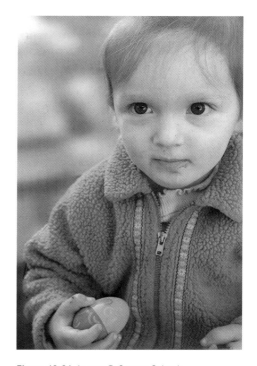

Figure 13.31 Image © George Schaub.

Figure 13.32

Final Thoughts

As you work with your images, you'll find many paths and begin to understand that your original photograph is a sketch, a study for further interpretation and refinement. Although there are many charming qualities to a silver print made in the chemical darkroom, the digital darkroom affords us tools and techniques that conventional printers could only dream of in the past. Have fun, explore the tools and techniques, and you'll soon find that your images are more expressive of what you saw when you first snapped the shutter.

Part 4

DIGITAL ART STUDIO

Chapter 14

Digital Fine Art Part I: How to Create It

Stephen M. Burns

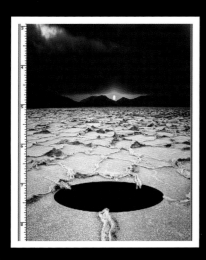

There is a new movement happening now in art, and it is digital. When an art movement happens, it has a tendency to separate those artists who can adapt to and embrace a fresh new outlook of their environment from those who choose to stay with tradition or wait and see. The digital movement and the possibilities it brings to artists not only render endless the creative realm of possibilities, they also affect how we conduct business, communicate, and thrive and grow as an art community throughout the world. The digital art movement is now just beginning to tap into the digital tools we may use to visually interpret and communicate to others through fine art the world around us. With that said, let's explore some interesting possibilities using photography and one of the most exciting digital tools available today, Photoshop CS.

When I set out to create a fine art piece, I always have a mindset of finding ways to challenge the viewer's psyche by presenting the unknown. I combine the animate with the inanimate. I use what is in nature. I like to use several unrelated images to create one harmonious digital art piece. I believe we are inseparable from our environment

and the energies that affect us, and I attempt to express and convey this in my fine art creations.

In this chapter I share how I created Sipapu (Figure 14.1). Throughout my creative process, I use a Wacom graphics tablet regularly. The tablet affords me the feel of brush painting in the digital medium. I work in Photoshop CS. I hope to share not only how I create my digital work, but also how I think as I create.

Creating Sipapu

Sipapu was created with six different images. My final image size after flattening it into a single layer in Photoshop 7.0 is close to 400 ppi with dimensions of 20 × 30 inches. With the layers attached, the file size is over 2 gigabytes. All my files are drum scanned at anywhere from 4000 to 8000 ppi to ensure that I maintain the color richness and depth of the original transparency.

As you have probably guessed I use film cameras: a Canon A2E for 35mm, a Rolleiflex 6008 with an 80mm Zeiss lens for medium format, and a Calumet Cambo for 4 × 5 format. For this final image (Figure 14.1) I used the Rolleiflex for the sunset (a), the Canon for the mountains (b) and the model, and the 4 × 5 for the salt flat in the foreground (c). Leaves (d and e) also were used. Because 4 × 5 film records the best detail in tonal and color information, the Calumet Combo was ideal selection for the foreground-dominated image.

I prefer to work with a large file because I often will take the file to my lab that uses a Durst Lambda (Durst Corporation) printer, an expensive (six-figure) large-format laser writer that writes digital information right onto photographic paper with RGB lasers. The Durst Lambda produces a lightjet print. I have them enlarged into 30 × 40 inches and higher files and prints. With this approach I get incredible detail.

For the Sipapu work I formatted the canvas, the overall size and shape for the final image, to be vertically long and slender. These somewhat uncommon proportions give "Sipapu" a greater sense of mystery. Let's take a look at how I used the following images to create the final piece.

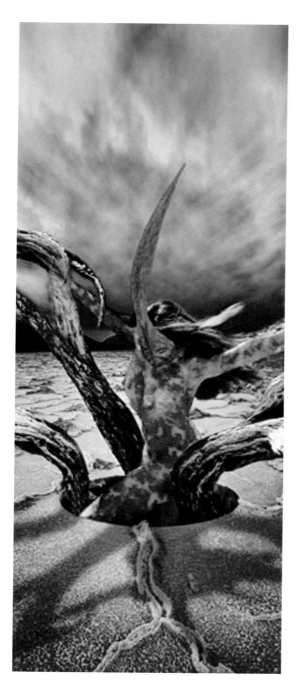

Figure 14.1 Final Sipapu. Image © Stephen M. Burns.

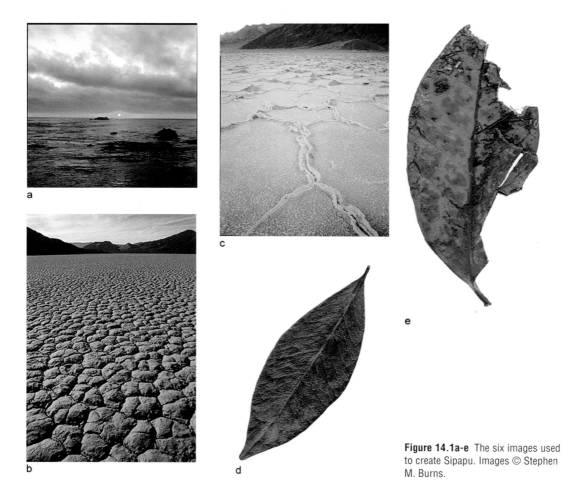

a

b

c

d

e

Figure 14.1a-e The six images used to create Sipapu. Images © Stephen M. Burns.

Step 1: Composite Race Track and Salt Bed

After extending the canvas (Image > Canvas Size) an
additional 9 inches to the top to gain more spatial area
above the race track horizon, I place the race track layer on
top of the salt flat image (Figure 14.2). I then apply a layer
mask to the race track by clicking the second icon from the
left at the bottom of the layers palette (Figure 14.3). The
areas painted black exclude the visual aspects of the image
with which the image was associated. In this example
I retain only the mountains. This works well as a horizon.

Figure 14.2 Race track layer on top of the salt flat image.

Figure 14.3 A layer mask is applied to the race track.

Step 2: "Composite" Carmel Sunset into Mountain Horizon
The area above the horizon in both the race track and the salt flats layers are transparent (Figure 14.4). This is ideal for placing the Carmel layer underneath the sunset, allowing it to seamlessly integrate into the upper half of the image (Figure 14.5). Now that the basic stage is set, let's include more detail.

Figure 14.4

Figure 14.5 Original image © Stephen M. Burns.

Step 3: Add Adjustment Layers to Race Track and Salt Bed Layers

By adding adjustment layers to intensify contrast and colors, I create a more dynamic looking background. Notice the intensified clouds in the sky. Finally, I merge these layers together to get a single layer to work with. This helps you because the reduced size of the image is more manageable. Now, let's add the circular opening in the ground.

Figure 14.6 Original image © Stephen M. Burns.

Figure 14.7

Step 4: Add Layer Mask to Make Hole

By clicking the icon in red I add a layer mask to my new landscape layer. I use the elliptical marquis tool to select a horizontal oval near the center of the salt flats and fill the selection in the mask with black. I now have the beginnings of my hole. With a few modifications using the Clone brush tool, I add additional salt detail that extends past the hole. Next we add some 3D dimension to the hole.

Figure 14.8a

Figure 14.8b Original image © Stephen M. Burns.

Step 5: Add Depth to Hole

I duplicate the landscape layer and place the new landscape copy below. After offsetting the landscape copy layer down by 30 pixels, I give it a vertical motion blur (Filters > Blur > Motion Blur) that gives the hole a new sense of volume. By playing with the contrast and color adjustment settings, I am able to visually integrate the two layers pretty well. Let's add yet a little more detail.

Figure 14.9a Original image ©
Stephen M. Burns.

Figure 14.9b

Step 6: Creating More Detail for the Hole

Using my square marquis tool I cut out a section off of the crackled mud from the Death Valley race track image. After copying it, I paste it into a layer underneath the landscape copy. I then apply the same motion blur technique to give it a sense of vertical depth.

Figure 14.10a Original image © Stephen M. Burns.

Figure 14.10b

Step 7: Enhance the Sky

I am not quite happy with the sky so I will create some clouds of my own. Making sure that my foreground color is medium gray and my background color is white, I use the Clouds command under the Filters > Render > Clouds. Photoshop renders the cloud shape based on my foreground and background colors that I will use to further create my clouds. By setting the layer mode to hard light, the medium gray areas of layer 3 are now transparent. I use the Edit > Free Transform commands to position the clouds in the upper half of the frame. Because I want to keep the integrity of my original clouds closer to the mountain range, I apply a layer mask with gradients from black to white as shown above (Figure 14.11a).

Let's add some more clouds.

Figure 14.11a Original image © Stephen M. Burns.

Figure 14.11b

Step 8: More Sky Enhancements

In this step I repeat step 7 in four other layers and change the color and add masks where applicable. Finally, I add motion blur to each cloud layer. Now I have a more dynamic cloud formation that shows a sense of perspective.

Figure 14.12a Original image ©
Stephen M. Burns.

Figure 14.12b

Step 9: Adding Body Texture

Making sure that I place the leaves in layers above my
model, I change the layer mode to hard light and position
each layer to get the maximum effect of the leaves over the
entire body. Once again I rely on layer masking to mold
the leaves to the shape of the body. I use the same
technique to shape the face mask. In addition, I use the
distort tool in Edit > Transform > Distort to further shape
the leaves. Finally, I use the model layer to create a shadow
and transform it into place in the foreground. The final
results are shown below.

Figure 14.13a Original image ©
Stephen M. Burns.

Figure 14.13b

Figure 14.13c Original image
© Stephen M. Burns.

Creating Digital Fine Art

The idea behind fine art (Figure 14.14), besides creating a beautiful piece of work, is to show that you can be creative with very few images. I begin by formulating a concept based on the use of texture, depth, and mystery.

Figure 14.14 Original image © Stephen M. Burns.

Most of the art piece is done with just two images. This self-challenge is a way to push my creative thoughts as far as I can with limited resources. Sometimes I even like to challenge myself to see what I can do with only one source image. With enough creative thought you will be surprised as to what you can do.

Step 1: I begin with a portrait (Figure 14.15a) that was taken on the beach of San Diego. I love to use dissimilar imagery that gives the image a chaotic appeal at first. Why? This to me creates not only a sense of rhythm, but it allows me to create with no preconceived notion of what the final image will be. The inherent shapes in the dissimilar images bubble up and suggest to me where to go in the process of creating the final piece.

a

b

Figure 14.15 a. Portrait on the beach. (Image by Stephen M. Burns.) b. Wall texture. (Image by Stephen M. Burns.)

c

d

Figure 14.15 Cont'd c. Elephant eye image. (Image by Yvonne J. Butler.) d. Side view of a Burchell's Zebra. (Image by Yvonne J. Butler.)

Step 2: After I place my wall texture above the portrait layer, I change the layer blending mode to hard light. This allows the texture to integrate into the flesh of the model to give some interesting visual effects.

Step 3: Next I apply a mask to the wall texture (Figure 14.15b) for the purpose of isolating its effects to the body of the woman.

Figure 14.16 Original image © Stephen M. Burns.

Figure 14.17 Original image © Stephen M. Burns.

Figure 14.18 Original image © Stephen M. Burns.

Figure 14.19 Original image © Stephen M. Burns.

Step 4: I continue on with this technique by duplicating the wall texture and strategically placing each layer over different areas of the image until I am satisfied with the overall visual results.

Step 5: I realize that I was working with in excess of 50 layers, and this number could be unwieldy. It is time to organize my layers into layer sets.

Figure 14.20 Making layer sets in Photoshop. Original image © Stephen M. Burns.

Step 6: This seems like a good time to introduce some
supporting texture. Yvonne Butler's elephant eye (Figure
14.15C) surrounded by textural hide is a strong image in
itself, and I must be careful to make sure it does not
overpower the other elements in the image. By using
layer masking I can isolate the hide to selected areas of
the face, shoulder, arms, and hand.

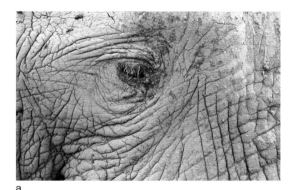

a

Figure 14.21 By using layer masking I can isolate the hide
to selected areas of the face, shoulder, arms, and hand.
a. Image ©Yvonne J.Butler. b. Original image © Stephen M.
Burns.

b

Step 7: At this stage of the game I do not want to get too greedy about completing the texture on the figure, so I begin working with the idea of including a chain element created from the chain support in wall texture image.

Figures 14.22 Series of steps for chain element.
Image © Stephen M.Burns.

Figures 14.23 Series of steps for chain element.

Figure 14.24

Figure 14.25 Series of steps for chain element.

Step 8: I transform the chain link (Edit > Free Transform) to resemble a single link in chain.

Step 9: Finally, I duplicate the layer as many times as needed to free transform each link until the final look resembles a chain flowing from the top of the image down to the female figure's body.

Figure 14.26

Figure 14.27

Figure 14.28 Original image © Stephen M. Burns.

Step 10: Moving along, I place what appear to be surrealistic goggles over the face for the purpose of adding a sense of mystery.

Figure 14.29 Original image © Stephen M. Burns.

Step 11: At this point I want to add a little more perspective to the piece. Using my flatbed scanner I scan in my hand and use it as a way to lure the eye from the foreground into the image.

Figure 14.31 Original image © Stephen M. Burns.

Figure 14.30 Original image © Stephen M. Burns.

Step 12: To keep the theme consistent, I blend both the wall and the elephant hide texture into the hand.

Step 13: I want to cut and paste a section of what I have created to help frame the image; however, at this stage my work still is in layers. I must now flatten all the visible layers into a separate layer. I start by creating a separate layer. Afterward I depress the Alt key on the keyboard and access the layers submenu, which is designated by a black triangle symbol on the top right-hand corner of the layers palette. Finally, I click the merge visible command. Now I have a single layer with the visible image from which I will make my framing panels.

Figure 14.32 Original image © Stephen M. Burns.

To give the image a greater sense of depth and balance, I create some framing by selecting a small rectangular portion of the left third of the newly merged image with my rectangular marquee tool. Using Ctrl C to copy followed by Ctrl V to paste, I place the copied image on its own layer. Next I apply some motion blur (Filters > Blur > Motion Blur).

Step 14: Continuing to use the merged layer, I select a larger portion of the right side of the image and use Ctrl C to copy followed by Ctrl V to paste the selected image into its own layer.

Figure 14.33 Original image © Stephen M. Burns.

Figure 14.34 Original image © Stephen M. Burns.

Step 15: Going further I use the original chain link to resemble cuffs on the figure's wrist.

Step 16: The work now looks closer to a finished state, but it still needs something more to draw in the eye of viewer for further exploration. Using my Wacom tablet, I draw a halo on a new layer above the figure.

Figure 14.35 Original image © Stephen M. Burns.

Figure 14.36

Step 17: A single halo to me is a little too much of a
religious cliché, so I choose to duplicate the layer and
rotate each one to create a headband effect.

Figure 14.37 Original image © Stephen
M. Burns.

Step 18: I now like the texture in the body of the figure,
but Yvonne's zebra skin image caught my eye and
I would like to use it. Some creative-masking work
(Figures 14.38 to 14.44) adds some more texture to
complete the figure. It works.

Figure 14.38 Original image © Stephen M. Burns.

Figure 14.39 Original image © Stephen M. Burns.

Figure 14.40 Original image © Stephen M. Burns.

Figure 14.41 Original image © Stephen M. Burns.

Figure 14.42 Original image © Stephen M. Burns.

Figure 14.43 Original image © Stephen M. Burns.

Figure 14.44 Original image © Stephen M. Burns.

Step 19: Now I look once again at the headband of light that I created in step 17. To me it does not seem to attract enough attention. "Maybe a little lens flare," I think to myself. Knowing that Photoshop needs pixels to create any filter effect, I create a blank layer and fill it with medium gray (Edit > Fill > 50% Gray).

Figure 14.45

Step 20: Next I apply the lens flare (Filter > Render > Lens Flare), making sure I position the flare in the center of the images to gain more of a circular effect.

Figure 14.46

Figure 14.47

Step 21: I change the layers blending mode to hard light to
make the gray transparent. After I reduce the size of the
lens flare and position it near the headband, I change it to
a bluish hue using the hue slider in the Hue and Saturation
(Image > Adjust > Hue and Saturation) adjustment.

Finally, I flatten the image to create the result shown in
Figure 14.48. Make note that in my steps I try not to
concentrate on one part of the image to completion. I
move around the image and modify it to keep balance as
well as to keep from getting bored.

I hope you have as much fun as I have creating digital
fine art.

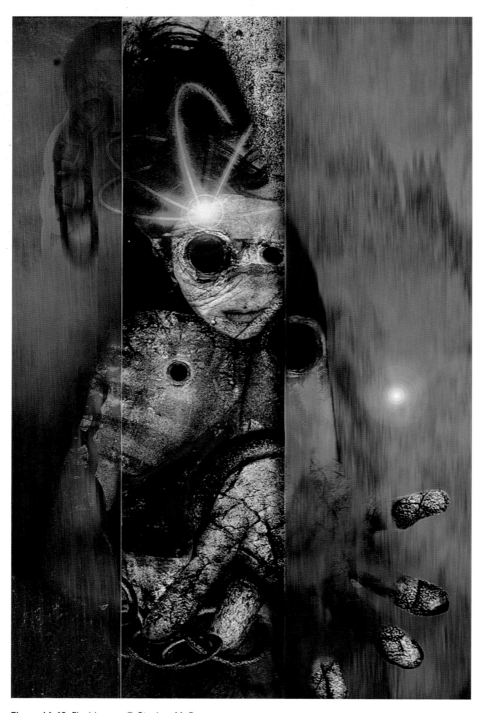

Figure 14.48 Final Image. © Stephen M. Burns.

Chapter 15

Painter Creativity: Transforming Your Photographs into Paintings

Jeremy Sutton

This chapter is intended to get you started with applying Corel Painter to your photographs. You will learn some basic techniques and procedures for emulating the look and feel of a pastel drawing and gain insights into mastering the vast array of brushes and art materials available to you in Painter software. The simple step-by-step approach to transforming your imagery shared here is intended only as a guideline to get you started. The best way to learn Painter is to experiment and explore on your own. Painter is a tool suited to a playful, improvisational, and intuitive approach to creativity.

Why Transform Your Photograph into a Painting?

You may not always succeed, but attempt to produce the greatest effect in the viewer's mind by the least number of things on screen. Why? Because you want to do only what is necessary to engage the imagination of the audience. Suggestion is always more effective than exposition. Past a certain point, the more effort you put into wealth of detail, the more you encourage the audience to become spectators rather than participants.

This quote by legendary film editor, Walter Murch, from his wonderful book, *In the Blink of an Eye*, cuts to the heart of the question, "Why should I make the effort to transform my photographs into paintings?" The old adage "less is more" applies to the enhanced emotional impact, power, and beauty we can achieve in our imagery by the use of brush strokes that selectively limit detail and guide the viewer's eye around our canvas.

Since the invention of photography, artists have used the captured photographic image as a basis for paintings. Historically, photographers have generally limited their use of paint to retouching and hand-tinting, leaving the creation of complete paintings to traditional painters. Now with the emergence of digital photography and digital painting, you have at your fingertips the opportunity to conveniently transform your photographs into beautiful paintings that you can then print onto canvas or fine art paper, taking your artistry and imagery to another level.

Your Digital Art Studio

Besides your camera, computer, and printer, there are two other key tools you will need to complete your digital art studio: Corel Painter software and a pressure-sensitive graphics tablet. All the techniques discussed here can be achieved with any version of Painter, though I recommend purchasing, or upgrading to, the latest version of Painter.

Your graphics tablet is your physical interface with your computer. When using a tablet, instead of holding a mouse you hold a special pen known as a stylus. Every point on the tablet surface corresponds to a unique point on the screen. Wacom tablets allow you to do everything you could do with a mouse (such as clicking, double clicking, and dragging in all applications), plus they add the extra dimension of pressure sensitivity that is crucial for controlling brush behavior in Painter. You will find once you start using a tablet you soon forget the mouse!

There are two models of tablet I recommend: the Wacom Cintiq, which is a combined LCD monitor and

tablet, and the Wacom Intuos3 Platinum 6 × 8 tablet. With the Cintiq you apply your stylus directly on the screen. This makes it very intuitive and easy to use, just like painting on a canvas. The Intuos3 6 × 8 is a light compact tablet that conveniently sits on your lap or in front of your monitor and, although not taking up too much space, is large enough for your hand to make fluid brush stroke movements (Figure 15.1).

The Ballerina: Emulating a Pastel Look à la Degas

In this project I show how I transformed the image of a ballerina, based on a photograph taken by David Taylor (www.photokailua.com) with his Kodak DCS 760 and

Figure 15.1 When using the stylus pen, keep the side of your palm on the tablet for maximum control. A mouse is also available. The Wacom Intuos3 Platinum 6 × 8 graphics tablet is shown in this example. Image courtesy of Wacom Technology.

Nikon 50mm f/20 lens. This project introduces the basic principles of working on photographs in Painter, which you can easily translate to your own work.

Step 1: *Preparation of your image in Photoshop.* Start by selecting your source image, resize and crop it if necessary, and make any adjustments to the image you believe are needed. This can be done in either Adobe Photoshop or Corel Painter. I generally start in Photoshop, crop the image, use Adjustment Layers (Levels, Hue/Saturation, etc. as needed), and save a master file in Photoshop format. I then flatten the image and resave another version in TIFF format (this is an important step because Adjustment Layers are not effective in Painter). It is this flat TIFF file that I then open in Painter as my original source image.

Step 2: *How big to make your source image.* Start with the end in mind. Ask yourself what size of final print you envisage and on what substrate. The size of your source image may vary according to your envisaged final usage— for example, ranging from 300 dpi at final size for high resolution print reproduction to 150 dpi at final size for a large format fine art print. Strictly speaking, dpi refers to the density of dots per inch that a printer produces, although it has also come into common usage to define the density of pixels in the digital image. If I need to resize my image, I generally resize the flat TIFF in Photoshop. As a general rule it's best to start with your raw image as larger, or slightly larger, than you need to avoid resizing up in size, which has a detrimental effect on image quality. In this case my original goal for this image was a magazine cover so I ensured I was working at 8×10 inches at 300 dpi.

Step 3: *To add a border or not—that is the question.* Continuing the theme of starting with the end in mind, ask yourself how you intend to mount or frame your final printed image. If you wish to print out on fine art paper and have the image fade into the paper like a watercolor, you may wish to add a white border to your source image that will allow you to conveniently

roughen and smear the image edge by hand. In Painter you do this by choosing Canvas > Canvas Size and adding the number of pixels of border you want in each direction. In this case I didn't wish to add a border.

Step 4: *Make a clone copy.* Choose File > Clone. This makes a clone (duplicate) copy of your original image. When you look at File > Clone Source you'll notice a checkmark by the original image indicating that it has automatically been assigned to be a Clone Source (Figure 15.2). In other words, the operation of cloning in Painter automatically establishes a special relationship between the original source image (Clone Source) and the Clone Copy (Clone Destination) image. Note that if

Figure 15.2 The Clone Source menu showing that the original image is automatically assigned as Clone Source. Original image © David Taylor.

Figure 15.3 Picking a background color from the Colors palette Color Picker.

you go back to working on a project later after closing down Painter, you will need to open up both the original image and the last working image and then manually set the original image to be Clone Source (using the File > Clone Source menu).

Step 5: *Fill the clone copy with color.* Select a color in the Colors palette Color Picker (using the Hue Wheel and Value-Saturation Triangle) that you wish to use as your background color (Figure 15.3). Choose Cmd/Ctrl F and fill your clone copy canvas with that color. In the case of Taylor's ballerina image, I decided to fill the clone copy with a beige background color.

Step 6: *Choosing a paper grain to apply to the background.* Having filled the clone copy with a flat background color, you have a choice as to whether to add the impression of paper grain in this background color. There are many ways to add the impression of paper grain to a surface in Painter. The first step in doing this is selecting the paper grain. You can select the Paper Texture either by using the Paper Selector below the Tools palette or from the Papers palette (Window > Show Papers). I like to use the Paper Selector in the Papers palette (rather than the Paper Selector below the Tools palette) so I can see a large preview of the selected paper and adjust its scale and contrast if needed. The default setting for the Paper Selector pop-up menu has the papers listed vertically with small thumbnails and the paper name. If you go to the small black triangle in the upper right corner of the Paper Selector, you can change the view option to thumbnail where you get a larger view of what the papers look like without any names (Figure 15.4). I personally find the thumbnail view more convenient.

Step 7: *Using dye concentration to apply a paper texture to the background.* My favorite effect for adding paper grain is the Effects > Surface Control > Dye Concentration (Figure 15.5). I then select Using: Paper in the Dye Concentration window and adjust the

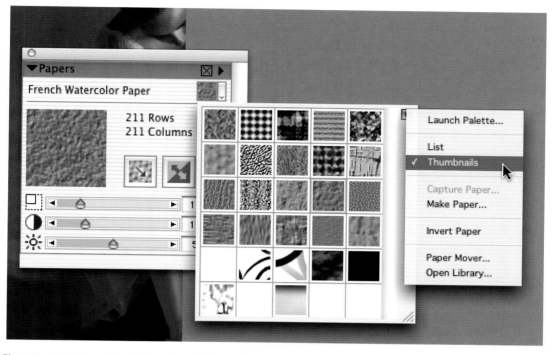

Figure 15.4 Selecting a Paper Texture from the Papers Selector in the Papers palette, showing List (left) and Thumbnail (right) options.

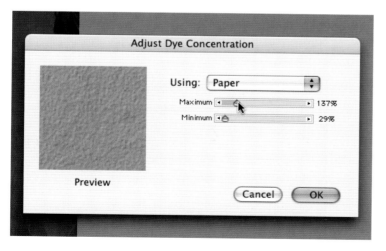

Figure 15.5 The Dye Concentration effect window with Using: Paper selected.

Max/Min sliders until I like what I see in the preview window.

Step 8: *Fading back dye concentration.* When applying an effect like this, it is easy to overdo it, in which case you can use Edit > Fade to fade the effect back anywhere from 0 to 100%. If I am going to print out the final image on a watercolor fine art paper that already has a built-in grain, then I may choose not to artificially add paper grain to the background. In this case I added a subtle grain because the image was going to be reproduced on a smooth glossy magazine cover (the *Rangefinder* magazine).

Step 9: *Rename clone copy.* Throughout a project save stages of your work regularly with sequential version numbers. When renaming a clone copy, choose File > Save As. Rename your clone copy image, getting rid of the "clone copy" and including a version number (01). I often add a short note after the version number reminding me what brushes I used or what I did in that stage. These title notes can be very useful when looking back later and trying to recall what brushes you used and so forth. In Painter 9 there is an alternative to Save As, which is File > Iterative Save. This automatically adds a sequential three-digit version number to the end of your file name (001, 002, etc.). It is safest to save your working image in Riff format because it preserves the ability to edit all special layers and plug-in effects in Painter. Riff is the native format for Painter and cannot be opened in Photoshop. Be consistent with your file naming system. Save all files, including your original, for a given project in a single project folder that is placed in a logical location. I recommend always backing up your latest working file as a TIFF (if flat) or as a Photoshop file (if there are layers) before you quit out of Painter.

Step 10: *Mount clone copy.* Choose Cmd/Ctrl M. This mounts your clone copy file and simplifies the desktop. You can toggle between mounted and unmounted using the same keyboard shortcut.

Step 11: *Choose a brush to paint with.* Brushes in Painter are grouped into brush categories. Within each brush category there is a group of individual brushes known as brush variants. Brushes are chosen in Painter by first selecting the Brush Category in the Brush Selector (left-hand icon) and then the specific Brush Variant from within that category (right-hand icon). You have three main choices of brushes at your disposal to apply to your clone copy image:

1. Brushes that paint color taken from the original source image
2. Brushes that paint the current color selected in the Color Picker
3. Brushes that don't add any color but instead smear or blend color already on the canvas

 In this example I chose the Chalks Brush Category > Large Chalk Brush Variant, which is an example of a brush that paints the current color selected in the Color Picker (Figure 15.6). Other brush categories that are good for a grainy, chalky, pastel look include Charcoal, Conte, Pastels, and Oil Pastels. Check out the brush variants in these other brush categories.

Step 12: *Choose paper texture for grainy brush.* The chalk brushes are grainy brushes that reflect the currently selected Paper Texture. You can choose to either leave the paper texture as the same one you selected for the background or you could alter and experiment with different paper textures.

Step 13: *Brush research.* At this point I pick a bright color that contrasts with the background color on my canvas. I then make test brush strokes while adjusting the sliders in the Brush Property Bar to get the size, opacity, and graininess of the brush stroke to suit the scale of features I am going to paint.

 I generally lower the opacity to get better control and more subtlety. The default opacity for many brushes is 100%, which I find too high. I prefer to build up my

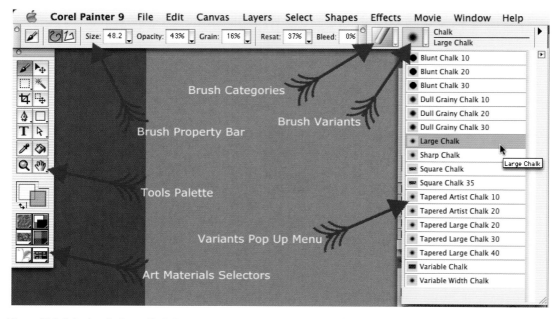

Figure 15.6 Selecting the Large Chalk Brush Variant from the Brush Selector.

brush work gradually, especially with a pastel look. I recommend when embarking on any project that you always take a little time for brush research where you check out different brush variants and, if relevant, paper textures, so you can home in on the combination that best suits your image and the look you are seeking. You have up to 32 levels of Undo (Cmd/Ctrl Z) as default in Painter. When you've completed your brush research just Cmd/Ctrl Z repeatedly until all your brush strokes have disappeared. If by chance you'd done more than 32 research brush strokes, then just select File > Revert, which brings your canvas back to its last saved state (i.e., before brush research).

When you adjust to brush settings that you wish to come back to again and again, I suggest you choose Save Variant from the Brush Selector pop-up menu

(click on black triangle in upper right of Brush Selector). This allows you to create your own custom-named variants.

Note that, for adventurous souls, more advanced and deeper levels of brush adjustment and customization are available in the Windows > Brush Creator. However, I would suggest leaving this until you are comfortable with the basic painting mode operations in Painter.

Step 14: *Convert your chalk into a cloner brush.* To turn the large chalk into a clone brush that takes color from the original (Clone Source) image rather than the color picker, click on the Clone Color icon (looks like the Photoshop Rubber Stamp) located just below the hue wheel in the Colors palette (Figure 15.7). Notice the color picker is now rendered inactive (grayed out).

The Clone Color icon, which I refer to as the photographer's "Magic Button," can be used to turn almost any brush in Painter that paints color into a clone brush. The clone Chalk can now be used to paint color into your current working image, or destination image, based on color in your original, or source, image. Click on the same Clone Color icon to return a brush to regular color (the color picker will be made active and rendered in full color intensity). Note that the brush variants in the Cloners category are all set to be cloners by default.

Figure 15.7 Color palette showing the Clone Color icon, or "Magic Button," activated and the Color Picker deactivated.

Step 15: *Turn on Tracing Paper.* Choose Cmd/Ctrl T (Canvas > Tracing Paper). This turns on Tracing Paper, which allows you to "see through" to your underlying original image for visual reference (Figure 15.8). What is really happening is that Tracing Paper creates a visual mirage that superimposes your original image at 50% opacity with your current working (destination) image at 50% opacity.

Tracing Paper can be misleading because you don't accurately see how you're affecting your image as you paint. Therefore I recommend using it sparingly. When you do use Tracing Paper, turn it off frequently (Cmd/Ctrl T toggles Tracing Paper on and off) so you can see what your image really looks like.

Figure 15.8 Tracing Paper turned on, giving a visual reference that can be used for placing brush strokes.

Step 16: *Start general.* Start with a large soft brush and gently brush in overall blocks of tone and color without worrying about detail. Use this large soft brush to map out the basic forms of your main subject and, if needed, the background (Figure 15.9).

Step 17: *Work toward detail.* As you start to define more details in your painting, reduce the size of your brush to suit the scale of the features you are painting (Figure 15.10). Follow the forms of your subject as you paint, as if stroking a sculpture.

Step 18: *Add your own color.* Click on the Clone Color icon so it is inactive and the color picker is reactivated. Select your own colors in the color picker to add to your image, picking up the highlights and shadows, adding warmth and color to draw the viewer's eye to the main focus of your composition (Figure 15.11).

Note that besides the use of clone color or the Colors palette Color Picker (Hue Wheel and Value-Saturation Triangle) there are two other main ways you could pick color: the Color Mixer and Color Sets. The

Figure 15.9 Starting with large general brush strokes to evoke basic forms.

Figure 15.10 Working into detail with small brush strokes following forms and shapes of underlying composition.

Figure 15.11 With Clone Color off and adding your own color to the image to bring out selected regions, boundaries, and contrasts.

Mixer gives you a mixing palette scratch pad that is more akin to the traditional painter's way of mixing colors on their palette.

There are many Color Sets to choose from. Each Color Set is a collection of color swatches where you just click on a color swatch to select that color. You can easily generate your own custom color sets. Color Sets are useful when you want to limit your range of colors.

Step 19: *Blending your colors with Clone Color.* You may find that, particularly in the skin areas, your added color brush strokes may look a bit blotchy or stand out too much. One way to blend them into the surrounding color is to simply recheck the Clone Color icon and softly brush over the edges of color with clone color (Figure 15.12).

Step 20: *Smearing, smudging, and blending.* Choose Blenders Brush category > Just Add Water Brush Variant in the Blenders category. Lower the opacity and apply gently with light pressure. This brush is good for softly smearing some of the chalky brush strokes, especially at the edge (Figure 15.13).

Other good variants for blending and smearing in the Blenders Brush Category are the Grainy Water, Smear, and Runny Brush Variants.

At this stage a lot of your brush choices will depend on whether you wish to keep a strictly pastel look and feel to your painting or whether you wish to go for a more watercolor look and feel. For instance, the

Figure 15.12 Blending a patch of color with Clone Color.

Figure 15.13 Applying the Just Add Water Brush Variant to smear the chalk.

Distortion Brush Category > Diffuser Brush Variant and any of the Digital Water Color variants will give a more watercolor than pastel look.

Step 21: *Final touches: bring back some of the original image.* Choose the Cloners Brush Category > Soft Cloner Brush Variant. The Soft Cloner is your "safety net" brush. It is the brush that brings you back to your original photograph. I recommend using this brush sparingly with low opacity and soft pressure. I used the Soft Cloner to subtly mix in some of the original image, for instance, around the face, eyes, and hair, and some of the detailing of the dress (Figure 15.14). It is also useful for defining important contours and boundaries in the composition that may have become obscured in the pastel brush work.

Once you've brought back hints of the original image, use your cloning chalk and blending variants to blend the Soft Clone areas into the rest of the image. Avoid having regions of pure photograph that jump out from the pastel brush work and detract from the beauty and harmony of the final image.

The security of the Soft Cloner Brush Variant gives you unlimited freedom to experiment without any risk. No matter how messy your painting, you can always use the Soft Cloner to bring any portion of your image back to the original photograph. By saving stages as you go (using Save As and renaming with sequential version

Figure 15.14 Using the Soft Cloner to subtly bring back some of the original photograph.

numbers) you can also use the Soft Cloner to clone back any portion of your image to any saved stage (just open the saved stage and manually set it to be Clone Source). Welcome to the power and versatility of computer painting!

Your Next Step

In the limited space available here I have only been able to give you a taste of what's possible. There is so much more I would like to share with you, such as watercolor and oil techniques, making the most of the Custom Palettes, using the Brush Creator to create your own wonderful custom brushes. The bottom line is dive in and have fun! Don't be shy about experimenting and taking risks with your imagery. The best way to learn Painter is to simply have a go.

Happy Painting!

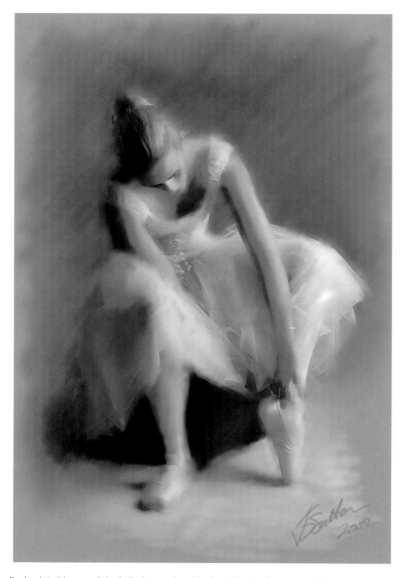

Figure 15.15 The final painted image of the ballerina rendered in the style of a Degas pastel drawing. Final image © Jeremy Sutton.

Part 5

ADVANCED DIGITAL OUTPUT

Chapter 16

Inkjet Printing and Color Synchronization

Joe Farace

From the beginning, I have placed great emphasis on the fact that darkroom work is an important element in the creative photographic process.

—Wynn Bullock

Ansel Adams, who was also a pianist, often compared photography with music. He believed the act of capturing the image was the production of the musical score, but the finished print was its performance. Nowadays it is more likely that this print will be digital than silver based.

Printing photographic images in your desktop darkroom means no more working in the dark, fingers soaking in smelly, maybe dangerous, chemicals while waiting for results to appear on dripping wet paper. This is not to demean traditional darkroom methods; there is nothing more luminescent than a platinum or palladium contact print made from a properly exposed large format negative. Printing using digital technology is simply the latest link in a chain that started when Louis Jacques Mandé Daguerre placed a silver covered copper plate in iodine vapors and watched an image appear.

Some photographic purists may scoff at digital printing, claiming that the images created using computer technology are not permanent, but the truth is that whereas some traditional photographic prints may be processed to ensure permanence, others, through either the

choice of materials or the processes used, may not be either. In much the same way, some digital prints may be produced using inks and papers that *will* create an archival print, whereas others may not. The choices made by the image maker, whether through experience or inexperience, determine the final result.

Everything You Didn't Think You Needed to Know About Inks and Papers

We all know how today's photorealistic inkjet papers work, don't we? All you have to do is stick in some paper, tell Adobe Photoshop to print photo quality output, and the results are always perfect. Right? If that hasn't been your personal experience, maybe you need to read what follows.

All inkjet printers spray ink through nozzles—*jets*—onto paper and the technology used to print images falls into two general categories:

- Micro piezo: Much like a tiny *Super Soaker*, the micro piezo print head used in Epson printers squirts ink through nozzles using mechanical pressure. Depending on the amount of current applied, the print head changes shape to regulate the amount of ink released.
- Thermal: In this system used by Canon, Hewlett-Packard, Lexmark, and others, ink in the print head is heated to its boiling point and expands to where it's forced though the print head's nozzles in and onto the paper. There are variations with how each company accomplishes this, but you get the idea.

Some printers have nozzles built into the print head, whereas others place nozzles in the ink cartridges, but I've never seen much visible difference in the output. How much ink exits the print head is measured by *droplet* size. In general, the smaller the size, the better the image quality. Ink droplets are measured in *picoliters*, which is one million *millionth* of a liter! Printer resolution is rated in dots per inch or *dpi*. A 720 dpi device prints 518,400 dots of ink in 1 square inch; the greater the number of dots, the higher the resolution.

Out Here in the Real World

One of the first things digital imagers are in a hurry to do after capturing an image is to print it. It is here in the real "digital darkroom" where technical advances have freed them from most of the restrictions of the traditional wet darkroom.

Once an expensive luxury, photo quality printers are affordable for even the most casual snapshooter, but it wasn't always that way. The photo printing landscape changed with Epson's (www.epson.com) 1995 introduction of the Stylus Color inkjet printer, a device under $500 that could output text as well as 720 dpi photographic quality images. In talking with professional photographers around the country about how they used photo quality printers, their answers broke down along the line of the three "Ps"—proofs, prints, and portfolios.

- Proofing: Most digital color printers started life as proofing devices for making a quick approval print for a client before producing separations, and many photographers still use their desktop printers for proofing. A paper proof printed on inexpensive but high quality media provides insurance that the image looks the way it looks on your monitor. Because large format paper is expensive, I always make proofs on inexpensive paper, such as Epson's Inkjet Photo Paper, when getting ready to print 11×17- or 13×19-inch images. Making a paper proof is also a good idea when sending a digital file to a client or service bureau so the recipient knows what the finished image should look like.
- Printing: Like many photographers, I often deliver inkjet output for images that don't require long life, such as business portraits and model head shots. Certainly, papers and inks used with some of the latest inkjet printers produce prints that have a life as long as a lab-made "C" print. For most applications, the people receiving the prints don't even ask if they're "digital" because they look just like "real" photographs.
- Portfolios: For professional and aspiring professional photographers, one of the advantages of producing

photo quality output in-house is the ability to update and customize a portfolio. Having an inkjet printer, like the Epson Stylus Photo 1280, Stylus Photo 2000P, or the Stylus Photo 2200, lets photographers print high quality portfolio images up to 13 × 19 inches.

What's the Bad News?

The revolution in color inkjet printing technology forever changed the deskscape. For less than $100, inexpensive printers from companies such as Canon, Epson, HP, and Lexmark let you produce photographic quality output, but there is a price to be paid for this capability. As Ford Motor Company discovered when they started making their automobiles quieter, the quieter they made the cars, the more noise they found. As color printers became better and better (and cheaper too), computer users began to demand more from them, not just higher resolution but better, more accurate color. This quest engendered an endless cycle of continued printer improvements to find color nirvana: WYSIWYG color.

Before starting on the path to accurate color there are many roadblocks that must be overcome, including price. Somewhere along the way, you are going to have to stop and ask yourself this question: "How much am I willing to pay for accurate color?" Your answer determines which of the several available software and hardware solutions are appropriate for your situation. That's why one of my goals in this chapter is to point you toward inexpensive solutions to the color management dilemma.

Real-World Color

There are few obstacles standing in the way of obtaining an exact color match between what you see on the monitor and what your printer will deliver. The most fundamental difference is that when looking at a monitor you are viewing an image by *transmitted* light. Much as when viewing a slide on a light box, light is coming from behind that image. When looking at output, you are seeing

the print by *reflected* light. Right away there is a difference, but these differences can be exacerbated by environmental factors, including monitor glare and ambient light color. Although light may appear white to our eyes, it actually comes in many hues. Image makers interested in this phenomenon can read about it in my Focal Press book, *Better Available Light Photography*.

Depending on chemical composition (more on ink idiosyncrasies later), the output of printers using pigmented inks exhibits a characteristic called *metamerism*. If you look up "metamerism" in the *American Heritage Dictionary of the English Language*, Fourth Edition, 2000, it states this is "The condition of having the body divided into metameres, exhibited in most animals only in the early embryonic stages of development." Aren't you glad you know that? As the coachman said to Dorothy when taking her to see the Wiz, that is "a horse of a different color." Metamerism refers to situations where output from a color printer looks fine under one set of viewing conditions but not under another. When this occurs, the match is said to be *conditional*. Other types of metamerism include geometrical and observer metamerism. What all this mumbo jumbo boils down to is that sometimes colors look one way under certain lighting conditions and different under another.

Because metamerism can never be completely eliminated with output from some desktop printers, you should make sure it's originally viewed under consistent lighting. If you go into any professional photographic lab or a commercial printer, you'll find a special area set aside for viewing output. This area will have test prints posted and will have lighting fully corrected for daylight. If it looks good there, as the song goes, it'll look good anywhere. Most computer users can't afford the kind of viewing boxes professional labs have, but Ott-Lite (www.ott-lite.com) sells affordable accessory lamps that can bring color correct viewing to your desktop printer. They offer a family of modestly priced VisonSaver lights that you can place near your printer to help you see color

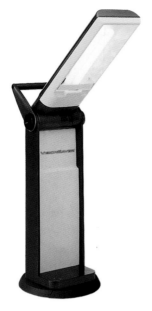

Figure 16.1 Ott's 13-watt portable lamp.

properly. Ott's 13-watt portable lamp (Figure 16.1), for example, should fit into anybody's workspace and is blueberry colored to match Apple Computer's original iMac. A similar model in a neutral graphite color is available to match the Power Macintosh G4.

Calibration Options

Once you're aware of the effect of environment on output, you need to take steps to bring your computer system into color harmony. There are a few ways to minimize problems, but the key is in knowing what the color of your image is to begin with. Using Adobe's Gamma software (www.adobe.com), which is automatically installed with recent versions of Photoshop, or even the inexpensive Photoshop Elements is the first step. The Gamma control panel lets you calibrate your monitor's contrast and brightness, gamma (mid-tones), color balance, and white point. There are two ways to work with Gamma and both are easy, including a step-by-step wizard approach. More detailed information of setting Gamma can be found in Adobe's on-line technical guides (www.adobe.com/support) and in Chapter 1. The settings you obtain by working with the Gamma control panel are used to create a *profile* for your monitor that is used by color management systems such as ColorSync for the Mac OS and Microsoft's ICM for Windows.

Although Gamma isn't perfect, it will get you into the ballpark. Once again, the better the color match, the pickier you may become. The secret in pursuing the quest is *not* to hunt until the color dragon is slain but until you are satisfied, considering how much it has cost so far, with the match between monitor and print. One of the least expensive ways to calibrate your monitor is by using ColorVision's (www.colorcal.com) Monitor Spyder. This is a Plexiglas and metal device that attaches to your LCD or CRT monitor, the way you may already have stuck a stuffed Garfield there. When used with ColorVision's software, such as PhotoCal or OptiCal, it's relatively

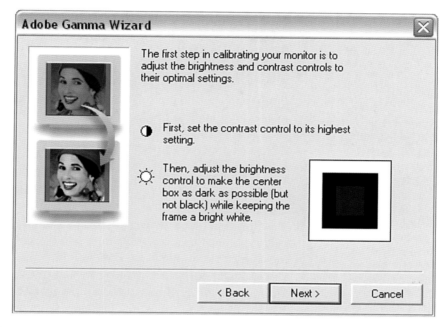

Figure 16.2 Adobe Gamma Wizard. Original image © Joe Farace.

simple to calibrate your monitor. This combination of hardware and software can calibrate any CRT monitor and will produce International Color Consortium (www.color.org) profiles for Mac OS and Windows color management systems. I found the hardware and software easy to use, although environmental factors initially gave me a too-red profile until I fashioned a homemade monitor hood out of neutral gray cardboard, shielding the Spyder and screen from colored light pouring though translucent green window blinds.

Monaco Systems (www.monacosys.com) offers a color management package that includes MonacoPROOF software and X-Rite's Digital Swatchbook spectrophotometer. Digital Swatchbook works with Macintosh or Windows computers using measured

spectrophotometer readings for color managing desktop computers. MonacoPROOF builds custom ICC profiles to let you obtain accurate color from scanners, digital cameras, monitors, printers, and even color copiers. The software has a wizard-like interface that guides users through the profiling process and displays on-screen images accurately to produce "soft" proofs. Some devices, such as the Epson Stylus Photo Color 1280, bundle a copy of Monaco EZcolor Lite that lets you create a single monitor profile for your system.

Output Solutions

You may find that after you've tried one of these monitor calibration methods, although on-screen image and output are a much closer match, they are not quite the same. (Don't forget differences in reflective and transmitted light and the possibility of metamerism.) In my own case after happily using Adobe Gamma for many years, I started using ColorVision's Monitor Spyder and PhotoCal software. The result was that output from my printers looked *better* than it did on screen. If you're still not happy with your prints, it's time to look at output profiling.

There are two kinds of people in this desktop darkroom: those who need output profiles and those who don't. When using inkjet or even laser output as a proofing media, prepress users know output profiling is critical. The client, who doesn't know anything about *metamerism* or Lord Kelvin (see Sidebar), expects the off-the-press product to look just like the proof the designer shows them. Photographers who are using inkjet output as the *final* product have different needs from prepress users. All these people need is for the prints to match their monitor or their original vision of how the image should appear—what Ansel Adams called *previsualization*.

Prepress users need slightly more expensive solutions to their color problems, and there is help from some of the

Lord Kelvin to the Rescue

Long before Edison invented the incandescent light, Lord Kelvin, an Englishman, proposed a temperature scale suitable for measuring low temperatures. During the nineteenth century, he suggested that an absolute zero temperature should be the basis for his scale. Lord Kelvin's idea was to eliminate the use of negative values when measuring low temperatures with either the Fahrenheit or Celsius scales. In honor of his contributions, this system is called the Kelvin scale and uses the unit "Kelvin" or sometimes just "K." The color temperature emitted by light sources is measured in degrees on the Kelvin scale. The sun on a clear day at noon measures 5500 degrees Kelvin. On an overcast day, the color temperature of light rises to 6700 degrees Kelvin, whereas 9000 degrees Kelvin is what you'll experience in open shade on a clear day. These higher color temperatures are at the cool or blue end of the spectrum. On the lower side, however, light sources are on the warmer end of the spectrum. Lights used by videographers or photoflood lights have a Kelvin temperature of 3200 degrees. Household light bulbs are close to that color temperature and measure about 2600 degrees. A sunrise may be well down on the Kelvin scale—at about 1800 degrees.

companies that provide input solutions. A great companion to ColorVision's Spyder Monitor is their Profiler RGB software, which is one of the neatest ways I've found for color managing a desktop printer. ColorVision provides target files that you output on your printer. After you digitize that output with your scanner, Profiler RGB compares your image with the original file and creates a unique profile for a specific paper–ink–printer combination. If you're serious about color management, you might want to check out two other ColorVision products. Doctor Pro software lets you edit RGB and CMYK printer files and uses Photoshop's capabilities to create adjustment scripts for editing output profiles, including color cast removal, opening shadows, correcting color mismatches, and adjusting brightness, saturation, and contrast.

The second group of users has several software options, including two useful Photoshop-compatible plug-ins. Vivid Details (www.vividdetails.com) Test Strip functions the same way a traditional darkroom worker might produce a test strip. Printing a digital Test Proof shows what the image looks like with user-specified increments of additional cyan, yellow, and magenta or red, blue, and green so you can see how much of what color to add in the printer driver to get output matching your previsualization. Its Metamorphosis feature is a guided system (Figure 16.3) that corrects images based on a user's response to a series of side-by-side on-screen comparison images generated from your original photograph. All you have to do is click the image you prefer and keep making choices until the software figures out what you *really* want and produces the finished version.

Extensis (www.extensis.com) Intellihance Pro offers some similar yet different capabilities (Figure 16.4a) within the context of its interface. Both plug-ins are available in Mac OS or Windows versions, and you can download trial versions from their respective websites.

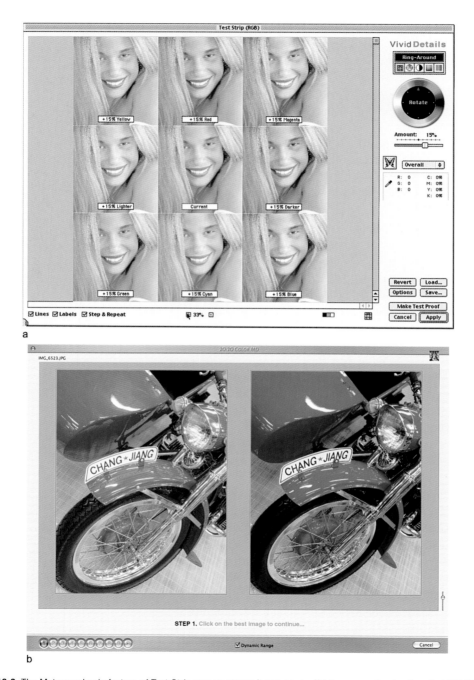

Figure 16.3 The Metamorphosis feature of Test Strip was so strong it was spun off into a separate plug-in called 220.20 color MD from PhotoTune (www.phototune.com) shown in Mac OS X form. (Original images © Joe Farace.)

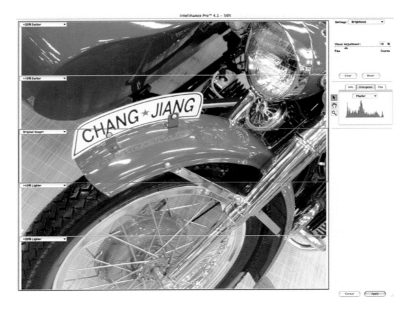

Figure 16.4a Extensis Intellihance Pro. Original image © Joe Farace.

Ink on Paper

Four-color inkjet printers have the same cyan, yellow, magenta, and black color combination used by commercial printing presses. To reproduce delicate textures such as skin tones and metallic surfaces, six color printers add light cyan and light magenta. Some Epson (www.epson.com) printers, such as the Stylus Photo 2200, use *seven* colors, adding a light black for more depth and better monochrome reproduction. There is a trend to keep adding more colors. Most desktop inkjet printers use one or two ink cartridges, but professional inkjet printers typically have a separate cartridge *for each color*, something Canon (www.canon.com) popularized for desktop photo printers.

Inkjet printers do *not* have the same ink formulations. Some companies use pigmented-based inks for their black ink cartridge and dye-based inks in their CMY or CMYcm color cartridges, whereas others use all dye-based inks or all pigmented inks. Why do you care? Pigmented inks last longer but are not as vibrant; dye-based inks are colorful

but have less longevity. On plain paper, dye and pigmented inks mix easily because of this media's high ink absorption rate, but when printing on coated stock, such as photo paper, printers with different types of inks turn *off* the black ink. (Black in the output then becomes a composite of the CMY inks.) Pigmented black ink is slightly better than dye-based ink for printing sharp, dense, black text on plain paper, and some manufacturers prioritize black text over photo quality. Epson's UltraChrome ink, found in the Stylus Photo 2200 and their large format printers, is water resistant and provides bright colors that are similar to dye-based inks but retains pigmented ink's lightfastness.

Because of these differences, selecting the paper type in the printer driver is a critical step in achieving the best possible output. Each type of paper shown in the printer software driver uses a different look-up table and assigns different ink saturation. *Any* inkjet printer can print black and color inks on plain paper at the same time, but if you select the wrong media—either by accident or on purpose—you'll get poor results. So what do you do to get the best results?

- Read the paper's instruction sheets to see which driver settings are compatible with the paper and what settings should produce the best results.
- Not every paper and ink combination works together perfectly. Before making a big investment in papers, purchase a sampler pack or small quantity of a paper and make prints with your *own* test files (more on how to do this later). Write notes about the settings and paper on the back of the prints and put them away in a file for future reference.

Ink Alternatives

There are all kinds of generic inks out there that are theoretically designed to replicate OEM (Original Equipment Manufacturer) inks, and if you don't mind getting messy, you can refill those puppies yourself. Using non-OEM inks will void your printer warranty. A few of

my friends and several readers of my books and articals have purchased home-placement inks to use in consumer and professional Epson inkjet printers. Within a short time, *all* of them had to send their printers back to the manufacturer for repair, and those costs exceeded any savings they never realized.

On the other hand, I know many more people using replacement inksets, especially continuous flow systems from Luminous (www.luminos.com) and Media Street (www.mediastreet.com), who have been happy with the results. A user of Media Street's Niagara II system told me, "I am not only saving a tremendous amount of money…but I also get the advantage of using specialty ink which allows me to print long lasting photos right from my inkjet…and will never run out of ink again in the middle of a print."

The real question to ask is do I really care what the output looks like? Although your printer is still covered by a warranty, your best bet for achieving that goal is with OEM inks. On-line websites such as InkjetArt.com have some of the best prices available anywhere on OEM ink and paper. I advise digital imagers who want to work with archival and gray ink sets to do it with *another* printer, not the bread-and-butter model used for everyday work. Go to eBay or look for deals at the sales shelves of computer superstores to find discontinued models and experiment to your heart's content with cheap, recycled, or whatever home brew ink you want.

Black and White in Color

One of the biggest challenges in color managing output is printing black and white or monochromatic images. This is especially a problem with inkjet printers because the best you can accomplish by using colored inks is cool or warm toned output. When used with printers using pigmented inks, metamerism rears its colorful head. You can always print using black ink only, and I have successfully produced output this way, especially using 2800 dpi printers, but the results are heavily dependent on the

original image. To get truly continuous tone black and white output, you need a grayscale inkset. These replacement inksets and complimentary software are available from companies such as Lyson (www.Lyson.com) and Cone Editions Press (www.piezography.com). These companies offer archival quality inks that when used with acid-free paper produce museum-quality giclée images that can be sold in art galleries anywhere in the world.

Print Me

Sometimes it seems that different people can get different results from the same photographic file, printed while working with the same kind of inkjet printer while using the same kind of paper. How is this possible? The biggest difference is that one of these pixographers is getting the most out of his printer's driver, whereas the other is just clicking the "Print" button. I get this question all the time from people who ask why the prints made on my printer look different from those that they're making with the same brand and model of inkjet printer.

There are a few steps you should take before even starting to work with your printer's software.

Download the latest printer driver (Figure 16.4b). Don't assume that just because you unpacked a brand new printer you'll have the latest driver. *Au contraire, mon frére*. It may be that support has been added for new different kinds of paper for it or bugs have been fixed, but take the time to go to your printer manufacturer's website, download the most current driver, and then install it. Don't forget to check back periodically for updates.

Clean the printer heads! So many time photographers come up to me with inkjet prints and ask what's wrong with them, when the answer is simply that the heads are clogged. In the next section you will get to know your printer driver, but the most important is head cleaning! How do heads get dirty? If the printer is left on and not

Figure 16.4b

used regularly, air gets into the heads and clogs the ink.
Make sure you have the printer turned OFF unless you
plan to use it. Plus print heads get dirty or clogged from
not being used, so try to use them every day. But mostly
inkjet print heads get dirty because that's what they do.
Until somebody invents a self-cleaning head, we'll have
to clean them periodically wasting precious Dom
Perignon-priced ink in the process. Hey, you used to
have to scrub your oven by hand too; now self-cleaning
ovens make that chore a cinch. So maybe somebody will
figure out something similar for inkjet printers or
maybe not.

*And before you make your first print, you should do
something that some readers may find difficult:* read the
instruction manual. If you do, you'll usually discover
several utilities that will help your printer produce the
best possible results. With new Epson inkjet printers, it's
always a good idea to run both the Head Alignment and

Figure 16.5 Epson Printer Utility

Nozzle Check utilities (Figure 16.5) before putting in any "good" paper and making a print. Some new printers run two-head alignment tests, one for black ink and the other for color. When you run these tests, it's a good idea to evaluate the output using a high quality loupe so that the feedback you provide the utility is as accurate as possible.

Get to Know Your Printer Driver

Some printers, such as Hewlett-Packard's PhotoSmart line, have built-in calibration routines that set up the device after you've made your initial connections. With most computer systems, this will most likely happen when the printer driver is installed, but you may also need to recalibrate it from time to time. HP's PhotoSmart Toolbox software, which is bundled with printers such as the PhotoSmart P1100, let you perform an automatic series of diagnostics and corrections and when completed it outputs a test page.

No matter what brand of printer you use, its driver software has many controls (Figure 16.6) that allow you to print on different kinds of paper, which are usually those offered by the printer manufacturer. Although you can use other products, such as ColorVision's Profiler RGB, to precisely calibrate a specific kind of paper for your printer, the driver itself provides enough controls that let you fine tune the color, density, and contrast of your output. I liken these controls to manual tweaking a color enlarger in a traditional wet darkroom.

Figure 16.6 Printer driver settings.

What's a Driver, Anyway?

After connecting your printer to a computer, you need to install software that lets the two devices communicate. This is called "driver" software because it *drives* the printer and makes it work. With Mac OS computers, I prefer to insert the driver software CD-ROM and then double click the icon to make it work. With Microsoft Windows computers I've found the most prudent way to install printer drivers is by connecting the printer and restarting the computer. This will cause Windows' Plug-and-Play feature to recognize that a new device is connected and will guide you through the process of installing the driver. Although more experienced computer users may believe they can just install the hardware and then install the software, I've often found that when working with some printers, *not* using Windows Plug-and-Play installation features can create problems with partially installed software. This is more trouble to fix than simply letting Windows guide you through the installation in the first place.

Printer drivers do more than just direct your computer to send data to the printer. In most cases, the drivers let you specify information about the kind of paper you're using and how you want the finished print to appear. You can simply pick the kind of paper you're using: click the Automatic button, set the slider to Quality, and you'll usually get a pretty good output but maybe not the best possible print. Just as you sometimes need to take your camera off its automatic mode and apply all your experience and take manual control over a special photographic situation, there are times you need to do the same thing printing digital images. With most drivers, you can tweak output by slightly increasing or decreasing brightness or contrast settings as well as the color balance to get the best results. Before making a print, take a look at any Advanced settings available in the driver. For many inkjet printers, they include full manual control over the output's brightness, contrast, saturation, and color, but before you work with these controls, it's a good idea to create a personal test print file.

Making a Personal Test Print

Some inkjet printers automatically output a test page shortly after you connect it to the computer and install the driver, and although these pages may tell you that the printer is actually working, you may want more information than that. One of the best ways to discover your printer's capabilities is to create and print a "personal" test print.

Comparing test prints is one of the best ways to evaluate different kinds of printers as well as different brands of paper. I'm not talking about the kind of test prints seen in computer and electronics stores where you press a button and output rolls off the printer. Although these files are usually optimized to make the printer look good, the output can be compromised if the paper used is either the best or cheapest available. In this kind of setting, there are too many variables present to use these test prints

for comparing one printer with another. The key to comparing results from different printers or papers is to create a standardized test file and use *it* to compare results.

Your personal test file should reflect your typical image, whether it's a portrait or landscape photograph. Use your favorite image-editing program to save a photograph in a high resolution format such as TIFF. Instead of making the image 8 × 10 or full letter size, keep it around 5 × 7. This will make the file size smaller and take less time to print. The file should then be saved on some kind of removable media, such as recordable CD/DVD or Iomega Zip disk, so it can be found later when testing new printers, inks, or papers.

Start by printing the testing image on your own printer, but also ask friends if you can output it on *their* printer so both of you will be able to make a valid comparison. Use the test print with the printer driver's Advanced settings and experiment with the slider settings for brightness or contrast. Then take a look at color bias. For this test, a monochrome version of your test file will clearly show any kind of color shifts for the paper, inks, or printer because color shifts will be more apparent with theoretically no color in the image. Working with your customized test file will let you know what driver settings will produce results you like and can also be a big help when evaluating different kinds of paper brands. After a little testing, you'll find the best paper and settings that will produce the optimum quality output from your printer.

Inkjet Papers

The inkjet paper you use can have a dramatic effect on the quality of your output. Printer manufacturers may insist that the best output will *only* be produced when using their papers, and I won't argue that some of them are spectacular, but we wouldn't be photographers if we weren't looking for something different. When working in a traditional wet darkroom, I used Agfa, Ilford, and Kodak papers and would try to match the paper used to

the image. Now I keep papers from Adorama, Epson, Ilford, Legion, Tetenal, Pictorico, and others on hand and use the same concept of matching paper to the image's mood. I like glossy shiny papers such as Epson Premium Glossy Photo Paper and Konica's (www.konica.com) Professional Glossy QP for photographs of automobiles and other shiny machines. Portraits look fabulous on Tetenal's (www.hpmarketingcorp.com) Pearl Lustre or Legion's (www.legionpaper.com) Matte paper, but don't let yourself get bound by anybody's dictums. Adorama (www.adorama.com) offers a true heavyweight paper (80 lb. 12 mil) that's double-sided matte and perfect for use in presentations or portfolios. Complementing their Double-Sided Matte is a Double-Sided Matte Gloss and a Royal Satin, which has a fine "pearl" surface. Experiment!

Experimenting with different kinds of papers with interesting textures and ink absorption characteristics can be fun, but judging from the questions I get during *Shutterbug's* digital workshops, this is often when fun goes *out* of the process. The stock answer is that you should create a custom profile that is hardware, ink, and paper specific. Many new digital imagers don't want the hassle involved, but some forward-thinking paper companies are taking steps to put that creativity back into printing. Legion Paper and other paper companies have created generic profiles for each of their papers and different kinds of inkjet printers. Custom profiles can also be purchased from on-line resellers such as GalleryPrint (www.galleryprint.com) and InkJetMall (www.inkjetmall.com).

I used to go to the art supply store to find papers with interesting textures, but now papermakers such as Legion, Hahnemühle (www.s-und-s.de), and even Adorama are offering interesting surfaces. But there's more than just creating art or snapshots. There are all kinds of interesting craft projects that you can produce with your inkjet printer. Epson and Adorama offer T-shirt transfer papers that can be first printed on your inkjet printer and then, using a moderately warm iron, "ironed" onto a plain T-shirt.

Although the *safest* way to get the best possible results is to use the inks and papers produced by the printer manufacturer, it isn't always the best way. If you are still not satisfied with the results but before you go running off to try other inks and papers, make sure that the printer itself is capable of providing the best possible results. It may not be. If your friends and colleagues are getting better results than you, the first place to look for improvements is the printer driver. Only after you've first optimized the printer to produce the best possible results should you start looking for ways to improve your printer output.

Make 'em Last

One of the best things to ensure a print's longevity is to take a few simple steps:

- Allow prints to dry for 24 hours before framing them. Avoid framing when humidity is high because condensation can form behind the glass. Don't hang prints in direct sunlight or display prints outdoors.
- When storing prints in a stack, allow them to dry for at least 15 minutes and then place a sheet of plain paper (I use copier paper) between the individual prints. Allow a full day for prints to dry before removing the separator sheets. And don't force dry prints with a hair dryer.
- Keep prints away from sources of ozone, such as computer monitors, television, air cleaners, or high voltage electricity. Don't store prints where they are exposed to chemicals, such as in a traditional darkroom.
- When storing prints in photo albums, use acid-free archival sleeves.
- Finally, visit Wilhelm Research's website (www.wilhelm-research.com) regularly, which is continually updated with information on the stability and longevity of new inks and papers.

Chapter 17

Black and White Part II: The Digital Black and White Print

George Schaub

The end product of black and white images, made with a digital camera or scanned from film images, is the print, whether it is seen in a book or magazine, on a gallery wall, or held in the hand. A successful print is one that communicates the thoughts and feelings of the photographer at the moment the shutter is snapped; it is often a faithful rendition of the quality of light that appeared in the original scene. However, most prints are refinements of the moment and can even be reinterpretations of the scene. These refinements are made to enhance the image or to add further visual expression; the reinterpretations are made as the photographer explores the visual possibilities of the image and finds new forms or ways to go deeper into the image beyond what was glimpsed or intuited when the shutter was first released.

The ability to enhance the moment or to reinterpret the vision is one of the most exciting aspects of the art and craft of photography. The artistic freedom this brings is key to the ability to communicate photographically. Fortunately, doing so in the digital darkroom means that the printer need not work in the chemical darkroom,

which takes up space, requires plumbing, can be unhealthy, and, in many cases, is out of the reach of most people.

The Artist and the Craftsperson

Ideally, the photographer and the person who makes the print should be one. Digital black and white requires involvement—it is not like snapshot photography where the picture taking is the end of the process. If the photographer fails to become involved in the printmaking, much of the character of the image, and certainly most of the fun and excitement of the work, will be lost.

Part of making a great print is the understanding of what goes into an effective print—for you. Just as those who would be writers must read the great books,

a b

Figure 17.1 The digital darkroom allows you to make refinements on an image that are expressive of what initially inspired you to make the image. This "straight" from the camera version (a) is given more tonal variation and depth through the use of contrast, applied with the burn and dodge tools (b). Images © George Schaub.

photographers should take the time to study the work of both classical and contemporary colleagues. It is important to understand the inherent power of the black and white medium and to have a grasp of the terms and visual associations that make it work. The first stage should be looking at prints, regardless of who may have created them. Study prints that touch you, that evoke a range of emotions. Find prints that are blunt and raw, that speak of subject matter that depicts the real world. See what it is that moves you and how printing technique reinforces the vision.

Paper and Ink

As you get ready to make your first prints, there's another item to check on the prep list—choosing paper and ink. If you've made black and white prints in the conventional

Figure 17.2 An effective image is often one that displays as full a tonal range as appeared in the original scene. The lights and darks—highlights and shadows—help create a visually interesting photograph that communicates a sense of "being there." Image © George Schaub.

darkroom, you might know that you have to choose between graded and variable contrast paper (the paper itself has the "contrast" built in) and from a range of surfaces from glossy to matte. Unfortunately, as black and white conventional darkroom work has declined, so have the paper choices. Not so with inkjet print media. You can get everything from glossy to matte to silk to canvas to print on. There's even a specially treated canvas paper on which you can apply traditional photo oils.

The choice of printing paper can have a profound effect on results. I will often work an image differently depending on the paper it will be printed on. This difference has to do with the nature of the image formation. Briefly, when an inkjet print is made, the image is composed of dots that are literally sprayed onto the paper. That's probably a bad word because it implies a pretty random placement. In actuality the dots created are very very small and are placed with amazing accuracy. The density and placement of these dots are what create the illusion of a continuous tone image. But each paper will require a different amount of ink. Some papers are more absorbent than others, with some requiring a very fine layer of ink and others heavier placement.

Paper Surface Effects

Paper surface and base color also have a profound effect on the image. Just as in conventional photographic printing, there are differences in how an image will look if it's printed on glossy or matte stock or if that stock has a brilliant white or cream base color. I often print duotone or sepia images on a warm paper base stock to enhance the image. I rarely print natural scenes on glossy stock. I always print commercial or work for repro on glossy stock. Your personal choices will be based on taste and tests.

Ink Options

There are two choices when working with black and white images. One is to print using the grayscale mode and the

other RGB or color mode. This might be a matter of taste, but if you are working with a file in grayscale mode, you can work with either depending on how your printer works. Some files look fine in grayscale mode, whereas others create a weaker looking print than when working in RGB. If you have converted your grayscale file to duotone or have scanned a toned image into RGB, then work with the printer in RGB mode. I print almost all work using RGB.

Printer Setup

When you are ready to print, there are few steps that will help you "get the most" out of each printing session. The first step is to make sure you set the image up so that it has the proper resolution for your printer. You do this in the Image > Image Size dialog box. Open any image on the screen. Open the Image Size dialog box. Here you'll see the number of pixels that compose the image, the file size, and the resolution of the image itself.

When you first open the image you'll probably see the size with a 72 dpi. This is the screen resolution of the image. You must change this number. If you do not your image size (dimensions) will be quite large, but the resolution (at 72 or 96 dpi) is too small to yield a good print. Change this number to 300 dpi or 240 dpi (a good number for most printers). When you do so you'll see the image size get smaller. That's why inputting the image at a larger file size always allows you to get good sized prints.

When you first open a digital file it might show in the Image Size dialog box as having a resolution of 72 dpi, the screen resolution on your monitor (Figure 17.3). To see what size you can make from the file size you have and to set proper resolution for a good print, change this setting to a number from 240 to 300 dpi (Figure 17.4). This is the proper resolution for most printers. Try it at the lowest setting and then the highest and compare print results. As you'll see, setting a slightly lower (acceptable) resolution will allow you to make larger prints.

Figure 17.3 Image Size dialog box, set for 72 dpi resolution, which is the resolution of your monitor.

Figure 17.4 Another Image Size dialog box, this one set at a higher resolution of 240 dpi, which should be an appropriate setting for most printers.

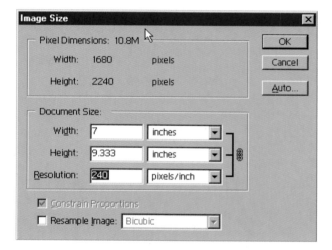

After you have accepted the new resolution/image size by clicking OK, go to the File menu and scroll down to Print. When you do the Print dialog box will open up. Now, every dialog box may look somewhat differently, but each will have certain components that we now have to set. The first box in the dialog to click on is Properties. This will show you your options. Here's where you put in the size of the paper you are using (8.5 × 11, Letter, 11 × 14,

etc.). This tells the computer how large the receiving paper is, and it is important to check this each time you print.

You next find the type of paper you are using—whether it is glossy, matte, art paper, or an assortment of others. This actually tells the printer how much ink to lay down according to the paper selected. Print on glossy paper with matte selected and you'll have poor ink lay-down, which may result in muddy colors and "pooling" that will not dry correctly. Choose glossy with matte paper loaded and the results might be "thin" with poor coverage. This identification of paper is called a "profile" and is the key to success. It helps the whole system decide just how to apply ink.

An important key to success is ensuring that you have informed the printer about the type of paper you are using for your print. This is called "profiling," and all it means is that the proper amount of ink will be used to match the paper. Here (Figure 17.5) I have set up the printing system using the Properties dialog box that is a submenu from the File > Print menu. Each printer and operating system might have different types of dialog boxes, but they all can be set up to customize your print.

The next step is to choose Portrait (vertical) or Landscape (horizontal) orientation. Finally, you may be offered other options, such as Photo Enhance and Saturation or given the opportunity to use sliders to heighten contrast or other aspects of the look of the print. Play with these as you like, and experiment with different types of images. For the most part, however, once you feed in the paper type and size, the printer and computer will have a good basis for printing and you should get good results.

If you use a paper that is not listed in the options (like a third party non–printer brand art paper), experiment with the given options to see what works best. For advanced users you might be able to go to the paper company's website and download a "profile" that you then add to the options in the paper pop-up menu.

Again, experimentation is the key. Explore new ink and paper options, work in areas in which you have not delved, and keep raising the bar on your printing techniques.

Figure 17.5 An important key to success is ensuring that you have informed the printer about the type of paper you are using for your print.

Chapter 18

Digital Fine Art
Part II: Selecting
Printers and Papers

Stephen M. Burns and Yvonne J. Butler

Giclée Prints

So what is giclée anyway? you ask. Isn't any inkjet print that comes off a printer that sprays ink onto paper or another substrate a giclée print? Good questions. Yes is the answer to both questions, but not exactly.

The French word giclée means a spray of a liquid like ink. The term giclée print is used when high resolution images or scans are printed with archival quality inks on various substrates, preferably archival as well. Fine artists use fine art papers, canvas, photo paper, and whatever will work with the printer. The process by which giclée prints are produced is intended to provide the best possible color accuracy.

Giclée is often connected to and confused with Iris prints, which happen to be four-color prints. True giclée prints are produced on professional-level 6-color to 12-color inkjet printers. In the not too distant past, the expensive Iris 3047 printers and the prints from them were the only ones considered by many to be "giclée." The Mimaki JV4 ($30,000 range) and Epson 7600 (under $3000) followed the just under $90,000, four-color Iris 3047 printers. The focus of our discussion is the range of

Epson wide-format professional printers, all capable of producing glicée prints.

Both the Epson Stylus Pro 7600 and 9600 produce museum-quality output. The most recent price competitive addition to the group is the Epson Stylus Pro 4000 that comes with professional-level ICC profiles and auto-switching between matte and photo black inks. The 4000 is yet another printer up for serious consideration by in-home and small studios. Of course, Epson also manu-factures the Epson Stylus Pro 10600.

The Epson Stylus Pro 4000, a 17″ wide printer, is a 7-color Ultrachrome ink printer with 8-channel print head technology. A professional edition of the 4000 model has internal Ethernet (communication) and PostScript language features. The Pro 7600 prints at 24 inches and the 9600 and 10600 print at 44 inches. All three use 6-color Epson Photographic Dye and 7-color Ultrachrome inks, with an additional 6-color archival ink feature on the 10600.

Other manufacturers such as Roland, Canon, and HP also make printers for giclée-level output. Canon has its 1200 dpi BJ-W9000 professional fine art printer; see the Canon website for details. Hewlett Packard has 5000ps and 5500 printers, with 42- and 62-inch widths and that allow switching between dye-based and pigmented inks; see the HP web site. Literature on the HP printers state they produce prints with 100-year life spans. Other traditional wide-format Iris Giclée printers are made by CreoScitex and MacDermid ColorSpan.

Hey, if you haven't tried this, don't take it lightly. The giclée print you may see hanging on someone's living room wall might be an expensive piece. At www.gicleeprint.net a report about giclée prints has some interesting information. The author states giclée prints hang at the Metropolitan Museum, the Museum of Modern Art, and the Chelsea Galleries, all in New York City. The author further states art auctions of giclée prints by Annie Leibovitz, Chuck Close, and Wolfgang Tillmans have gone for tens of thousands of dollars. Our own Tony Sweet and Stephen Burns, contri-butors to this book, are avid giclée printers. Get busy!

Once you use all the digital image-capture, processing, and darkroom techniques offered in this book and get your images archived, any or all of them may be set up for giclée reproduction, even on-demand reproduction. You will be able to use a variety of substrates along the way. Having carefully stored your digital images on CD/DVD, external hard drives (in a safety vault), and other storage media, your precious images will be available well into the future.

What about the quality of giclée prints? One of the advantages of using giclée printing is the potential for mass production at the highest quality level, some say comparable with silver halide and even gelatin prints. We say they rival any other form of output. If some of the top museums in the world accept giclée prints, then that's good enough for us.

Some printers of choice for in-home and professional studio use are the line of 13-inch or wider Epson Stylus Photo printers: the Epson Stylus 2200, 4000, 7600, and 9600. Epson's UltraChrome pigmented ink technology puts these printers in the forefront of the giclée market. As outlined in Chapter 16, these Epson printers use pigmented inks instead of dye-based ink. Ultrachrome pigmented inks give longevity to the fine art.

It is important to keep in mind several factors that will affect the longevity of a giclée print: the type of ink used, exposure to light, moisture, heat, ozone, and the acidity of the paper. Although the ideal environment for a giclée print is a cool and dry location with indirect sunlight, the two factors that appear to be most problematic are the paper's acidity and effects of ozone on it.

It is also important to seriously consider using acid-free papers to further ensure the longevity of the print. The neutral pH of the paper will assist in preserving the integrity of the image because it is free from the types of solvents normally found in commercial papers that will interact with the ink and cause it to quickly fade over time. Once the paper is established as acid free, the other problem to be aware of is the ozone. Problems in ozone

include any gases in the immediate environment that will cause the print to fade quickly. This is especially the case with dye-based inks.

Types of Papers

We use a variety of papers for fine art printing, including the Epson papers. The longevity of Epson papers is significant, anywhere from 30 to close to 100 years. Although Epson does not guarantee the longevity of its papers, several experts suggest the papers have significant longevity of approximately 80 to 100 years.

Coated and Non-Coated Papers

For giclée printing you have the option to use both coated and non-coated papers. Non-coated papers do not have a substrate or coating that will properly accept the ink sprayed from the inkjet nozzles. The result is that the ink will spread as it is absorbed into the paper. This is referred to as dot gain. The amount of dot gain that results depends on the paper that you use. Because paper is made of fiber it will absorb any liquid, thus preventing the possibility for sharp luminous detail. This is why imagery on non-coated papers appears to be faded with lack of detail. The coating on the paper is paramount to how well the images will stand out.

If you want to get the best results from your giclée printer, you should always use a coated paper. Having a coating on paper is analogous to applying gesso before applying paint to a canvas. The gesso provides the surface to which the paint may adhere. For giclée printing the quality of the coating can mean the difference between a vibrant image with great amount texture details and one that is flat and lifeless. Digital Art Supplies in San Diego (www.digitalartsupplies.com) specializes in papers from all around the world that are formulated for giclée printers.

Some of the Epson papers to consider for fine art are as follows.

Professional Media
Fine Art Papers

Luxurious weight, texture, and finish give these 100% acid-free archival cotton papers a true museum-quality appearance.

- Canvas
- Epson Velvet Fine Art Paper
- PremierArt™ Water Resistant Canvas for Epson
- Smooth Fine Art Paper by Crane
- Somerset® Velvet for Epson
- Textured Fine Art Paper by Crane
- UltraSmooth Fine Art Paper

Coated Papers (Gloss and Semigloss)

Epson Coated Papers are formulated to meet the demanding needs of the professional graphics industry and offer a wide selection of products unparalleled in performance, quality, and value.

- Glossy Paper Heavyweight
- Glossy Paper Photo Weight
- Photo Glossy Paper
- Photo Paper
- Photo Quality Glossy Paper
- Photo Semigloss Paper
- Posterboard Semigloss
- Semigloss Paper Heavyweight

Coated Papers (Matte)

Epson Coated Papers are formulated to meet the demanding needs of the professional graphics industry and offer a wide selection of products unparalleled in performance, quality, and value.

- Doubleweight Matte Paper
- Enhanced Matte Paper
- Enhanced Matte Posterboard
- Matte Paper Heavyweight
- Photo Quality Ink Jet Paper
- Presentation Matte Paper
- Watercolor Paper Radiant White

Source: *Epson.com* website. Descriptions are from Epson.

We also like to experiment with several other types of papers from various manufacturers. Every artist has their preference in terms of paper color, texture, and thickness. Below is a chart (Figure 18.1) that Digital Art Supplies carries in stock.

In addition to the papers displayed below, another favorite is the line of acid-free papers created by the German company Hahnemuhle. Stephen Burns, Yvonne Butler, and many other photographer/fine artists regularly use the Hahnemule German Etching paper which is a heavyweight paper with a surface that resembles heavyweight watercolor paper. Its ability to produce deep

Bugra German Antique 140	300 Linen gsm	Photo Rag 308 gsm
German Etching Board 310 gsm	Japan 90	Linen 150
Allegretto 160	Hahnemuhle 230	Linen 150
300 Velvet gsm	Hahnemuhle Photo Gloss 180	Bugra Natural White 140

Figure 18.1 Papers from www.digitalartsupplies.com.

textured blacks and render great depths of saturation is ideal for use with the Epson Ultrachrome inks. Imagery on this paper can be rendered with photographic precision on a painterly surface.

Some of the other Hahnemuhle papers that you should experiment with include the following.

Photo Rag
William Turner 190
German Etching Board 310
Board Products
William Turner 310
Torchon
Albrecht Dürer 210
Photo Matte 170

We highly recommend that you play play play. Do not get too influenced by tests, opinions, and critical reviews to the point that you become stubborn about playing. We urge you to experiment as much as possible with a variety of papers at various output resolutions. Learn to discover the outcome of the results for yourself and allow any mistakes or unpredictable results to influence a new way of creating. Sometimes new ideas can spring from unpredictable results. So have fun and be creative.

About the Authors

Steve Anchell

Steve Anchell is an internationally published photographer. His fine art work has been exhibited in galleries, private collections, and 36 exhibits, including 13 solo exhibits. Steve has been a contributing editor to *Outdoor Photographer*, *Camera & Darkroom*, and *PhotoWork* magazines and has written columns, feature articles, and interviews for *View Camera*, *PIC*, *Shutterbug*, and *Rangefinder* magazines. He is also the founder and former editor of *Photovision* magazine. His three books, *The Darkroom Cookbook*, *The Variable Contrast Printing Manual*, and *The Film Developing Cookbook*, are all international photography bestsellers. Photo-Eye Books of Santa Fe named *The Variable Contrast Printing Manual* the best technical title of 1997. The first anthology of his work, *The Nude at Big Sur*, was released in December 2002. His internationally known clientele included Vivian Woodward Cosmetics, Merle Norman Cosmetics, Jordache, IBM, Teledyne-Inet, Mitsubishi-Fudosan, and many others. His specialty was photographing for "underground" L.A. fashion designers. In 1984 he closed his studio to devote full time to his photography, teaching, and writing on photography. He has conducted photographic and darkroom workshops since 1979, including workshops for Santa Fe Photographic Workshops, Zone VI, Cape Cod and Tuscano Photographic Workshops, the Universities of California at Los Angeles, Santa Barbara, and Irvine, the University of Cincinnati, and the University of Denver. In addition to teaching private workshops from his home in Crestone, Colorado, Steve accepts commercial assignment work and also licenses photographs for the advertising and publishing industries. See his website at www.steveanchell.com.

Stephen Burns

Stephen Burns, an award-winning photographer and digital fine artist, has discovered he has the same passion for the digital medium that he has for photography as an art form. His background began as a photographer 22 year ago and, in time, progressed toward the digital medium. His influences include the great Abstractionists and the Surrealists including Jackson Pollock, Wassily Kankinsky, Pablo Picasso, Franz Kline, Mark Rothko, Mark Tobey, and Lenore Fini. Stephen is the co-founder and leader of a large Photoshop User Group in the San Diego area, Photoshop trainer, and contributor to other books on digital imaging and fine art. Stephen's website address is www.chromeallusion.com.

Yvonne Butler

For Yvonne Butler, professional photographer, writer, and content and technical editor of and major contributor to this book, photography has been a lifetime passion. This passion is closely followed by an inherent condition of wanderlust and, an ongoing sense of urgency to capture on (now digital) film the beauty of people, objects, and special locations around the world. Yvonne has amassed a representative body of black and white and color images taken in over scores of countries, many of them so-called third world countries, while she works on specialty abstracts and close-ups as fine art form. Her work has appeared in several magazines, websites, and collateral materials of the groups and client for whom she leads workshops or provides consulting. Butler was the creator and former director of the *Shutterbug* magazine digital workshop series. Given Yvonne's role with this book, it is appropriate to state that Butler earned a master's degree in Information Systems at Northeastern University School of Engineering and thereafter completed extensive doctoral-level coursework in Communication at the University of South Florida; she has worked in and with information technology since the early 1980s, including time overseas,

and digital imaging since 1999. Butler now conducts her own digital workshops throughout the US and world. She is represented by galleries on Cape Cod and in Toronto, Canada. Visit her website at www.yvonnebutler.com and e-mail her at Yvonne@yvonnebutler.com.

Eric Cheng is a professional photographer and software engineer who has experimented with digital infrared photography since early 1998. He has been published in numerous photography magazines and maintains one of the most comprehensive websites about digital infrared photography on the web (http://echeng.com/photo/infrared/). Eric is also a published marine photographer and is the editor of Wetpixel.com, a hub for digital underwater photographers featuring news, reviews, and a forum of over 1000 digital divers.

Eric Cheng

Joe Farace's interest in photography and digital imaging combine the engineering education he acquired at Johns Hopkins University with training in fine art photography at the Maryland Institute of Art. Joe has been writing about and practicing digital imaging since 1990, when some people didn't even know what to call this new technology. He is the author of more than 20 books on photography, digital imaging, and computing and is a contributing photographer/writer to *Shutterbug* magazine, which publishes his monthly Digital Innovations and Web Profiles columns. His work, including the Buzzwords column designed to demystify techno-speak, appears in eDigitalPhoto.com. Joe is also Contributing Editor to *ComputerUser* magazine and published more than 1300 magazine articles in the United States and around the world. Joe's philosophy about capturing, enhancing, and printing digital images is that it has to be fun. Part of that fun involves finding, choosing, and working with software and hardware that take the drudgery out of creative imaging. You can visit with Joe at www.joefarace.com or www.joefaraceshootscars.com.

Joe Farace

Lou Jones

Lou Jones specializes in photo illustration and location photography for corporate, advertising, and collateral projects. Many know him for his decades of work photographing Olympic events, all critically acclaimed. Others know his work in advertising spreads for Nike, Federal Express, KLM, Met Life, and in *Fortune* and numerous other magazines. Still others know him for his six-year odyssey documenting men and women on death row in the United States and then writing, with Lorie Savel, *Final Exposure: Portraits from Death Row*. In 1990, the Museum of Afro-American History commissioned Jones to document women of success and influence, resulting in a highly acclaimed exhibition called "Sojourner's Daughters." Jones's images have been exhibited in galleries throughout the country, including Corcoran Gallery in Washington, DC, the San Francisco Museum of Modern Art, the Cooper Hewitt Museum in New York City, and the Museum of Afro-American History in Boston. See his work at www.fotojones.com and on the Nikon website.

Rick Sammon

Rick Sammon is the author of 22 books and more than 2000 magazine and newspaper articles. Rick is also the host of the Digital Photography Workshop on the Do It Yourself (DIY) network and the guest host of the Photo Safari on the Outdoor Life Network. In his TV workshops, as well as in his live workshops, Rick covers the basics of digital imaging: shooting, scanning, saving, enhancing, sharing, and printing. Rick's other efforts include an interactive CD, *Photoshop for Outdoor and Travel Photographers*, from Software Cinema. Visit with Rick at www.ricksammon.com.

George Schaub is the Editorial Director of *Shutterbug* and *eDigitalPhoto* magazines. His website, http://georgeschaub.photofolio.com, contains many more examples of his digital black and white work. He has authored many books on black and white photography, including two on digital black and white printing, the latest being *The Digital Photolab: Advanced Black and White Techniques using Photoshop* (Silver Pixel Press). He teaches digital photography and printing at workshops and schools throughout the country. Visit his site for more information and a schedule of his classes.

George Schaub (Photo © Monte Zucker)

Jeremy Sutton is an internationally renowned award-winning portrait artist, author, and educator. Jeremy has written three books, authored instructional videos and DVDs, had his articles and artwork featured in numerous magazines, and been an invited platform speaker at prestigious international conferences. His publications include the following: *Painter 8 Creativity: Digital Artist's Handbook* (Focal Press, 2003), *Painter Creativity for Professional Portrait and Wedding Photographers 4 DVD Tutorial Set* (PhotoVision, 2003), *Secrets of Award-Winning Digital Artists* (co-author Daryl Wise, Wiley, 2002), *Total Painter Video Series* (Total Training, 1998), *Painter 4 Video Series* (MacAcademy, 1996), and *Fractal Design Painter Creative Techniques* (Hayden Books, 1996). For deeper understanding of the Painter visit www.jeremysutton.com and e-mail Jeremy at jeremy@paintercreativity.com.

Jeremy Sutton (Photo by Tom Deininger)

Tony Sweet

Tony Sweet is a widely published photographer. His work has been featured in *Nikon World*, *Shutterbug*, and *Rangefinder* magazines, along with countless greeting cards, calendars, and stock images leased worldwide. He is contributing photographer in Amphoto's *The Best of Nature Photography,* and in Globe Pequot's *New Hampshire on my mind.* His popular first book, *Fine Art Nature Photography*, will be followed up January 2005 with *Fine Art Flower Photography*, both published by Stackpole Books. His award-winning DVD, *Visual Rhythm*, is a "workshop in a box." Tony was a professional jazz musician before he became a photographer, and he sees a strong relationship between his music and his photography. Sweet said, "Jazz is an abstraction and so is this kind of photography. In both cases, I'm playing with and rearranging elements, accenting certain elements, adding visual grace-notes, and composing visual rhythm."

Taz Tally

Prepress "guru" Dr. Taz Tally is renowned for his fun and entertaining teaching style, keeping you on the edge of your seat throughout each session! He's a Ph.D. and author of *Avoiding the Output Blues*, *Avoiding the Scanning Blues*, and *Electronic Publishing*, a textbook. He has also created numerous training videos and CDs and authored textbooks used throughout the industry. He is in demand nationally as a presenter on topics related to pre-press and graphics. More than 30,000 graphics professionals have attended his seminars, with universal approval and praise. His content-rich seminars are presented in a simple easy-to-understand fashion, making him one of the industry's most popular presenters.

Eddie Tapp

Eddie Tapp is a photographer, lecturer, consultant, and author on digital imaging issues. As an award-winning photographer with over 20 years of experience in computer technology, Eddie has been actively involved in educating and consulting corporations, studios, and agencies in the applications of digital imaging workflow, color management, pre-press, and digital photography globally through workshops, seminars, on-site consulting, and training. He has also served as print judge at many professional photographic competitions and is a Nationally Qualified Juror for the Professional Photographers of America Association in Electronic Imaging. He serves on Adobe's Photoshop Beta Team and NAPP's (National Association of Photoshop Professionals) Photoshop Dream Team. Eddie has a series of CDs available from Software-Cinema (www.software-cinema.com) on Professional Enhancement Techniques Color Management and Digital Workflow and he is writing *Production Techniques in Photoshop and Digital Photography* (Amherst Media). See his website at www.eddietapp.com and e-mail him at etapp@aol.com.

Index

Note: Page number followed by "f" indicate figures; "t" tables.